Frederick DOUGLASS

in

WASHINGTON, D.C.

The Lion of Anacostia

John Muller

FOREWORDS *by* FRANK FARAGASSO, PhD,
KA'MAL MCCLARIN, PhD & CLIFFORD MUSE, PhD

Charleston | London

THE
History
PRESS

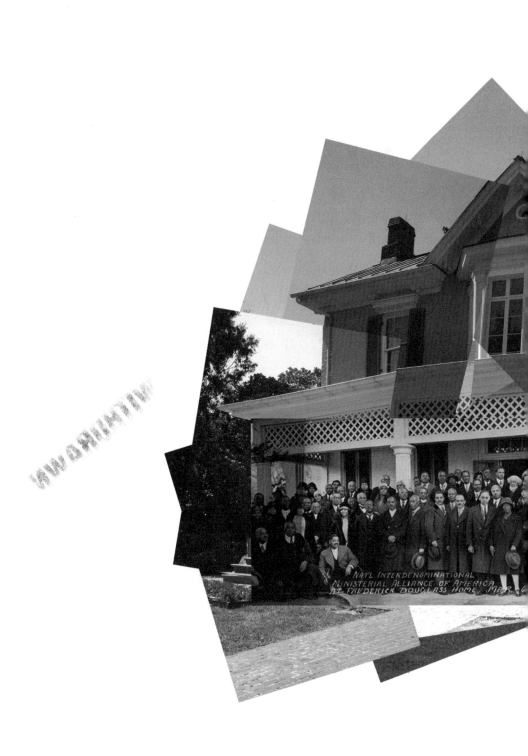

NATL. INTERDENOMINATIONAL
MINISTERIAL ALLIANCE OF AMERICA
AT FREDERICK DOUGLASS HOME, WAS

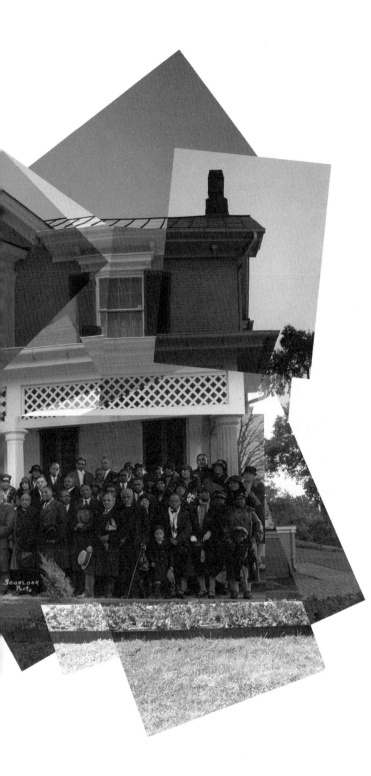

Published by The History Press
Charleston, SC 29403
www.historypress.net

Copyright © 2012 by John Muller
All rights reserved

Frontispiece photo collage by Matthew Parker.

Cover image: Marshal Frederick Douglass at his desk in city hall. Print watercolor from *Frank Leslie's Illustrated*, December 13, 1879. *Author's collection.*
Back cover, left to right: Frederick Douglass with Helen and Eva Pitts. *National Park Service, Frederick Douglass NHS*; Postcard of Cedar Hill, circa 1910. *Collection of John DeFerrari.*

First published 2012

Manufactured in the United States

ISBN 978.1.60949.577.0

Library of Congress CIP data applied for.

In Loving Memory of

William Bernard Hemmer (1924–2000)

...A man of an angel's wit and singular learning. He is a man of many excellent virtues; I know not his fellow. For where is the man (in whom is so many goodly virtues) of that gentleness, lowliness, and affability, and as time requires, a man of marvelous mirth and pastimes and sometime of steadfast gravity—a man for all seasons.

—Robert Whittington, 1520

Contents

Foreword

Since the death of Frederick Douglass in February 1895, much has been written about his extraordinary life. There are several full-length biographies and hundreds of articles. Early biographies by James Monroe Gregory, Frederic May Holland and Charles Chesnutt are still useful. Benjamin Quarles's 1948 book, *Frederick Douglass*, was the first biography written by a professional African American historian. Philip Foner's biography and collection of Douglass's writings was an important first step for scholars. Dickson J. Preston, an investigative journalist, provides groundbreaking insight into Douglass's early life in his 1980 book, *Young Frederick Douglass: The Maryland Years*. William S. McFeely's *Frederick Douglass*, published in 1991, is a comprehensive study by a Pulitzer Prize–winning historian. David Blight's well-written *Frederick Douglass and the Civil War: Keeping Faith in Jubilee* was also published in 1991. The exhaustive gathering of Douglass's speeches, interviews and writings by John Blassingame is a true achievement. Numerous articles and essays appeared in 1995, the centennial of Douglass's death. In recent years, an essential cluster of books (and a play performed at Ford's Theatre) has emerged that examines the relationship between President Abraham Lincoln and Frederick Douglass. Significant scholarship is expected in the coming years as the sesquicentennial of Douglass's birth approaches.

Despite all that has been written, John Muller shares in this new work the first thorough study of the years the "Sage of Anacostia" lived in Washington, D.C. Muller's work is critical to understanding Douglass's later

years. During this time period, from 1865 to 1895, Douglass's life underwent dramatic shifts that were nothing short of seismic. When he first came to the District of Columbia, Douglass did not come to stay. He came, off and on, to run the *New National Era*, the first national newspaper for African Americans. Douglass and his family considered Rochester, New York, to be "home." But when their house was destroyed by fire in 1872, Douglass decided to make a permanent move to Washington, D.C. That single decision changed his life. The Civil War had ended eight years earlier. The District of Columbia was becoming a true center of national power. For the ambitious, there *seemed* to be no better place. Congress had passed the Thirteenth, Fourteenth and Fifteenth Amendments, which were essential to ensuring that the protections of the United States Constitution applied to the more than four million Americans now fully recognized as citizens.

Douglass often said that without the vote, freedom for African Americans was meaningless. He believed they had to be active in the political system if they were to achieve equality and wealth. With this in mind, Douglass did what he could to cultivate new leadership among the younger generation of African Americans. For many years, he was involved with students at Howard University. While causes consumed much of his time and energy, Douglass *did* find time for his first loves: home and family. He purchased Cedar Hill, a sprawling estate in Anacostia complete with a Victorian mansion, in the fall of 1877. The house eventually included a library, a nursery and a kitchen. It was spacious enough to shelter his large family, *and* it welcomed everyone who entered. For a former slave to purchase such a home was, before Douglass, unthinkable. It was also unthinkable, for many, that this same former slave might marry a white woman, but that is precisely what Douglass did. After the death of his first wife, Anna, he married a college-educated white woman, Helen Pitts of New York.

As the most influential African American of the nineteenth century, Frederick Douglass championed many causes for "his people." In other words, he did not forget his roots. He also championed his family by providing them with a home rivaling that of any white man at the time. Without question, Douglass dared to live and love in and across the color line. He did all of this in his later years, after he moved to the District of Columbia. We are fortunate that John Muller, through his pioneering and spirited research, makes those years come alive.

Frank Faragasso, PhD
July 2012

Frank Faragasso was the historian for the National Park Service's Frederick Douglass National Historic Site in Washington, D.C., for sixteen years. During his tenure, Dr. Faragasso promoted an understanding of who Douglass was and why he is important to our history. To this end, Dr. Faragasso organized the first international conference on Douglass in 1999. He has also partnered with other agencies and private organizations to produce conferences and dramatic presentations, spoken to groups of all ages and conducted tours at various locations. Although retired, Dr. Faragasso maintains an interest in Douglass and his time.

Foreword

From this vantage ground [Cedar Hill], *I have a magnificent view of the most magnificent city* [Washington, D.C.] *on the continent; I view, also, the history of the country for a half century as well as the history as it transpires from day to day.*[*]
—*Frederick Douglass, September 1892*

Cedar Hill was Frederick Douglass's final home. Also known as the Frederick Douglass National Historic Site, this twenty-one-room Victorian mansion and its surrounding eight acres are among America's national historic treasures. Located in the heart of Historic Anacostia in the nation's capital, Cedar Hill, Douglass's home of the last seventeen years of his life, represents his crowning achievement and progress. It signified to the world the heights to which Douglass had risen by the end of his life as the "Sage of Anacostia." Providing him and his family spiritual and physical fulfillment, Cedar Hill was their suburban oasis. Standing atop an expansive hill, the residence itself is renowned as America's emblematic "Watch Tower of Freedom." Off in the distance to its far left is a beautiful view of the United States Capitol.

Today, the Frederick Douglass National Historic Site is a tangible symbol of Douglass's enduring legacy, embodying "American Exceptionalism," as espoused by historian Gordon Wood, which held that America's mission was to lead the world toward liberty and democracy. Simultaneously, Douglass's

*. Timothy Thomas Fortune, "The Sage of Anacostia," *Cleveland Gazette*, September 10, 1892.

legacy is also a metaphor for his life as he transitioned from slavery to freedom. The site, open seven days a week, is visited annually by thousands of individuals of all nationalities who have a deep connection to Douglass's ideas concerning freedom, liberty and, above all, equality for everyone. An icon of the American collective memory, it serves as both a steadfast advocate for progress for the world at large and a catalyst for change in the nation, particularly the surrounding Anacostia community.

The site's staff uses the historic furnishings and serene grounds to provide clear meaning to the complexity of Douglass's character. They serve as points of contact, especially for those visitors who identify with Douglass, finding his life a source of inspiration to achieve their own goals. Many of these visitors consider this historic site as their pilgrimage destination. Cedar Hill's furnishings and books are a rich material culture that reveals to visitors the many aspects of Douglass the man, making this historic landmark much more than brick and mortar.

With their southern Victorian character, the rooms and artifacts tell their own story of a significant period in the history of our nation. An example of the narration for visitors is as follows: "Here lived a man of complexity who experienced wonderful times on this estate. A man of many seasons, he had the immense pleasure of reading, writing and partaking in musical performances with friends and family inside the venerable walls of Cedar Hill." This historic site gives background to the colorful stories of Douglass, the intellectual, activist, statesman, writer, orator, musician, family man, friend, colleague, naturalist and Victorian gentleman. The home symbolizes Douglass's unparalleled struggle for his freedom and that of other African Americans.

Within this larger context, this national historic site also represents the African American experience in America pre- and post slavery while at the same time expressing universal concepts of courage, liberty, freedom and equality in the face of political, social and economic obstacles. His wide-ranging advocacy for social justice issues, including abolition, civil rights and equal education, regardless of race or gender, helped to transform America into a nation seeking to live up to its ideals—ideals that continue to be relevant today.

Ka'mal McClarin, PhD
July 2012

Ka'mal McClarin is the curator of the Frederick Douglass National Historic Site in Washington, D.C. He earned his PhD in United States and Public History at Howard University in 2012 and was the editor of Frederick Douglass: A Voice for Freedom and Justice.

Foreword

The establishment of Howard University and its development have been appropriately described as "one of the great romances of American education." The romance is one of extraordinary men and women accomplishing noble deeds, of institutional survival wrought by biracial education, of American societal and federal government largesse and of the interaction among people of different racial, sexual, economic and cultural backgrounds. Howard University's founding policy guaranteed its unique position in higher education as the first American university operating on a basis of a nondiscriminatory admissions policy. The first Howardites enunciated their fervent belief in the educability of African Americans, belief in the necessity to challenge the concept of social inferiority applied to African Americans based on pseudo-scientific mythology, belief in the necessity of coeducational and multiracial education to foster a solid foundation capable of surviving in the American system of higher education, belief in educating African Americans as well as "disadvantaged whites," belief in the African American race's potential for progressive interaction with the nation's diverse majority population and belief in creating an African American intelligentsia who would come to understand the "genius of American life" and its potential for growth.

The policymaking authority of Howard University is the Board of Trustees, which derives its power from the university charter. Howard's board is unique in that the university charter establishes a board in which the trustees are "designated a body politic and corporate, with perpetual succession in deed or in law." In effect, the Howard trustees are empowered to select their own successors, and their policymaking authority, in theory,

is not subject to external influences or review. As a member of the Howard University Board of Trustees from 1871 to 1895, Frederick Douglass was viewed as an important member of the board who could facilitate actions beneficial to African Americans as they related to Howard, mediate internal university squabbles to successful conclusions and defend successfully the university, both internally and externally.

In John Muller's *Frederick Douglass in Washington, D.C.: The Lion of Anacostia*, the chapter describing Frederick Douglass's contributions to Howard University, the American nation and especially the black community highlights the extraordinary career and accomplishments of a most unique individual. With the death of Frederick Douglass on February 20, 1895, Howard University lost one of its most gifted sons. At the February 23 meeting of the Board of Trustees, President Jeremiah Rankin made the following remarks, which the board adopted and placed in the minutes:

> *Resolved that in the death of* [the] *Honorable Frederick Douglass, L.L.D., the Trustees of Howard University have lost the most remarkable of their number; a man singular in the humility of his origin, as well as his wonderful career as an orator and public man; a man recognized and honored by two continents of the Anglo-Saxon race, the acknowledged representative and leader of the Afro-American Race, in richness of intellectual endowment and wisdom, and the emphatic and lasting disproof of the theory that men and women of African distraction can not stand unchallenged among the great ones of the earth.*

In looking at the tenure of Frederick Douglass as a member of the Howard University Board of Trustees and a devoted supporter of the university, one can say that Douglass was one of those "extraordinary men and women" who contributed to the establishment and development of the Howard dream: "a university for the education of youth in the liberal arts and sciences."

Clifford L. Muse Jr., PhD
Howard University Archivist

Dr. Clifford L. Muse Jr., the Howard University archivist and associate director of the Moorland-Spingarn Research Center, has been a university staff member since 1981. Dr. Muse has worked as an archivist in the Office of Presidential Libraries in the National Archives and Records Service (NARS) and served as a senior archivist on the NARS

Nixon Presidential Materials Project. Dr. Muse is a member of the American Historical Association, the Society of American Archivists, Mid-Atlantic Regional Archives Conference, Association of Records Managers and Administrators and the Association for the Study of Afro-American Life and History. Dr. Muse is a graduate of Hartwick College and Howard University.

Acknowledgements

If I were to thank everyone who made this book possible, I'd run out of space. Foremost, thanks to God. Second, thanks to my family—B.A.M., Horselady (world's best mom and editor!), Leeroy, Uncle G and family, Alexandre Husson and family and Gramma Hemmer—who have always been there. My gracious research assistant, Sweet Pea, who has had to compete with Frederick Douglass, I love and thank you.

Without the years of support of the Adult Literacy Resource Center (Ben, Stephon, Marcia, Elaine, Toni and Ms. Maxine) and the help of the wonderful staff of the Washingtoniana Division of the Martin Luther King Jr. Memorial Library at 901 G Street Northwest, this book couldn't have been written. The world-class staffs at various divisions of the Library of Congress have all made invaluable contributions. Thank you to University of Rochester's Frederick Douglass Project for sharing its great collection, to the District of Columbia Archives and to Irma Clifton at the Workhouse Prison Museum for saving important Douglass documents from the incinerator. Dr. Muse, Joellen Elbashir, Dr. Ida E. Jones and Richard E. Jenkins III at Howard University's Moorland-Spingarn Research Center have been gracious in their support, uncovering Frederick Douglass's Washington. The early support of David Turk at the U.S. Marshals Service, Nan Card at the Rutherford B. Hayes Presidential Center and D.C.'s community historian and griot C.R. Gibbs proved to be instrumental. Thank you to the Glenwood Branch of the Howard County Library; Braden Paynter; Padriac Benson;

Stan "da Man" Voudrie; John DeFerrari; Professor Leigh Fought; Professor Sutton; Professor Kristensen; Professor Buntman; Gordon Yu; Robert J. Washek; Brian Kraft; Sandra Schmidt; Steve Ackerman; Zoe Trodd; Celeste-Marie Bernier; Robert Ellis; Mark H. Metcalf; Donet D. Graves, Esquire; the Advoc8te and her work with ARCH Development Corporation; Quique Aviles and el barrio; the creative vision of Matthew Parker; Gwen Kimbrough of the Metropolitan African Methodist Episcopal Church; and too many others who, by kindly sharing their time and offering support, have been surrogates of the irrepressible spirit of Frederick Douglass. Thank you to Historic Anacostia residents Arrington Dixon, Angela Copeland, Catherine Buell, William Alston-El and Reverend Oliver "OJ" Johnson for your support. Special thanks to "pool shark" Zabia Dews of old Barry Farm.

The early encouragement and steadfast support of Matthew Gilmore, who for decades has been tireless (no sleep) in his commitment to all things D.C. history, has meant more than I can express here. Much love and respect to Bell Clement, who since my days as a playwright riding the 70 bus tough (with Justin McNeil), has believed in me. Thank you to Andrew Lightman at Capital Community News and David Alpert at Greater Greater Washington. Hannah Cassilly at The History Press believed in this project from inception and has been supportive to its birth. Thank you to Katie Parry for getting the word out and to Jaime Muehl and the entire production staff at The History Press for putting together a wonderful project.

Finally, to the tried-and-true friendships of my brothers, Justin L. McNeil and Anthony Moore, who were the genesis and sustaining inspirational force behind this work; to community leaders working their hands and feet raw to the bone to make their families, communities, schools and streets better places day in and day out, with or without recognition—this is for you. To those in their school days in the 202, 301 and 410 discovering the words and life of Frederick Douglass anew, minds opened to new ways of thinking and seeing the world, this is eternally for you. If nobody else sees you, the spirit of Frederick Douglass does, watching your back, front and both sides from the early morning sunshine to the midnight darkness from the Uptown to the Southside and everywhere in between.

I take full responsibility for any errors or omissions, which are unintentional yet unavoidable. Due to publication restraints on word count, endnotes are not included here; however, a fully annotated version is publicly available at the Washingtoniana Division of the Martin Luther King Jr. Memorial Library at 901 G Street Northwest in Washington, D.C.

Preface

At last he found out from one of the city newspapers, probably in February 1833, when there was much agitation, that they had been sending petitions to Congress, asking for the abolition of the slave trade between the states, as well as of slavery itself in the District of Columbia. Thenceforth he knew that he was not without friends upon the earth.
—*Frederic May Holland,* Frederick Douglass: The Colored Orator, *1891*

In the bustling port of early 1830s Baltimore, Frederick Augustus Washington Bailey, an adolescent slave, roamed the streets. Bailey had been sent to the city from the plantation fields of Maryland's Eastern Shore by his master, who recognized his intellectual acuity. Bailey was singled out to serve as the playmate of "little Tommy" Auld; this was Bailey's first introduction to a world other than that of the field slave. His mistress in Baltimore, Sophia Auld, initially treated him kindly and opened his mind to the power of learning alongside her son, Bailey's playmate. She began to teach Bailey the alphabet and how to read passages from the Bible. When her husband found her out, he put an immediate stop to it. She now disciplined Bailey to make sure he was not reading whenever alone. However, by providing the most rudimentary instruction to Bailey, Sophia Auld had created an intellectual tour de force.

In the city, Bailey's intellectual ambition took full advantage of the mobility urban life afforded. Exhibiting a spirit that defined his life, the juvenile Bailey was ruthlessly defiant, facing down the consequences of the "unpardonable offence to teach slaves to read in this Christian Country."

He boldly read whenever he could, picking up discarded newspapers and "scattered pages of the Bible from the filthy street-gutters." Headstrong, with Webster's spelling-book clutched in hand, when "sent of errands," Bailey moved quickly to secure "time to get a lesson before [his] return." A city slave, Bailey's home had ample victuals, making him "much better off in this regard than many of the poor white children in [the] neighborhood." Jetting into the wild and untamed thoroughfares with abandon, Bailey took to the back alleys and cuts, where he "turned the street into a school-room and made his white playmates his teachers." His pockets bulging, Bailey hustled hand-to-hand, bestowing bread "upon the hungry little urchins, who, in return, would give [him] that more valuable bread of knowledge."

In and out of the back streets and on and off the docks of the city's harbor, Bailey confided in these children his yearning to be free. The white children were powerless beyond their ability to commiserate; they could understand, but they couldn't help their friend. Bailey realized their fates would be unequal. "You will be free as soon as you are twenty-one, but I am a slave for life! Have not I as good a right to be free as you have?" he asked them. Invoking his play fellows' "liveliest sympathy," Bailey, at yet a tender age, knew that while their encouragement was fleeting, his knowledge of self was eternal. His physical person might be proprietary, but Bailey's consciousness, through the power of the written word, had been manumitted, and there was no turning back.

His ears, cutting through the turbulent noise of the streets, were attuned to pick out the sounds of freedom. There was recurring chatter about a book, *The Columbian Orator*, which his friends were using in their school exhibitions. Bailey wanted his own copy. Using money he made "blacking boots for some gentlemen," the audacious Bailey presented himself at Mr. Knight's bookshop on Thames Street in Fells Point, Baltimore, inquiring about the book—a book Douglass would carry with him as he escaped slavery and have with him for the rest of his life. With an investment of fifty cents, his mind kicked open new doors, provoking him to question the system he was trapped in.

Ever listening for the discords that might free him, Douglass repeatedly heard of "abolitionists," who were "cordially hated and soundly abused by slaveholders" and "generally alleged" to have assisted any slave in their escape. His intellectual curiosity was ablaze: "Hearing such charges often repeated, I, naturally enough, received the impression that abolition—whatever else it might be—could not be unfriendly to the slave, nor friendly to the slaveholder." To discover the who, what and why of abolition, the

dictionary afforded Douglass no help: "It taught me that abolition was 'the act of abolishing'; but it left me in ignorance at the very point where I most wanted information—and that was, as to the *thing* to be abolished."

In February 1833, Bailey found "the incendiary information denied me by the dictionary." He picked up a loose copy of the *Baltimore American*: "In its columns I found, that, on a certain day, a vast number of petitions and memorials had been presented to Congress, praying for abolition of slavery in the District of Columbia, and for the abolition of the slave trade between the states of the Union. That was enough." To the young student studying in the streets of Baltimore, a mention of the nation's capital city—Washington, D.C.—was the context clue that triggered a "HOPE in those words" of abolition. Emerging out of the depths of Maryland's slave plantations and the streets of antebellum urban America, Bailey would become one of the world's most famous abolitionists. When the work of abolition was done, Bailey, then known to the world as Frederick Douglass, would settle in Washington, D.C., spending the last twenty-three years of his life making the city his home. In the nation's capital, Douglass struggled on through the tumultuous post–Civil War era of Reconstruction, using his influence in person and in print to advance the cause of the first generation of civil rights leaders in the hearts, minds and souls of presidents and paupers alike.

1

Mr. Douglass Goes to Washington

It was not uncommon as well for Congressmen, Bureau officers, and the loitering
gentry of Washington to so embarrass themselves at the gaming tables as to be
obliged to sell their body servants.
—*George Alfred Townsend*

B y the time Frederick Douglass's feet first touched down on the unpaved
streets and mud-caked sidewalks of Washington, D.C., in the summer
of 1863, the Civil War was in its third year. Just weeks before, Douglass's
eldest son, Lewis, a soldier with the Fifty-fourth Massachusetts Volunteer
Infantry, had stormed the Confederate-held Fort Wagner on Morris Island,
South Carolina, and survived to tell about it.

During Douglass's first interview with President Lincoln, he advised the
commander in chief of the Union forces on policies that would attract black
men to enlist en mass: equal pay, meritorious promotion, an agreement with
"the Confederate States to treat colored soldiers, when prisoners, as prisoners
of war" and a declaration that when colored soldiers were "murdered in
cold blood," the Union would "retaliate in kind." According to Paul and
Stephen Kendrick's recent scholarship, President Lincoln replied:

> *Mr. Douglass, you know that it was with great difficulty that I could get*
> *the colored soldiers, or get colored men, into the army at all. You know the*

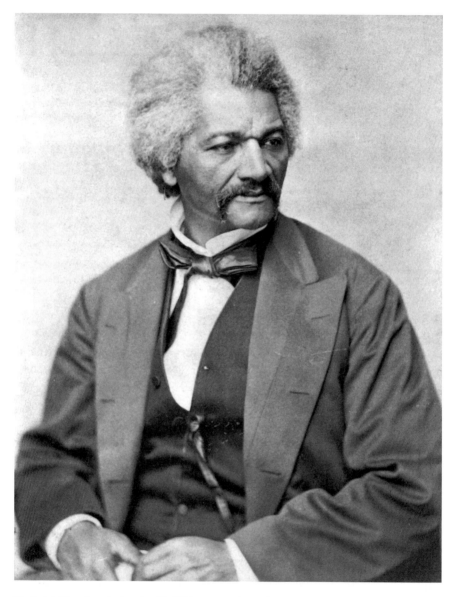

Frederick Douglass during the Civil War years, circa 1860. *Library of Congress.*

prejudices against them; you know the doubt that was felt in regard to their ability as soldiers, and it was necessary at the first that we should make some discrimination against them; they were on trial.

Douglass and Lincoln, both self-made men, ended their meeting with a newfound respect for each other. Lincoln had a war to win, and Douglass knew it could be won by putting the musket into the hands of black troops. So did Douglass's son Lewis. "I wish we had a hundred thousand colored troops—we would put an end to this war," Lewis famously wrote to his future wife from the front lines.

By the fall of 1863, enlistment of black soldiers had begun in earnest, with the full backing of President Lincoln and General Ulysses S. Grant. According to the Bureau of the United States Colored Troops, black soldiers filled the Union ranks of 142 infantry regiments, 13 artillery regiments, 1 independent battery and 7 cavalry regiments; they worked as engineers and served at sea. In total, more than 209,000 black Americans wore the uniform of their country. Twenty-three received the Medal of Honor, the highest award for valor in action against an enemy force. More than 36,000 made the ultimate sacrifice. With the enlistment of black troops and the overall technological and materials advantage of the Union, by the beginning of 1865, the Confederacy was on the brink of defeat. On March 13, 1865, less than a month before Confederate general Robert E. Lee's ultimate surrender to General Ulysses S. Grant, the Confederate Congress passed a law calling for the enlistment of black troops.

Back in Washington to hear President Lincoln deliver his second inaugural address from the Capitol's portico on the morning of March 4, 1865, Douglass sensed "murder in the air," as the "Confederate cause was on its last legs." The night before, Chief Justice of the United States Supreme Court Salmon P. Chase had entertained Douglass. "He had known me in early anti-slavery days," Douglass wrote of the former Ohio governor in *Life and Times of Frederick Douglass*, "and had welcomed me to his home and table when to do so was a strange thing in Washington, and the fact was by no means an insignificant one." Maneuvering through the morning crowd of thousands of onlookers, Douglass "got right in front of the east portico," within range of President Lincoln. Eyeing Douglass, Lincoln pointed him out to Vice President Andrew Johnson. "Mr. Johnson, without knowing perhaps that I saw the movement, looked quite annoyed that his attention should be called in that direction," Douglass

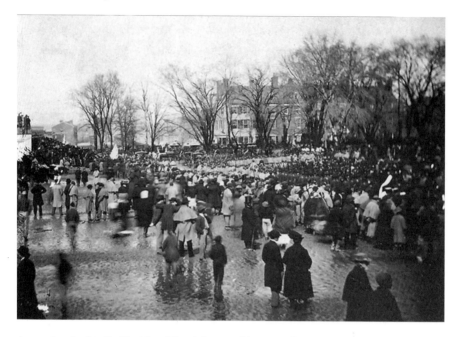

A crowd gathering for President Lincoln's second inauguration. *Library of Congress.*

remembered years later. "So I got a peep into his soul. As soon as he saw me looking at him, suddenly he assumed rather an amicable expression of countenance." Trusting his visceral instincts, "which all subsequent developments" would prove true, Douglass "felt that, whatever else the man might be, he was no friend to my people."

In a speech that ran less than five minutes, President Lincoln sought to mend the country's pain. His solemn address concluded:

> *With malice toward none, with charity for all, with firmness in the right as God gives us to see the right, let us strive on to finish the work we are in, to bind up the nation's wounds, to care for him who shall have borne the battle and for his widow and his orphan, to do all which may achieve and cherish a just and lasting peace among ourselves and with all nations.*

When Douglass clapped his hands in jubilation, he scanned the crowd and "saw in faces of many about me expressions of widely different emotion." The inaugural reception was later that evening at the Executive Mansion.

Mr. Douglass Goes to Washington

As "freedom had become the law of the republic, and colored men were on the battle-field mingling their blood with that of white men in one common effort to save the country," Douglass crashed the party to "offer his congratulations to the President with those of other citizens."

Ever bold, Douglass wanted to share the experience with good company. He had looked "in vain for some one of my own color to accompany me" but found nothing but excuses from his fellow "colored friends." Mary L. Dorsey, the wife of prosperous Philadelphia caterer and former enslaved Marylander Thomas J. Dorsey, who had been with Douglass at Lincoln's inauguration, joined him for the reception. As they approached the door of the White House, two policemen forbade their entrance. If President Lincoln knew he was at the door, the president would order his admission, Douglass told the police. Not budging, Douglass and Mrs. Dorsey were whisked to a "temporary passage for the exit of visitors." This would not do. Seeing a friendly face, Douglass asked a man passing by to tell Lincoln he was at the door. Within a moment's time, Douglass and the president were face-to-face in the East Room. Lincoln, calling Douglass his friend for all within earshot to hear, asked Douglass what he thought of his speech. "Mr. Lincoln, that was a sacred effort," Douglass reported. Within weeks, President Lincoln was dead, the first American president felled by an assassin's bullet. Andrew Johnson, who had looked at Douglass and Mrs. Dorsey with "bitter contempt and aversion," was sworn in as the seventeenth president of the United States on April 15, 1865.

Less than a year later, in February 1866, Douglass and Lewis, along with other prominent "colored representatives," including George T. Downing and John F. Cook, met with President Johnson. According to widely published reports, Douglass followed Downing in, saying:

> *Mr. President: We are not here to enlighten you, sir, as to your duties as chief magistrate of this republic, but to show our respect and to present, in brief, the claims of our race to your favorable consideration. In the order of Divine Providence, you are placed in a position to save or destroy us—to bless or blast us. I mean our whole race. Your noble and humane predecessor placed in your hands the ballot with which to save ourselves.*

Johnson would prove wholly unsympathetic to the plight of the freedmen. Angering radical Republicans in the House and the Senate with his

"New Washington," *Harper's New Monthly Magazine*, February 1875. *Author's collection.*

obstructionist policies, Johnson survived impeachment by a lone vote. Johnson is regarded as one of the worst presidents in the country's history.

In March 1869, General Ulysses S. Grant was inaugurated as the eighteenth president. According to Kenneth Bowling, Grant was the first president to envision Washington, D.C., as a source of national pride, to both the former states of the Union and the former states of the Confederacy, some of which had still not been readmitted by the time of Grant's inauguration. In Grant's annual message of 1871, he said, "Under the direction of the territorial officers, a system of improvements has been inaugurated, by means of which Washington is rapidly becoming a city worthy of the nation's capital." With Grant's interest in the city and appropriations made toward its public works, the Republican Party took a keen interest in the city "so that the city physically, constitutionally, and symbolically reflected the supremacy of the federal government over the states."

Mr. Douglass Goes to Washington

Over the next few years, Douglass would be drawn frequently to D.C. by the pull of politics, business and family. By Grant's second administration, Douglass had made Washington his permanent residence.

2

Honorable Frederick Douglass

These people are outside of the United States. They occupy neutral ground and have no political existence. They neither voice nor vote in all the practical politics of the United States. They are hardly to be called citizens of the United States. Practically they are aliens; not citizens, but subjects.
—Life and Times of Frederick Douglass

Whether arriving by foot, horseback, carriage or streetcar, attendees could see the radiant glow for blocks in all four directions. In one blaze of light, hundreds of Chinese lanterns lined Four-and-a-half Street from Pennsylvania Avenue to city hall, where three large grandstands had been erected. The porticos were draped in patriotic bunting. Hours before the meeting's start, the vacant space in front of city hall swelled with people from all walks of life. As representatives and club members from every district began to emerge, they were greeted by applause and a brass band. The rally of the Republican Party to ratify the nomination of General Norton Parker Chipman as candidate for the District of Columbia's non-voting delegate to Congress on the evening of April 12, 1871, was, according to the *Evening Star*, "the most imposing political demonstration ever witnessed in this city."

Speculation on possible candidates for the Republican nomination had included Frederick Douglass, former mayor Sayles Bowen, former city tax collector John F. Cook, a retired judge of the Orphan's Court and others. There was also chatter about Richard Wallach, Washington's mayor during the Civil War. The Democratic candidate was Richard T. Merrick, a

former Maryland state legislator whose father had represented Maryland in the United States Senate. Merrick had become a prominent lawyer in Washington during the Civil War and was widely known for providing counsel to John Suratt during his 1867 trial on conspiracy charges to assassinate President Lincoln.

To nominate their candidate, prominent city Republicans gathered in the early afternoon of March 29, 1871, at Lincoln Hall, on the corner of Ninth and D Streets Northwest. Surprisingly, Frederick Douglass, editor and publisher of the *New National Era* and recently returned to Washington from the Caribbean island city of Santo Domingo, emerged as a nominee. In his way was Brigadier General Norton Parker Chipman, who had gained Northern celebrity and Southern infamy for leading the successful prosecution of Henry Wirz. Wirz was the Confederate officer in charge of Camp Sumter, the prisoner-of-war camp at Andersonville, South Carolina, where an estimated ten thousand Union soldiers died of disease and starvation.

With the first ballot tabulated, Douglass was just over a dozen votes behind Chipman. A second ballot was voted on, and the final tally stood at Chipman, sixty-six, Douglass, thirty-seven. Frederick Douglass Jr. of the First Ward did not vote. His older brother Lewis, John F. Cook, Dr. Charles B. Purvis and Nehemiah G. Ordway, the sergeant-at-arms of the House, did, casting their ballots for Frederick Sr. Prominent black Washingtonian Perry Carson went for Chipman. After the results were certified, an announcement was read that it was "unanimously agreed that President Grant be requested to appoint Frederick Douglass to the position of Secretary of the District, which will be vacated by the election of General Chipman to Congress," reported Douglass's paper, the *New National Era*.

Years later, rumors were spread that the Board of Public Works had manipulated the vote of the nominating convention to select Chipman. "To sooth Douglass at the time he was promised," the *Baltimore Sun* reported, "that he would be appointed Secretary of the District, and in carrying out their promises the board of public works had him appointed a member of the district council."

After the second nominating tally, the attention now turned to Douglass, and he was asked to speak. His remarks strictly political in nature, Douglass said that the only way the Republican Party could crystallize views into law, organize the statute and enact it to become the rule of life and of the republic was "through a party that is able to elect its candidates." The crowd applauded. Douglass said, "Any man can have a little party. I can have a

Honorable Frederick Douglass

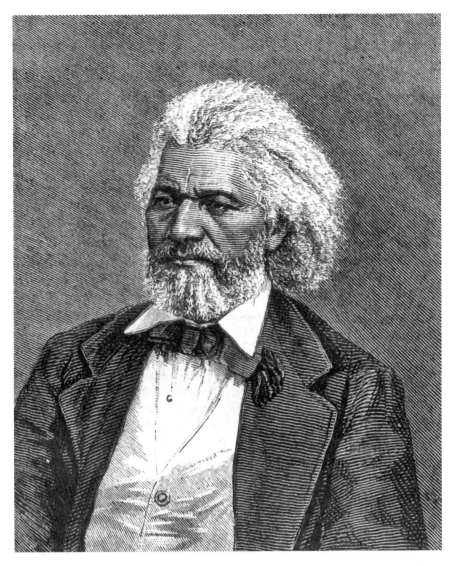

Frederick Douglass in *Harper's New Monthly Magazine*, February 1875. *Author's collection.*

little party; you have can have a little party, but it will be inefficient and impracticable. But what we want is a true party." Douglass was interrupted by the sounds of agreement from the audience. He concluded his remarks by asking all those who voted for him to pledge their support on election day for Chipman, who spoke next.

Uncertainties were thick in the air "in this initial effort to launch our new government into the great sisterhood of States and Territories," but Chipman believed that "when I see here the mechanic and the merchant, the artisan and the lawyer, the laborer and the physician, the poor, the rich, all assembled with one mind," victory was assured. Chipman denounced the stark contrast between the nominating conventions for the Republicans and Democrats. The Democrats had "excluded, by its proscriptive declarations, by the very essence of its constitution, at least one-quarter of the entire population of the District." He asked, "Is that democracy which deliberately erects an impassable barrier against a large and respectable class of our citizens whose only offence is the color of their complexion?" Answering his own rhetorical question to the crowd's delight, Chipman proclaimed, "No! It is oligarchy!" In reference to his competitor for the nomination, Chipman remarked, "In my mind it is marvelous that a party, having the intelligence claimed for Democrats should have the audacity to attempt the proscription of such men as Frederick Douglass."

Two weeks later, a well-lit evening rally was held at city hall to unify the citywide Republican ticket from top to bottom. After the slate of officers from all twenty-two city districts was confirmed, local and national figures took to the podium. Alexander Shepherd served as the event's master of ceremonies. Massachusetts senator Henry Wilson remembered, "Ten years ago tonight we in this city were enduring the most intense anxiety, and the rebels were lighting their matches to burn and destroy the old flag, disrupt the Union, and to lay waste this fair land." But it was a new day, Wilson said. Unified Republican victory "would place the capital of this great nation, a city of which we are so proud, among the standard Republican cities of the Union."

Introduced by Shepherd as a "true friend of the District" who had "labored long and earnestly for the redemption and advancement of the colored race, of which he was probably the ablest exponent," Frederick Douglass was next to lead the rally. Greeted with prolonged cheers, he took to the speaker's platform as though it were a Shakespearean stage. "It is literally with you and I and all of us of this color 'to be or not to be.'" He

Old City Hall. *Library of Congress.*

argued that both the country and his newly adopted city were "standing at a pivotal period" in history. "It is whether we shall be permitted to enjoy the liberties which have been won for by the loyal blood of the white man as well as the black, whether we shall enjoy our own rights, or whether we shall be deprived of those liberties, proscribed and reduced to our former wretched state."

Stumping for Chipman, Douglass shared, "I think him to be a loyal man, whose public history is identified with the preservation of the American Union and the triumph of the great Republican experiment of liberty to the nation." Chipman's opponent, Merrick, was well known "since coming into this District" as being a gentleman, firm friend and a good husband. However, Douglass advanced, "I have never heard that when this great nation was about to rent asunder, when hostile armies were endeavoring to break up the Union and our brave boys rallied to preserve it. I have never heard that Richard T. Merrick was on the side of the Union"

General Chipman spoke next. He wanted all to know his sympathies were with the laboring man, for he was little above them and knew what it was to struggle. The election of a delegate to Congress would mean nothing

if the city's House of Delegates, which had the legislation of the District in its hands, was split. Chipman closed his remarks, with a collection of congressmen, including Robert B. Elliot of South Carolina, looking on, thanking and encouraging all to vote the local Republican ticket.

True to the workings of the city political machine, the day after his conspicuous role in the rally for Chipman, Frederick Douglass was nominated by President Ulysses S. Grant for a two-year term to the Territorial Government's legislative council, its upper body. Congress's passage of the District of Columbia's Territorial Government in January 1871 created an elected non-voting delegate to the United States House of Representatives and a District legislature with a twenty-two-member House of Delegates, which would pass municipal laws, as well as a presidentially appointed governor and eleven-member legislative council.

Frederick Douglass kept his own counsel. If he lived with regrets, he took them to the grave. Late in his life, he was excoriated by members of his own race who claimed he sought office over all else. However, when the window was open, however wide or small it really was, to join the elected ranks of the United States Congress, Douglass turned away. The Fifteenth Amendment, ratified and incorporated into the Constitution, "opened a very tempting field to my ambition, and one to which I should probably have yielded had I been a younger man." By the time the Fifteenth Amendment became law, Frederick Douglass had just turned fifty-two.

"I was earnestly urged by many of my respected fellow-citizens," Douglass recalled years later in *Life and Times*, including the suggestions of his own son Charles, "both colored and white, and from all sections of the country, to take up my abode in some one of the many districts of the South where there was a large colored vote and get myself elected, as they were sure I easily could do, to a seat in Congress—possibly in the Senate."

Just over a year earlier, Charles Douglass had sat in the gallery of the United States Senate, his protruding eyes not believing what they were seeing. On February 23, 1870, the oath of office was administered to the first black United States senator, Hiram Revels of Mississippi. Revels was elected by the Mississippi State Senate to fill the seat vacated nine years before by Jefferson Davis, who had said farewell to Washington to assume the presidency of the Confederate States of America.

"Many voices in the Galleries were heard by me to say, 'If it would only have been Fred Douglass,' and my heart beat rapidly when I looked into that crowded Gallery," Charles wrote to his father with a newfound pride,

Honorable Frederick Douglass

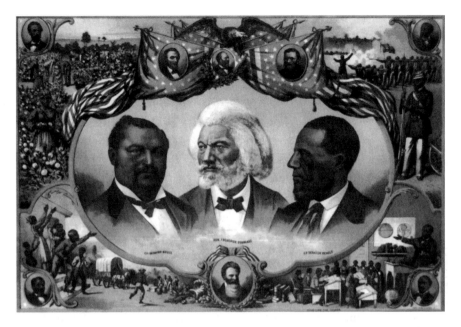

Heroes of the colored race, *from left to right*: Senator Blanche K. Bruce, Frederick Douglass and Senator Hiram Revels. *Library of Congress.*

and upon the crowded floor, to notice the deep and great interest manifested all around, it looked solemn and the thought flashed from my mind that that honor, for the first time conferred upon a colored man, should have been conferred upon you and I am satisfied that many Senators would much more willingly see you come there than to see that Reverend gentlemen who has just taken his seat. But the door is open, and I expect to see you pass in, not though, as a tool as I think this man is, to fill out an unexpired term of one year, earning from a state too that a has a large majority—of colored votes; but from your native state to fill the chair for the long and fullest term of either [Senator] Vickers or [Senator] Hamilton—who only yesterday, made long wails and harangues against negro citizenship.

In June 1870, a voice from Douglass's past emerged, reminding Douglass he had once, while a slave, fervently expressed his desire to become the first black American to serve in the United States Senate, the highest legislative body in the land. In an affectionate letter to his old running mate, William E. Lloyd, writing from Baltimore, asked after Douglass's family, fondly speaking

of Anna, who had recently been in Baltimore. After asking if Douglass would kindly return to his home city to deliver a benefit lecture on behalf of the Dallas Street Church (Lloyd was the secretary), he gently reminded Douglass that now was the time to act on the conviction Douglass had held as a young man. "Now, my dear brother and friend I have not forgotten the remark you made in the old frame house in Happy Alley rented by James Mingo in the debate one night you told me you never meant to stop until you got in the United State Senate." Not the first person to remind Douglass not to forget them, Lloyd closed, saying, "[T]hink of me when times [*sic*] goes well with you, when you arrive in that great House."

Despite the pleas of his son and the encouragement of his old friend, Douglass did not pursue a seat in the Senate by appointment or election. There have been only six black American members of the United States Senate, five elected either by their state legislature or popular vote. Only three have served full terms. The six are Revels, Republican from Mississippi (full term); Blanche Kelso Bruce, Republican from Mississippi (full term); Washington, D.C.'s own Edward Brooke, Republican from Massachusetts (popularly elected to two full terms); Carol Mosley Braun, Democrat from Illinois (full term); Barack Obama, Democrat from Illinois (vacated his seat upon winning the 2008 presidential election); and Roland Burris, Democrat from Illinois (appointed to fill Obama's seat).

To Douglass, the "thought of going to live among a people in order to gain their votes and acquire official honors was repugnant to my self-respect." Writing in *Life and Times*, Douglass says, "I had not lived long enough in Washington to have this sentiment sufficiently blunted to make me indifferent to its suggestions." Douglass trusted his instinct and knew his own limitations. He modestly confessed, "I had small faith in my aptitude as a politician, and could not hope to cope with rival aspirants." Instead, Douglass settled for the Legislative Council of the Territorial Government of the District of Columbia. He wasn't there for long.

Since 1851, the three-story commercial building's iron façade, seven bays wide, had graced Pennsylvania Avenue between Ninth and Tenth Streets (now the site of the FBI Building). By the end of the war, the edifice, originally known as "Iron Hall" for the second-floor hall over the ground-level retail, was rechristened Metzerott Hall by music store owner William Metzerott. It was in this spacious second-floor meeting hall that the roll call for the first session of the legislative council was answered by Frederick Douglass on May 15, 1871. The hall would now play host to political theater rather than the dramatic productions of previous years.

Chief Justice of the District of Columbia Supreme Court David Kellogg Cartter, a former Ohio congressman, administered the oath of office. John A. Gray, a free black Washingtonian in his early forties who had received an education at the schoolhouse at Fourteenth and H Streets Northwest run by Henry Smothers and Reverend John F. Cook, made a motion to nominate Douglass as vice-president of the council. It was unanimously carried. Douglass moved to appoint Joseph S. Weems, a local party man, as sergeant-at-arms of the council. It was agreed to. The next day, standing committee assignments were handed out. The most notable and traveled public figure on the neophyte municipal political body of the nation's capital, Douglass was logically assigned to the National Relations Committee, as well as Railroads and Canals and Rules. As the standing publisher and editor of the *New National Era*, Douglass was naturally assigned to the Printing Committee; an impassioned voice for equal education, Douglass found himself selected for the Committee on Schools.

With less than two months of service to the upper deliberative body of Washington's local government under his belt, Frederick Douglass was restless. On June 20, 1871, he "formally announced, that in consequence of imperative engagements elsewhere, he had tendered his resignation as a member of the Council, and briefly thanked the members for the uniform courtesy shown him during his brief official connection with this body," according to the *Journal of the Legislative Council*. Before the council was adjourned for the day, a resolution was read and unanimously adopted that expressed "its regrets at the necessities, which in the opinion of Hon. Frederick Douglass, have induced his resignation, his association having during its deliberations been most pleasant to each member thereof, as well as profitable to the people he represented." Secretary of State Hamilton Fish sent Douglass a letter confirming that his resignation had been received and accepted by the president.

In retrospect, Douglass saw his appointment to the city's territorial legislature by President Grant "at the time it was made, a signal evidence of his high sense of justice, fairness, and impartiality." The city was, according to Douglass, about one-third black. "They were given by Gen. Grant, three members of this legislative council, a representation more proportionate than any that has existed since the government passed into the hands of the commissioners, for they have all been white men." President Grant appointed Lewis Henry Douglass, Douglass's eldest son, to fill his father's seat. Lewis served the entire two-year term, picking up where his father had left off in advocating for, among other policies, the fair and equal distribution of municipal monies to the city's colored schools.

However short-lived his tenure as a legislator, it would stick with Douglass for the rest of his life. "It has sometimes been asked why I am called 'Honorable.' My appointment to this council must explain this." Douglass never took "the pains to dispute its application and propriety; and yet I confess that I am never so spoken of without feeling a trifle uncomfortable." Douglass preferred Frederick Douglass, Esquire, a title that would be conferred on him in 1872 by Howard University. His "Honorable" title would be more formalized in 1889, when President Harrison would appoint Douglass minister to Haiti.

For the next two decades after Douglass's short duration in the city's legislative body, he would become increasingly involved in municipal affairs, fully becoming a citizen in and of Washington.

3

Frederick Douglass,
Editor of the New National Era

The fact that our paper dares to take its place among the many lights existing to guide, and the many shields uplifted to defend the colored race in their transition from bondage to freedom, requires neither defence nor apology.
—*Frederick Douglass, "Salutatory of the Corresponding Editor,"* New Era, *January 27, 1870*

Black newspaper boys manning their street corners throughout downtown Washington on the morning of Thursday, January 13, 1870, had something new to peddle—a paper uniquely speaking for their place in the country and city. Moving papers out of the 400 block of Eleventh Street Northwest, just off Pennsylvania Avenue, the *New Era* joined the ranks of local and national affiliates at the epicenter of the great American guild known as "The Press." For city correspondents from "the more important newspapers in distant cities," Eleventh and Pennsylvania Avenue and the surrounding blocks, known as "Newspaper Row," were the open-air information marketplace of the enterprising metropolis.

The opening prospectus of the *New Era*, "A Colored American National Journal," declared it was "devoted especially to the promotion of the Political, Educational, Industrial, and Economical interests of the Colored People of the United States, and to their Moral and Religious improvement [and] will be issued weekly in Washington, D.C." Its publication was a "necessity of the times" and "approved by prominent public men and philanthropists in every section of the Union."

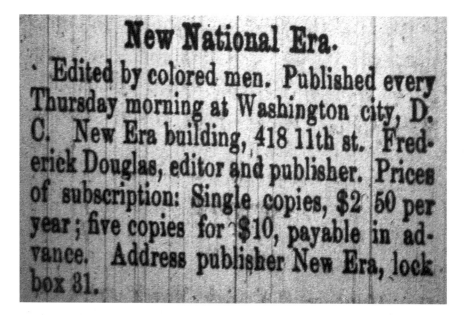

The 1871 Boyd's Washington, D.C. City Directory listing for the *New National Era*. *Author's collection.*

One of the men who invested money to finance the paper's start was veteran editor and leader of the first generation of the black press, Frederick Douglass. "For sixteen years, against much opposition, single-handed and alone, he demonstrated the fact that the Afro-American was equal to the white man in conducting a useful and popular journal," author Irvine Penn wrote in 1891, when assessing the contribution of Douglass's *North Star* and subsequent Rochester papers to the formation and tradition of the American black press.

Back in the fall of 1847 a notice had appeared in New York City's the *Ram's Horn*, launched in January of that year with Douglass's editorial aid, for an "Anti-slavery paper, to be entitled *The North Star*." It would be published in Rochester, New York, by Frederick Douglass. Penn wrote:

> *The commencement of the publication of* The North Star *was the beginning of a new era in the black-man's literature. Mr. Douglass' great fame gave his paper at once a place among the first journals of the country; and he drew around him a corps of contributors and correspondences from Europe, as well as from all parts of America and*

the West Indies, that made his columns rich with the current literature of the world.

After the Civil War, now finding himself in and out of Washington, Douglass, with the pledged support and urging of leading men George T. Downing, a successful businessman, and John Sella Martin, a former runaway slave turned minister and orator, reluctantly returned to the editor's desk. The publication of the *New Era* was to provide a voice for America's recently enfranchised citizens. Dissemination of information would embolden and enlighten the freedmen's cause, and Douglass was selected as the torchbearer for the movement.

The name of Douglass's Washington paper was derived from the city's old-line abolitionist newspaper, the *National Era*, published weekly from 1847 to 1860 under the editorship of Gamaliel Bailey and John Greenleaf Whittier. From 1851 to 1852, it published *Uncle Tom's Cabin* in serial form. During the Pearl Affair in 1848, the largest planned escape of enslaved persons in American history, a Washington mob almost destroyed its offices and printing presses. Douglass's paper sought to emulate the literary and political emphasis that the *National Era* had first established.

When Douglass took full control of the *New Era* in the late months of 1870, he rechristened the paper the *New National Era*. Soon thereafter, he entrusted the paper to two of his sons, Lewis and Frederick Jr., who had formed a publishing company, the Douglass Brothers. "I was not long connected with this enterprise before I discovered my mistake. The cooperation so liberally promised, and the support which had been assured, were not very largely realized," Frederick Douglass conceded in a late edition of his autobiography.

John Sella Martin

John Sella Martin, associate editor of the *New Era*, was born in Charlotte, North Carolina, on September 27, 1832. As a child, he "sustained the double but incongruous relation to his owner of master and son." At the age of six, the young Martin was taken to Columbus, Georgia, where he was separated from his mother on the auction block. He was purchased by "an old bachelor, with whom he lived in the capacity of *valet de chambre*, until he was eighteen years old. His opportunities, while with him, for acquiring a

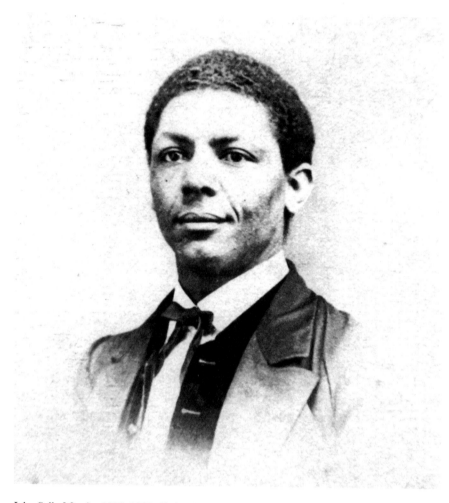

John Sella Martin, 1832–1876. *National Park Service, Frederick Douglass NHS.*

knowledge of books and the world generally, were far better than usually fall to the lot of the most favored house servants."

When his owner died, Martin was sold and taken to New Orleans, where he became a dealer in fruit and oysters. He soon made his escape for Chicago on a steamer heading up the Mississippi, and "the great hope of his younger days had been attained" by January 1856. After hearing him speak in the town of Coldwater, Michigan, a newspaper reporter recalled, "Nature has made him a great man. His proposition and his arguments, his deductions and illustrations, are new and original; his voice and manner are at his command and prepossessing; his efforts are unstudied and effectual." He eventually moved to Boston, where he led the pulpit at the Joy Street Church. Describing Martin in 1863, William Wells Brown wrote that he "is somewhat taller than the medium height, firm, dignified walk; not what would be termed handsome, but has a pleasing countenance, in race, half and half; eyes clear and bright; forehead well developed; gentlemanly in his deportment; has a popularity not surpassed by any of the preachers of Boston."

In late March 1869, John Sella Martin, now in Washington as the new pastor of the Fifteenth Street Presbyterian Church, wrote to Douglass, who was in Rochester, New York. For two months, circulars had been passed out in the nation's capital to raise funds for the publication of a weekly that "would be in the interest of the colored people of America; not as a separate class, but as a part of the *Whole People*." A meeting of the paper's prospective shareholders had just been convened. Martin reported "it is thought that five thousand dollars ($5,000) will run the machinery smoothly for six months." Martin and others felt "by that time we will be able to open other channels of assistance and support." Through the efforts of Martin, Downing and Douglass's eldest son, Lewis, "Twenty-five hundred dollars ($2,500)" was raised "and will be immediately forth-coming from colored people here." Martin would serve as the associate editor and Douglass as editor-in-chief, and making the paper a family affair, the shareholders selected Lewis Douglass as "Chief Compositor and manager of the proposed printing room" and desired that "all the work [be] done by colored people."

Finding Martin's letter upon his return from a two-month lecture tour out West, Douglass laid out his reservations in six precise clauses. To begin with, the "paper in question should be a first class journal—superior in appearance and in character to any paper ever published in the U.S. by colored men." Setting the tone, Douglass employed the "proverb that we should creep before we walk applies better to babies than to men and newspapers. In

regard to the latter, it is not only the first step that costs, but is the first step that pays." Next, the experienced editor conveyed that "any paper started by the colored people at the Capital of the Nation should be built upon conditions, not only favorable to success but upon such as will make success, almost certain." Third, if the paper was to fail in six months, it would "bring more shame and mortification to our already sadly depressed people than had not the attempt been made at all." Fourth, colored newspapers "have failed less for want of literary ability than for business ability. They have died in infancy and from starvation. I am not disposed to add another to the already long list of failures." Douglass reminded Martin that Bailey had started the *National Era* with $20,000 "to begin with besides a good subscription list." Bailey "succeeded because he could keep his paper up long enough to inspire confidence and respect. The same rules of success apply to white and colored papers alike."

Second to last in his list of concerns, Douglass said that everyone would have to be fairly compensated: "Work that is done for nothing is generally worth the price and seldom more." Pulling no punches, Douglass closed with the following: "Now according to my figuring—it will cost about two hundred dollars per week to publish an addition [*sic*] of five thousand copies so that in ten weeks your five thousand dollars would be swallowed up." Unless, of course, Martin already had subscribers secured. He didn't. Although ambivalent, Douglass would support the paper.

A couple days after the *New Era* appeared on the city's streets, the *Baltimore Sun*'s "Washington Letter" took notice:

> *The* New Era *made its appearance this morning. As heretofore stated, it is to be the organ of the colored people of the country. The editor is Rev. Sella Martin; corresponding editor Frederick Douglass. The first issue contains a card from Douglass, stating that pressure of his business prevented him from sending an editorial this week. Three white and one colored printer perform the work of composition.*

The colored printer was Frederick Douglass Jr. Duly noted was the upcoming meeting of the Columbia Typographical Union to finally decide the admission of Lewis Henry Douglass, a printer at the Government Printing Office. As an adolescent, Lewis had toiled with his two younger brothers on their father's newspaper, learning the trade as thoroughly as one could. He was not admitted to the union but would become an eventual editor of the *New National Era*.

"Not less than ten thousand colored people were in the march, and ten thousand more lined the sidewalks"—this was the scene of a grand parade in Baltimore on May 19, 1870, celebrating the Fifteenth Amendment, which gave male citizens the right to vote regardless of race, color or previous condition of servitude. It had been ratified and enacted that spring. Included in the cavalcade was Anacostia Club No. 1 with a display celebrating the Native American origin of their neighborhood name; it consisted of an advance guard of eight men with muskets leading fifty men clad in Indian costumes in front of a wagon of twenty women "dressed in the costume of Indian squaws, and several of them carried in their arms infants." The organization carried a banner proclaiming, "We are the True Supporters of the Republican Party. Anacostia Club organized March 26, 1870."

At the front of the procession were the carriages of Frederick Douglass, John Sella Martin and John M. Langston, of Howard University. "Every class and condition was represented—old men worn out by the toil of many years of servitude; young men whose early manhood was saved from degradation by the effects of Freedom; and a great army of boys and girls, in whose lives the auction-block will not be a hideous reminiscence," wrote the *New Era*.

The band played its last introductory note, the master of ceremonies spoke quickly and soon Frederick Douglass was before a crowd of Baltimoreans who knew Douglass as a son of Maryland. "During the last thirty years I have often appeared before the people as a slave, sometimes as a fugitive slave, but always in behalf of the slave. But today I am permitted to appear before you as an American citizen." Douglass took his audience back for a moment, "When toiling on the plantation we slaves desired to talk of emancipation, but there stood the overseer, and a word could ensure a flogging." Recalling a dexterity now known as code-switching, Douglass further told his attentive listeners, "To talk about emancipation without being discovered we invented a vocabulary, and when the overseer thought we were talking of the most simple thing we were really speaking of emancipation, but in a way that was Greek to them." Applause and laughter broke out. "The negro has now got the three belongings of American freedom. First, the cartridge box, for when he got the eagle on his button and the musket on his shoulder he was free. Next came the ballot box; some of its most earnest advocates now hardly saw it three years ago, but we'll forgive them now. Next we want the jury-box," demanded Douglass.

Speaking before a large crowd of his compatriots, Douglass preached, "Educate your sons and daughters, send them to school and show that besides the cartridge box, the ballot box and jury box you have also the

knowledge box." Wishful and encouraging, he said, "Build on for those who come after you. I am no orator. The orators who are to come up in hereafter the colored race will throw me and Langston far into the back ground." Telling the crowd to "get education and get money" at all costs in order to be independent, Douglass told them, "I found that God never began to hear my prayers for liberty until I began to run. Then you ought to have seen the dust rise behind me in answer to prayer."

Just months into the paper's publishing, an item ran that underscored the financial difficulties of running a newspaper. "We receive a great many letters, saying that several subscribers have been obtained, and requesting us to forward the papers, and they will result as soon as a certain number of subscribers are procured." As much a message to its potential subscribers as to its fiscal agents, "Our friends should send the names *with the money*, just as fast as they are obtained, to prevent dissatisfaction on the part of the subscribers." Admitting a contributing reason for their eventual financial failure to the public, the editors disclosed, "We keep no book of account with subscribers, and cannot send any paper until the money is received." Later appeals said the paper "will be made a desirable visitor for the family and fireside." Subsequently, a picture of Toussaint L'Overture or Frederick Douglass was offered as an incentive to subscribe.

By the fall of 1870, the apprehensions Douglass had expressed to Martin were beyond mere suspicions; they were hardened fears. As Foner writes, "By the summer of 1870 [the *New Era*] was heavily in debt. The shareholders had abandoned the project, Martin had resigned as editor, the type and press were in hands of creditors, and the paper was about to fold up." If immediate action were not taken, the paper would close in less than a year. If Douglass did not act, no one else would. He purchased a half interest in the paper and its printing plant and took immediate editorial control of the paper. "It will be seen that we have this week changed the name of this paper from *New Era* to *New National Era*," said an item just below the September 8, 1870 masthead. The only person listed was "Frederick Douglass, Editor." By the close of 1870, Douglass had bought the remaining interest in the paper and its printing plant for $8,000, nearly $150,000 in today's dollars.

As the case is in modern newspaper and magazine publishing, subscription lists were sold and exchanged in an effort to better reach potential customers. For the *New National Era*, the Douglasses sought support from their old Rochester friends, such as Amy Kirby Post. On faintly lined paper complete with the journal's letterhead, Frederick Douglass Jr. wrote to remind Post that her subscription had expired. Frederick Douglass included a postscript

asking Post to give his regards to the family. Days later, on Valentine's Day 1872, Frederick Jr. wrote to Post to confirm that her renewal was received and to answer her question about the paper's position on women's suffrage. "You are right about the paper['s] non-committal [*sic*] position. Those who are acquainted with its editor are satisfied that he leans on the right side of the question of female suffrage."

In 1877, Eunice P. Shadd, younger sister of Mary Ann Shadd Cary, whose teaching in Washington's public schools was praised in the pages of the *New National Era*, became the first black woman to earn a medical degree from the Howard University College of Medicine. (The first four female graduates were white.) Before earning her medical degree, Eunice was an on-campus subscription agent for the *New National Era*. Agents for the paper were all over the city and the surrounding counties; up north in New York City; in the Midwest in Ohio; down south in Richmond, Virginia; farther down in Alabama, South Carolina and Georgia; in the West in Colorado; and out in the Southwest in Galveston, Texas. Even readers in London and Paris could find a local subscription agent.

The election of the first generation of black congressmen and senators was closely chronicled by the *New National Era*. By the close of the paper's freshman year, Republican Joseph Rainey had become the first black member of the House of Representatives. He was sworn in on December 12, 1870, after being selected by the South Carolina Republican Party to fill the vacated seat of Benjamin Whittemore, who was forced to resign after being charged with selling appointments to U.S. military academies. Rainey would be elected for four successive terms before losing reelection to the Forty-sixth Congress in 1878. He retired on March 3, 1879, becoming the longest-serving black American congressman during the Reconstruction period.

"Mr. Rainey's early education was extremely limited, never having attended a school in his life," introduced the *New National Era*, "but despite the disadvantages under which the colored people labored at that time, his thirst for education was so great that he took every opportunity that presented itself to acquire a knowledge of books, and, being naturally of an observing turn of mind, improved rapidly." Rainey "took his seat on the Republican side in the extreme southwest corner of the hall." He was described as having "straight hair and bushy side whiskers, and looks like a Cuban." For the record, the *New National Era* stated, the "colored race is now represented in the United States Senate by Hiram Revels, in the lower House of Congress by Mr. Rainey and on the Judicial bench by Mr. J.J. Wright, Associate Judge of the Supreme Court of South Carolina."

It was noted in the same issue that the "colored population of the United States now numbers about five million," which equaled "about nine hundred thousand votes, and probably a million in the next Presidential election." The previous census had accounted for forty-two million persons, which "will give the country another apportionment for members of the House." Crunching the numbers, the *New National Era* determined on "a basis of 150,000 inhabitants to a Representative the House to be chosen two years hence would consist of 250 members. Of these the colored population would furnish the basis for thirty-four members." In all the Reconstruction Congresses and those leading up to 1901, a total of twenty-one African Americans served as congressmen.

Their ears attuned to their hometown streets, the correspondents of the *New National Era* documented local affairs with an editorial flair. Before 1871, there was a nascent movement to move the nation's capital west. The *New National Era* took notice. "The second meeting of the band of adventurers engaged in working up a sentiment in favor of removing the Capital of the Nation was held at Cincinnati two weeks ago." Bluntly, they continued, "Not a mother's son of them was ever heard of except in connection with this removal question. They met, not in pursuance of any public sentiment, or as the representatives of any class of people, but to get a huge speculation." The movement failed, and the capital was never removed from Washington, D.C.

Just as local elections started up and the composition of the citywide government was taking form, the *New National Era* waxed prophetic about "Our Future Capital." The editor declared there is "nothing attractive in London or Paris, in Berlin or St. Petersburg that may not be imparted to Washington" that has "many advantages over all the capitals and principal cities of the Old World. All that art, science, genius, wealth, aided by a popular government can procure is in store for our future capital." Some of the "improvements that are certain to be made" included filling up and converting the canal into a shaded avenue that led from the Executive Mansion to the Capitol, the completion of the Washington Monument, which stood like a stump. In accordance with the best designs, paving with wood and lining with trees every avenue and public street.

To achieve all this, local enfranchisement would have to be protected: "It has been rumored that an employer in one of the legislative districts outside of Washington and Georgetown has indicated his intention of discharging his colored employees if they vote in opposition to his wishes at the ensuing election." Douglass wanted employers and anyone else reading

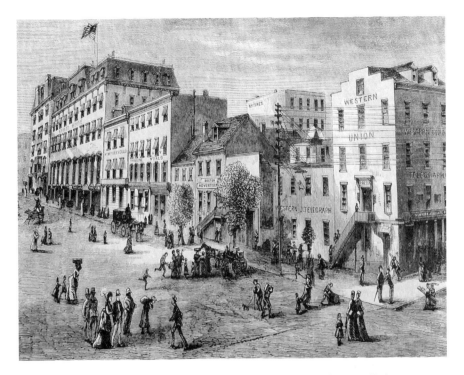

"Newspaper Row," *Harper's New Monthly Magazine,* January 1874. *Author's collection.*

to fully realize "that there is a law, and ability and determination to enforce it against just such threat or intimidation." Throughout the city, Republican clubs were "on the alert" and ready to "cause the arrest of any of the ex-slaveholders who do not remember that slavery is abolished." With the Fifteenth Amendment in place, "Ku-Klux acts will not be tolerated here under the very eaves of the Capitol."

Calling mayoral candidate and local Republican Sayles J. Bowen "a friend of our cause," the *New Era* endorsed him in May 1870. The paper observed that it is "here more than elsewhere that a merely municipal political contest will, to the people of the whole country, possess a more than ordinary and local significance." Washington, D.C., also held significance because it "was here that the first experiment of emancipation and impartial suffrage were inaugurated."

By January 1874, the reputation of Newspaper Row had grown too large to be contained locally. Benjamin Perley Poore, writing in *Harper's Monthly*, shared insights he had gleaned from the capital city beat: "From nine o'clock

in the evening until after midnight, unless there is a night session at the Capitol, Newspaper Row is a busy place. Each correspondent is on alert, anxious not be to be 'beaten' by some rival, who has perhaps been more fortunate than himself in obtaining information."

The work, Poore assured his readers, is not for the faint of heart, instructing what it would take to succeed:

> *A Washington chief correspondent is expected to be omnipresent himself, besides keeping his subordinates at work. He must daily visit the White House, haunt the departments, call at the hotels, drop in upon communicative Congressmen at their rooms, dine with diplomates* [sic]*, chat with promenaders on the Avenue, listen to the fellow-passengers in the street car—in short, he must ever be on the* qui vive *for "items" on week-days, Sundays, and holidays.*

At the *New National Era*, the work of a chief correspondent was a family affair. "In the publication and work incident to the paper, Mr. Douglass was assisted by his sons," Penn wrote in *The Afro-American Press and Its Editors*. "This accounts, in a great measure, for their love of newspapers at this writing, and their connection, from time to time, with many different journals."

By April 1873, the *New National Era* consolidated with the lately shuttered *New Citizen* to be published by a joint stock company. Among the trustees involved with the issuing of $20,000 (nearly $400,000 today) of capital stock were Lewis H. Douglass, Richard T. Greener, Charles R. Douglass, Frederick Douglass Jr. and John H. Cook. Cook, a lawyer and former city tax collector, had recently been elected a trustee of Howard University. Ads for his law firm ran in the paper. The joint company was organized for the "purpose of carrying on the business of printing, publishing, and book-binding" in all of its branches. An ad on the back page of the weekly paper promoted printing of cards, billheads, envelopes, checks, programs, invitations, bills of fare, posters and labels on the most favorable terms and with neatness and dispatch. Parties wishing to purchase shares of stock could write to Frederick Douglass Jr. at Lock Box 31.

Two months later, an item in the *New National Era and Citizen* noted that more than half of the stock had been sold. Furthermore, the paper was thinking big; by "the assembling of the next Congress we ought to have 10,000 additional subscribers, in order that our demand for CIVIL RIGHTS and EQUAL SCHOOL PRIVILEGES may be strengthened by such an army at our back." Under new management, the paper had an enlarged chip on its

shoulder. "While *The Christian Recorder* is ever ready to slur *The New National Era and Citizen*, it has no conscientious scruples against copying our articles without giving us credit." Allegedly, the *Recorder* had reproduced an article about Howard University "for which we do not blame them, but we do think we should have been credited with it."

Within a year, the joint venture had broken up. After stopping the presses for two weeks, in March 1874, the *New National Era* reemerged with a notice, "Our friends should be particular in addressing letters to publishers of the paper not to add 'AND CITIZEN.' It is possible that letters intended for us have fallen into the hands of those whose attempt to destroy the paper has led them into all sorts of annoying capers." Explaining the publishing lapse, the editors disclosed to their readers what an experience they'd had. "We have for the past four years struggled with adversity to keep alive a weekly paper at the National Capital." The Douglasses had, "under the circumstances, done our best to maintain the credit of our race by publishing such a paper that none but the enemies of the negro would wish to see destroyed."

The editors came clean: "Nearly one year ago we were of the opinion that our efforts in the publication of the *New National Era* were working our financial ruin, and that, consulting our private interests, it would be in accordance with reason and sound judgment to discontinue the publication of a paper that was loading us down with debt and poverty." When word of this got out, "young men, graduates of Howard University, and clerks in the Freedman's Bank, approached us with a proposition not to discontinue our paper, but to unite it with a little paper published by them and known by the title of *New Citizen*, assuring us that they had influence and ability to secure the taking of two thousand dollars worth of stock, for which the cash would immediately be paid." With an offer too good to be true, they continued, they were in control of a $30,000 a year printing job for the Freedman's Bank and that the contract "would be secured for the company to be organized by the union of the two papers."

In exchange, the *New National Era* let the group utilize its printing shop, yet its financial promises were not met. "Being graduates of Howard University and attaches of the Freedman's Saving Banks," the Douglasses didn't think the young men "would resort to trickery and false pretenses in money transactions; but, as the sequel will show, our confidence was misplaced." No payments were ever made. Debt accumulated for which the *New National Era* was now liable. The law got involved. In "the most insolent, bullying manner possible," a United States marshal secured the building to "prevent the removal of anything." The editors of the *New National Era* wanted to set

the record straight: "The ringleader of repudiators, John H. Cook, graduate at law of Howard University, and Solicitor for the Freedman's Bank [had] obtained an injunction against the company, which was so drawn as to deprive us of the control of our private property, and to place it in the hands of a receiver." This had forced the printers from the "premises for the occupation of which we had paid, this compelling the discontinuance of this paper for the past two weeks."

Douglass received a personal letter titled "High handed villainy" from a reader applauding the latest court ruling in favor of Douglass's interests and against the "cowardly" efforts to "extinguish the *New National Era*, to break up business and deprive you of your property." Douglass should know that his "courage, skills, and perseverance in the legal exposure of the high handed attempts to silence the only complete literal representative of the colored citizens of the country" did not go unnoticed.

"[A]s it concerns the organ of the colored people in this city," the business dispute between the two sons of Frederick Douglass and John H. Cook and other incorporators of the New National Era Company had attracted some public attention. The *Baltimore Sun's* "Washington Letter" noted, "It seems the Douglass Brothers owned the *Era*, and Cook the *Citizen* newspapers, and that the two concerns were fused into the *New National Era*, published by a company. The Douglass Brothers were the active parties in the paper, and their business proceedings did not satisfy Cook and others, who caused an injunction to be issued restraining the Douglass Brothers from going on with the business." The paper would not survive to cover the November elections of 1874. "Washington has been a financial misfortune," Douglass wrote freely to Amy Kirby Post, his dear friend from Rochester, New York, a couple years after the last edition of the *New National Era*. "I lost ten thousand dollars by my newspaper enterprise and have been losing in other directions ever since."

Whatever pressures pounded in John Sella Martin's head and wore on him ended on August 12, 1876, in No. 97 Gasquet Street, New Orleans, on the edge of the French Quarter. He was found slumped in his room beside a half-filled bottle of laudanum, leading authorities to believe that "he died by his own hand." Martin had "fallen into intemperate habits of late years, and also was accustomed to use drugs for the purpose of quieting his nerves." His obituary ran in the *New York Times*, which praised Martin as a "remarkable man of his race; a man of great natural ability and an eloquent and effective speaker."

The *Times* editorialized, "Because, reared as a slave, he made a man of himself, and for the good work he had done in the church when he was at

his best," with the contagious spirit that inspired Frederick Douglass to start a newspaper, "for the long years he had eloquently and earnestly labored for the advancement of his race, he is kindly remembered by the colored people of the United States." Ringing as true today as it did two centuries ago, "If he faltered on the good road before his work was completed, others have also given up in weakness to an enemy that slays thousands." When considering all "the good he has done and that was in him, he is mourned by his friends. He was bad only to himself."

In its short life, although the *New National Era* failed financially, it had its share of successes. It was a literary platform for diverse writers, from John Ruskin, the leading English art critic of the Victorian era, to black intellectual Richard T. Greener, whose essay "Young Men, to the Front!" first appeared in the *New National Era*. Many aspiring black journalists such as John Edward Bruce got some of their earliest work published in the *New National Era* alongside more established writers such as Martin Delany. The pioneering journalist Mary Ann Shadd Cary used the pages of the *National Era* to discuss the importance of education and uplift efforts. The short stories of Frank J. Webb, one of the country's first black novelists, appeared in the paper alongside news of the expansion of the Northern Pacific Railroad, a satire by Mark Twain on a high-profile criminal case, an address by the current commander in chief of the Grand Army of the Republic and frequent news out of Howard University.

However, the *New National Era* largely discussed the hard-grinding mechanics of Reconstruction and advocated for the Republican Party. The paper took hard-line editorial positions, from declaring "The Danger of Universal Amnesty Exposed" to advocating for the integration of local primary schools. Featured "Letters from the People" from as far away as Texas, Alabama and Mississippi, with frontline accounts of the hazards, distresses and violence of Reconstruction, often led the discussion on the front page, letting isolated readers in the capital city know the impact Federal policies had on the country. Although the *New National Era* has nearly been forgotten as one of the first organs of the earliest civil rights generation, official records confirm that the newspaper's editorials were read aloud as a leading authority of the day on the floor of the United States Congress.

4

Marshal Douglass

*An ex-constable was in the criminal court at Washington on business the
other day, and was asked by one of the bailiffs if he was looking for Marshal
Douglass. "No sir," was the reply, "not now; but there was a time, when he was
a fugitive slave, when I tried hard to find him."*
—New York Evangelist, *April 19, 1877*

In his lifetime, Frederick Douglass was the American Myth incarnate—
once a full-flight fugitive slave and later appointed United States marshal
of the nation's capital city by the president. Raising himself up from humble
origins, it was just over three decades prior to his appointment as an officer
of the law that Douglass was the world's most famous bondsman. Douglass's
1845 autobiography, *The Narrative of the Life of Frederick Douglass, An American
Slave*, stands the test of time. At the time of its release, Douglass was an
outlaw flaunting the freedom he enjoyed in the North. He put the fury and
wrath of the life experiences he had survived in writing in order to: 1) speak
out against human bondage beyond the lecture circuit and 2) prove to his
detractors that he was what he said he was—a self-educated runaway slave.

Traveling and orating on both coasts of the Atlantic Ocean, his
clarion voice boomeranged throughout American and British reformist
communities. Douglass's first autobiography identified people and places,
making his capture imperative for the antebellum South in the face of the
Northern freedom he aggrandized. Before anyone could capture the fleet
Douglass, his freedom was purchased while he traveled throughout the

British Empire. Upon his return to the United States, Douglass was no less of a risk taker; his Rochester home, just as in Lynn and New Bedford, was a safe house for runaway slaves grasping for the safety of Canada. Along with his wife, Anna, Douglass was a 24/7/365 conductor on the Underground Railroad—the 1850 Fugitive Slave Law and the United States marshals tasked with enforcing that statute be damned.

"The route for slavery to freedom, for most of the fugitives, was through Philadelphia, New York, Albany, Syracuse, Rochester, and thence to Canada," Douglass wrote to William Seibert in 1893. From Syracuse, runaways were sent "then to Frederick Douglass, Rochester and then to Hiram Wilson, St. Catherine's, Canada West." Often, Douglass would arrive in the early morning to his newspaper offices to find fugitives awaiting him. He recalled, "I had as many as eleven fugitives under my roof at one time."

As marshal of the District of Columbia, Douglass had the responsibility of bringing fugitives to justice, a long way from his days of quartering them. Douglass was in close contact with Washington's criminal class nearly every day as marshal. He said as much, telling readers in his last autobiography that the marshal's office "made me the daily witness in the criminal court of a side of the District life to me most painful and repulsive."

"[T]he police of this city deserve great praise for efficiency and vigilance," when "considering the vast territory to be guarded and the smallness of the corps," was how a popular 1887 guidebook to Washington described the Police Court and Police Headquarters. Each morning and often on holidays, the Police Court opened "to try parties arrested during the previous day and night." Often times "the scenes here witnessed are frequently worthy of the pen of a Dickens and the pencil of a Hogarth." The colorful guide continues that it "must be known that Washington City is the Mecca of the tramp, as well as the professional 'crook,' and the curious medley of figures, colors, and sex cannot probably be seen in any other city as is displayed at the nation's capitol."

However repulsed, it is clear Douglass did not waver in his commitment to executing the responsibilities of his office. Early biographer Fredric May Holland wrote, "One of his deputies, Colonel Perry H. Carson," a leading figure of Washington's black political class, "tells me that he worked like a tiger, and was on the spot early and late. He kept the office long enough to be present at Garfield's inauguration; but not long enough to have Guiteau in custody; and he did not take part in putting anyone to death."

According to historian David Turk, United States marshals are the oldest federal law enforcement agents in the nation, the first thirteen marshal

Marshal Douglass greets well-wishers at his office in city hall. *Frank Leslie's Illustrated*, April 7, 1877. *Library of Congress.*

appointments stemming from the Judiciary Act of September 24, 1789. "Although U.S. marshals were no longer required to coordinate the federal census, as they had until 1870, there were the special responsibilities of law and order in a federal city," Turk said in a 2005 lecture. These duties included posting bankruptcy notices and "official documentation of prisoners to be transferred to and from prison to be brought before the Judiciary. It was required to name each person and transfer the document to the Warden" of the D.C. jail. Additionally, Marshal Douglass and his office were responsible to the "federal court" with "service process, issuing legal notices, judicial protection, and the supervision of federal prisoners within the District."

During the early months of the Lincoln administration, the enforcement "of the Fugitive Slave Law in the District of Columbia became a question much discussed in Congress, and was a frightful scandal to the Radical members," writes Ward Hill Lamon, appointed marshal of the District by his friend Abraham Lincoln, in *Recollections of Abraham Lincoln, 1847–1865.* "The law remained in force; and no attempt was made by Congress to repeal it." Margaret Leech, writing in *Reveille in Washington*, notes, "Across the Potomac Bridges, [runaway slaves] trudged into a town where slavery was still entrenched." As Lamon remembered, "The District had become

an asylum of runaway slaves from the Border States, particularly the rebel state of Virginia and the quasi-loyal state of Maryland." This created an explosive conflict on the streets of Washington. The military governor of the District assumed that with the August 1861 implementation of the Confiscation Act, which gave liberty to all slaves who had been employed by the rebels for insurrectionary purposes, "all slaves that came into the District from whatever section had been thus employed." Therefore, the governor argued that they were free, and it "became his duty to give them military protection as free persons."

President Lincoln interpreted the legal remedy to deal with the influx of fugitives quite differently. "The President gave me private instructions to execute the [fugitive slaw] laws until Congress modified or repealed them," according to Lamon. Three presidential administrations later, the Fugitive Slave Law was abolished, along with the eradication of slavery, and Frederick Douglass would find new challenges facing the office of the United States marshal of the District of Columbia.

Appointment to Board of Police Commissioners

Swelling with contrabands, refugees, freedmen, Confederate spies, confidence men and military recruits during the Civil War, Washington was politically and socially radicalized in the immediate years following the war by six uninterrupted Republican administrations who sought, with varying levels of success, to ensure the protection of civil rights for long-suffering black Americans. There was a palpable tension in the city between the radicals and conservatives, the largely Southern-born white population of the city and the large black population; within the black community, there were divisions between the large community of free persons of color in the city prior to the Civil War and the recent influx of black Americans freed from Southern slavery.

The city was always on the verge; somehow kept together by a ragtag, hardscrabble police force that was formed during the war. By the end of President Ulysses S. Grant's administration, a scandal rocked the Board of Police Commissioners, with many calling for the elimination of the entire board. "Recent events have shown that gross violations of laws have existed in the District for years directly under the eyes of the Police," Ulysses S. Grant

wrote to Congress in late January 1877. The president wanted to eliminate the board or incorporate a new one altogether. On the first Saturday of the year, names of the new Board of Police Commissioners members were released, including dry goods merchant John T. Mitchell of Georgetown, respected and retired architect John C. Harkness, ex-mayor Matthew G. Emery and Frederick Douglass, and although President Grant had sought to reform the board, one member was reappointed, William J. Murtagh, the editor of the *National Republican*. He headed the board for many years.

News carriers spread word of the new police board far and wide in the city, their names "whispered over unlicensed bars and through deserted gambling halls with great significance." By nightfall, "it would have been difficult to find a man in the city who had ears who had not heard about the new board half a dozen times."

Reporters sought out all of the nominees, including Frederick Douglass outside his Capitol Hill home. Douglass, who was returning to the city from a lecture tour, said he had been told by a policeman at the depot as he came into Washington that his middle son, Frederick Jr. , had been selected as a commissioner. He was glad to hear it. Respectfully, the reporter told Douglass that he had been misinformed, and he was the Frederick Douglass selected. Still doubting the news, Douglass said, "I have received no official information to that effect. The position is one that would do honor to any man. In my present position you see it would be rather *infra dig* for me to state whether I would accept or not, or what I would do if I received the appointment." When told of the ongoing "war upon the gamblers," Douglass expressed interest and said, being settled down in the District, he had hoped to see the law enforced and vice purged from the city.

However real Douglass's interest was in a position on the police commission, his schedule took him away from the city at the same time of the next scheduled meeting. From Milwaukee, Wisconsin, on February 4, Douglass jotted a note to himself, a phrase presumably to be used on the circuit or in a future article: "He is the truest patriot who is honest enough to confess the faults of his country and brave enough to make a manly effort to correct them." Just days after he wrote those words, the *Evening Star* ran an item about a new police commissioner appointed "in place of Frederick Douglass, from whom nothing has been heard in connection with his appointment."

On his travel back to Washington, Douglass spoke with former Ohio governor Rutherford B. Hayes; his election as the nineteenth president was looking more and more likely as the Presidential Election Committee

Frederick Douglass's first home in Washington, D.C., 316–318 A Street Northeast. *Author's collection.*

was coming nearer to a compromise between Republicans and Democrats that would be reached at the hotel of James Wormley, a prominent black Washingtonian and Douglass's confidant. Hayes took note in his diary on February 18, 1877, "The indications still are that I am to go to Washington. I talked yesterday with Fred. Douglass and Mr. Poindexter, both colored, on the Southern question." Reverend James Preston Poindexter was well known in Hayes's home state. "I told them my views. They approved." However, the president-elect quickly learned that Douglass did not pass up an opportunity to express himself cogently in an advisory role. "Mr. Fred Douglass gave me many useful hints about the whole subject," helping to solidify Hayes's position, which historians have near universally marked as the end of Reconstruction.

Hayes wrote:

> *My course is a firm assertion and maintenance of the rights of the colored people of the South according to the Thirteenth, Fourteenth, and Fifteenth Amendments, coupled with a readiness to recognize all Southern people, without regard to past political conduct, who will now go with me heartily and in good faith in support of these principles.*

On March 4, 1877, Rutherford B. Hayes, in his inaugural address, alluded to the difficulties facing his administration and the country. "Many of the calamitous efforts of the tremendous revolution which has passed over the Southern States still remain. The immeasurable benefits which will surely follow, sooner or later, the hearty and generous acceptance of the legitimate results of that revolution have not yet been realized. Difficult and embarrassing questions meet us at the threshold of this subject." Less than two weeks later, Hayes nominated Frederick Douglass as United States marshal of the District of Columbia, the most significant domestic appointment ever bestowed by a president on a black American.

"The business men seem dissatisfied, and the members of the bar are almost unanimously against it," reported the *National Republican*. "[A] delegation of the Bar Association of the District will ask to be heard before the Senate committee in considering the nomination to show cause why Mr. Douglass should not be confirmed." Conceding Douglass "is a man of high culture and thoroughly educated," members of the city's established legal community asserted that "he is too theoretical." Democratic senators and "even some Republicans question the expediency of the appointment,"

reported the city's Republican rag. However, as "an office that properly belongs to the President's household, out of courtesy they are loath to seriously oppose the nomination." It was hinted that should Douglass be confirmed, the established tradition of the U.S. marshal of the District serving as the "adjunct of the receptions at the White House" need "not necessarily" be maintained.

The *Washington Sentinel*, a weekly paper founded by a German immigrant that closely hewed the Democratic Party line, took umbrage with the *Republican*'s insinuations. "When it is considered that but for the colored people the Republican Party would be nowhere, the appointment of Douglass must be regarded as a great stroke of policy." In the months leading up to Hayes's inauguration, the *Sentinel* had advocated Southern reconciliation, a withdrawal of the last remaining contingents of Federal troops in Florida, Louisiana and South Carolina. With this in mind, the *Sentinel* advised "our Democratic Senators" against rigidity and committing "the blunder" of opposing Douglass's nomination, possibly invoking Republicans to reconsider the full withdrawal of troops. Cleverly calling out the hypocrisies of Lincoln's party, the *Sentinel* could barely contain its indignation, both earnest and sarcastic: "Where is your love for the negro, without whose assistance none of you would be in office? Down with your aristocratic notions, and up with the colored brother, who has always been so dear to you!"

On Saturday, March 17, 1877, Douglass's confirmation was debated in an executive session of the Senate; no transcript of "one of the most memorable [debates] that has ever occurred in that body" exists in the Congressional Record. Filling one and a half columns of its March 19 front page, the most detailed account is found in the *New York Tribune*, telegraphed by its Washington correspondent. "The country loses much by the injunction of secrecy," intoned the newspaper founded by Horace Greeley.

> *The vote stood 30 in the affirmative to 12 in the negative, and of those who cast the latter every one disclaimed basing his opposition upon the race or color of the candidate. The debate is said to have exhibited throughout some of the loftiest, broadest, and noblest patriotism that has been witnessed in the proceedings of Congress for many a year.*

Maryland's William Pinckney Whyte, a Democrat, voted against Douglass's confirmation, he alleged, for no other reason than Douglass's qualifications. "Turning to his Democratic associates in the midst of his

speech, he is reported to have said that, although a native of Maryland," neither he nor any member of his family had ever been a slaveholder. In contrast, Alabama Democrat John Morgan, a Confederate general in the war, "startled the Senators present" in making a speech, "gladly" supporting Douglass's confirmation. He had read Hayes's inaugural address and "seen by his acts that the President is sincere and honest in his purpose to do justice in the South and to bring about a reconciliation of the sections," reported the *Tribune*. Morgan "had determined to cast no vote against any worthy nomination which this Administration might make, and to place no obstacle in the way of the successful accomplishment of the patriotic purposes" Hayes had sent forth in his inaugural. "The confirmation is looked upon by the best men of both parties in Washington as a triumph not only of the new policy of the Administration, but also, of the moderate Southern men, to whom the country owes so much for their patriotic course during the past Winter," the article said in closing. "Besides greatly strengthening the President's new Southern policy, it gives him the assurance that he will have adequate support for it in the Senate, no matter what discussions take place in the Republican party."

Upon Douglass's confirmation, he received a letter of both warning and support from major and superintendent of police A.C. Richards, who advised that it was "possible that efforts will be made by evil disposed persons to throw obstacles and embarrassments in your way." However, Major Richards, appointed by President Lincoln in December 1864, let Douglass know that he was, in fact, at his disposal should "such contingencies arise." The old cop plainly stated, "[I]t will be a pleasure to me, as it will be my duty, to render you such aid and assistance as may be in my power either officially or personally." Richards, an Ohio native, oversaw the city while the "war was in progress, and the capital city became the rendezvous of camp-followers and adventurers, of gamblers and thieves, and representatives of the worst element of society." Just weeks before Douglass was nominated as marshal, Richards had survived an investigation by the police board that resulted in his suspension and subsequent restoration to duty. In January 1878, Almarin C. Richards, the former post office clerk, educator and one-time mayoral candidate, resigned from the police department. He pursued a law degree, was admitted to the bar and practiced in "all the courts" of Washington before retiring in the fall of 1893 to Florida.

Despite inclement weather, on Monday, March 19, Douglass arrived early at city hall. Speaking with the bailiffs, Douglass "took each man by the hand, giving a kindly word to all," reported the *National Republican*.

Douglass enunciated his advocacy of civil service reform and intention to make "as few changes as possible." After taking the oath of office from Chief Justice Cartter of the D.C. Supreme Court, who had also administered the oath to Douglass as territorial legislator nearly six years before, Douglass put his detractors at ease. L.P. Williams, an assistant clerk in the clerk's office, was appointed by Douglass to fill the vacancy as deputy marshal. The decision would "go far to allay any feelings of distrust that may have been entertained as to the ability of Mr. Douglass to perform the duties of the office," noted the *Republican*. Questioning the "the competency of Mr. Williams" was beyond reproach. Already covering his flank, Douglass, according to city directories, letters and newspaper accounts, installed Lewis Douglas, a combat veteran of the war, to fill an additional deputy marshal position. Frederick Douglass Jr. served as a bailiff at the criminal court. Less than two months into the job, Douglass would heed the alert of Major Richards.

On a late November evening in 1875, Douglass Hall in Hillsdale was filled to capacity to hear Frederick Douglass deliver his carefully prepared lecture on "The Popularity of the Capital." Proceeds would benefit the Bethlehem Baptist Church, founded in 1872 and still serving the area today at the corner of Howard Road and Martin Luther King Jr. Avenue in southeast Washington.

Speaking on the occasion of the "Centennial days of the Republic," Douglass observed that "the very air is full and fragrant with patriotic deeds" that unfold "in all the panoramic splendor which poetry and eloquence can invest them." Douglass, "having spent several of the most eventful and perilous years of our national history at the city of Washington, especially since the late civil war," had become, by that time, "a deeply interested spectator and student of passing events." The crowd saw Douglass as a man of Washington, as their adopted own, a voice for their community.

His sons had come to Washington in the immediate years after the Civil War, finding the city to be a growing metropolis with a dignified, educated, propertied and influential black population. Soon thereafter, Douglass himself began splitting time between Rochester and Washington, reluctantly lending his name and support to the start of a Washington newspaper, the *New Era*, in January 1870. Douglass moved permanently to Washington after his Rochester home caught fire in the summer of 1872.

Douglass was equally involved in both local and national affairs. As one of the nineteenth century's foremost black historians, George Washington Williams, wrote of Douglass in 1883: "At the close of the war he moved to Washington and became deeply interested in the practical work of

reconstruction." Douglass settled in the city with other prominent blacks, both native Washingtonians and the first black citizens to win national elective office from the states of the former Confederacy, making Washington the epicenter of the earliest civil rights generation.

In 1875, the turbulent transformation of Washington, D.C., under the Territorial Government had just concluded, with the District now governed by three presidentially appointed commissioners. No one knew what would happen next—the commissioners were a temporary solution. Washington had been transformed physically but bankrupted financially through Alexander Shepherd's Board of Public Works, which had "accomplished more for Washington in three years than had been accomplished in sixty years before. With strong hands and sagacious heads, they have lifted the Federal City out of the mud in which they found it," Douglass lauded in his Hillsdale address. "They have banished miasma from its borders; they have given work and wages to a large class of poor workingmen; they have reduced the death rate of the city; they have increased the value of property five-fold," making Washington "one of the most beautiful and attractive cities in the whole world."

"Not only has the city itself, with its hundred churches and splendid school buildings, magnificent streets and avenues, been wonderfully improved but the distant hills which fringe its border have been touched by the spirit of material regeneration, and give hope to a noble future," Douglass said, speaking in an emerging neighborhood on one of the city's distant hills. "Not even the face of the solid earth has escaped the law of change," Douglass observed. Alluding to nearby Barry Farm, a neighborhood developed by the Freedmen's Bureau sale of lots to black Washingtonians, Douglass recognized that the "Freedman's spade, pick axe, and plough have been busy."

However, Douglass reminded his audience that Washington had "contamination in its touch, moral poison in its air; and it might be styled a graveyard of lost souls." Undergoing a quick transition from "being the most illiberal and oppressive city, Washington has become one of the freest in the country." For "colored citizens" the "change in the condition" was "great and marvelous." As evidence, Douglass stated, "A colored man may now visit the church or market, attend a wedding or funeral, without being subject to the humiliation and trouble of procuring a permit from the mayor." Ended for blacks was "the liability of being arrested, flung into prison, and after being shut up in a noisome cell for months, be sold into slavery. The moral triumphs of civilization here are not more striking than the physical. In both respects, the Capital is essentially a new city."

New Washington's progressivism, however, was subject to fits and starts. Not two full months into his marshalship, Douglass, under the auspices of St. Paul's Lyceum, gave the same speech to a crowded house at Baltimore's Douglass Institute. While the full remarks of Douglass's 1875 Hillsdale address had been printed in Washington newspapers to no ill effect, extracts printed from the same speech delivered in Baltimore nearly two years later caused a firestorm; petitions calling for Douglass's resignation would eventually reach the president. Douglass would find that criticizing Washington in Washington might be unremarkable, but taking that criticism on the road, out of the house, would be far more problematic. The 1877 Baltimore speech may have been a poor choice of timing—since 1874, the question of whether the national government would stay in Washington was on the table, as was the question of how and who would govern Washington itself. By 1877, the temporary government was still temporary and would not be made permanent until the next year.

"The effort to prevent my confirmation having failed," Douglass writes in his *Life and Times of Frederick Douglass*, "nothing could be done, but wait for some overt act to justify my removal, and for this my *un*friends had not long to wait." Less than two months after his confirmation, Douglass was invited to speak at Douglass Hall, in Baltimore, "a building named in honor of myself, and devoted to educational purposes." Douglass accepted and planned on "giving the same lecture which I had two years before delivered in the city of Washington, and which was at the time published full in the newspapers, and very highly commended by them."

On May 9, the *Baltimore Sun* reported on Douglass's speech on the "National Capital." Alluding to the cathartic moment in his own life when a teenaged Douglass vicariously learned the ways of Washington by picking up newspapers in the street that described the capital city, he said, "[E]very one knows something of Washington, and the Washington columns in daily papers are read more than any others. It never was so broadly national as now, never so creditable, and the interest in it will increase as the grandeur of the country increases."

A *Sun* reporter heard Douglass say that Washington now has chariots more elaborate than those with which Pharaoh pursued the Israelites, and the fare was only five cents. Douglass, repeating what he'd said in Hillsdale, noted that the typical Washingtonian "has a strong negro pronunciation learned from the slaves. There is also a class of poor white trash in Washington who in slave days were drivers of the negroes, but live now by huckstering, fishing and hunting."

Sparing no social strata, Douglass said, speaking from experience, "The hour [the office-seeker] takes up his abode in Washington, his relation to the Government is ascertained, and he is weighed, stamped, measured, and described," Douglass warned. "He is assigned to one of two classes. The first of these may be described as the class which uses everybody, and the second is the class which is used by everybody. There is no escape." Douglass spoke insightfully, "You must either go to the one or the other, or go out of Washington or into seclusion."

Little did Douglass know that he would almost become a victim of his own analysis. "The excitement over the lecture of Frederick Douglass in Baltimore on Tuesday evening last, in which he took occasion to deliberately malign and slander the residents of Washington is increasing," the *Baltimore Sun* noted a matter of days after first reporting Douglass's speech. "The movement looking towards his removal took shape to-day in the circulation of numerous petitions asking the President to remove him from the position of marshal of this district, in the duties of which he has signally failed." For speaking about Washington as it had been in the past, what it was at the time and what it was destined to become in the future, Douglass got, admittedly, "pretty roughly handled."

Of the two citizens who had put up a bond for Douglass, Columbus Alexander openly questioned "any official of any kind neglecting his duties, going about on a lecturing tour and characterizing the whole community as a set of thieves, robbers, and loafers." Alexander sought exception with Douglass's praise of the Board of Public Works: "It is astonishing to me how he denounced the whole community as robbers, while the very people who have been robbing the community he did not denounce, but praised to the skies."

Alexander, a Democrat, in justifying his support of Douglass, said, "For the purpose of aiding the President in conciliating all parties that I went on his bond. It was not mere lip service, but I showed that I was willing to go down in my pocket for him." Alexander would decide not to withdraw his support; Douglass would praise Alexander for his "magnanimity to give me fair play in this fight."

That afternoon, a man took up position near the stamp window in a city post office with a petition for Douglass's removal. Two hundred signatures were quickly secured. He came back that evening and gathered yet more signatures; reportedly, "numerous colored men freely signed their names to it." In total, two thousand names were turned into President Hayes. "Nearly every business man in Washington signed" the petition. However, even the

"more extreme of the radicals do not think that the President will remove Douglass, or, in fact, take any notice of the matter." Many of Douglass's friends and supporters pointed out that he had delivered the same speech before in Washington with little controversy.

On Saturday, May 12, the paper of Douglass's party, the *National Republican*, didn't mince words with its front-page headline, "AN INSULTED CITY. The Effect of Fred Douglass' Slanders on Our People." The publication of the respectful and earnest petition for Douglass's removal included more than one hundred names of individual citizens and businesses. In Douglass's speech, he mentioned banker William Corcoran, then nearly eighty years old, an old Southern sympathizer. During the war, secessionist Corcoran had fled the city, ending up in Paris. He represented old Washington. Corcoran's father was a mayor of Georgetown and a successful businessman. His son had become a successful banker and one of the greatest of the grandees in Washington society.

A reporter from the *Republican* called on Corcoran, who premised his comments with: "If he desired a political controversy he certainly would not select Mr. Douglass as his opponent." Corcoran viewed Douglass as beneath notice. "Mr. Douglass to the marshalship was such a mark of favor as ought to have made him grateful for the remainder of his life," Corcoran said. Instead of "resting content," Douglass "had shown a great lack of common sense by insulting the people of Washington and among them the very men who had so largely contributed to his confirmation, when the same might have been so easily defeated by the vote of the Democrats."

Corcoran advised that Douglass was not fit for the office of United States marshal. Douglass was a "man of strong partisan prejudices and calculated to keep alive an unwholesome enmity between parties." Corcoran told the reporter, before showing him the door, that he would not exert himself in the matter but would support any movement to remove Douglass.

Professor John Mercer Langston was restrained in criticism, saying, "I know nothing of the utterances of Mr. Douglass in his late lecture delivered at Baltimore other than I have of them in the papers of that city." The former Howard University president and dean defended his friend, saying, "I trust that it will yet turn out to be the fact that he made no such statement."

Langston, who had lived in Washington for the past ten years, observed that

the white people of Washington have certainly always exhibited since the abolition of slavery, a peculiarly practical sympathy for our colored fellow-

citizens, and colored fellow-citizens have not failed to appreciate the kind consideration indicated, and the opportunity which it has afforded them to cultivate all those things which appertain to dignified social existence.

The former Ohio town clerk, councilman and board of education member made sure to acknowledge that "the colored people of Washington city, in their schools, their churches, their homes and their families, as well as the general culture and refinement of their children, furnish incontestable evidence of the fact that this community, as far as this particular class is concerned, is certainly second to none in this country."

Douglass had been misunderstood, disputed the physician at Freedmen's Hospital, Charles B. Purvis, a member of a small fraternity of black surgeons commissioned by the U.S. Army during the Civil War. "I think he refers more to Washington as it was prior to the war than it is today." Purvis said he knew of the daily pressure and burden, as he felt it "in [his] profession, being denied access to institutions established solely for the purpose of discussing medical subjects, simply on account of color, meeting rebuffs from the people."

Purvis stood his ground. "Let me say why Mr. Douglass denounces the former slave-holding population of Washington," he went on. "It is because he feels the sting of their oppression. To show you his feelings," Purvis recalled, "when the fugitive-slave law passed, Mr. Douglass, in a public meeting, uttered these eloquent words: 'There's no mountain so high, no valley so deep, no plain too extensive, in this land, upon which I can stand and call myself an American freeman.'" Douglass later recalled that no other "colored man in the city uttered one public word in defence or extenuation of me or of my Baltimore speech."

Devoting her entire "Washington Note" to the "Fight on Marshal Douglass," the *New York Times*'s Sara Jane Lippincott, a longtime confidante, under her Washington correspondent's name, Grace Greenwood, upheld Douglass's dignity by observing, "It is true some of his criticisms were severe, and massed together presented an ugly front. They betrayed gratitude towards the class of people who once owned him." Greenwood insisted that much of the discussion over Douglass "intensified and concentrated the colorphobia, which had been on the increase here for the past two years." Greenwood suggested that there "is no use denying the fact, the question of color comes in here, and color's everything. If the predecessor of Mr. Douglass had delivered that lecture, no excitement would have followed except a little natural astonishment over the official eloquence and wit, and the capital points made on the capital."

Greenwood closed with, "Local pride, though not counted a cosmopolitan virtue and usually most rampant in country villages, is always a sacred and perilous thing to touch upon." Douglass "may criticize his fellow-citizen a little roughly, but I think I can answer for my old friend," Greenwood said with a blaze of sarcasm, "that should it ever be his painful duty to hang any of us, he will proceed with decency and dispatch, and see to it that everything is arranged to our satisfaction and for our comfort as circumstances will allow."

With gratitude, Douglass wrote to Greenwood, "You have done many services with your facile pen, guided by justice and enlightened liberality during the last thirty years, but you have never come to the rescue more chivalrously and effectively and I may add, when your help was more needed than in the present instance." With an attempt at humor, the old friend worried, "My only fear now is that you have invited to your own heart blows that ought to fall upon mine alone." Douglass was reassuring that "there is not the least danger of my removal from office at the bidding of those who have raised this storm against me. There is a country as well as a capital and the country is too large hearted to take up this reproach against me."

Departing from custom, as "the tide of popular feeling was so violent," Douglass publicly addressed the calls for his removal with an explanatory letter to the editor of the *Washington Evening Star*. Douglass saw the attacks on him as "both malicious and silly," expressing, "I very much mistake if this great city can be thrown into a tempest of passion by any humorous reflections I may take the liberty to utter."

Finally, Douglass said he knew how the game worked, citing that his speech "required more than an hour and a half," but it had been condensed into a "half or three-quarters of a column." He told the readers of the *Evening Star* that had "the reporters of that lecture been as careful to note what I said in praise of Washington" as "in disparagement of it, it would have been impossible to awaken any feeling against me in this community." As an old newspaperman, Douglass knew it "is the easiest thing in the world, as all editors know, to pervert the meaning and give a one-sided impression of a whole speech by giving isolated passages from the speech itself, without any qualifying connections."

During Douglass's years in Washington, there had been calls on the House floor to move the capital out West, perhaps to St. Louis, which never materialized. By the time of Douglass's Baltimore lecture, Washington had become embedded in the American consciousness and imagination. He closed his letter to the editor as he had closed his speech. "Let it stand where

it does now stand—where the father of his country planted it, and where it has stood for more than half a century—no longer sandwiched between two slave states—no longer a contradiction to human progress—no longer the hotbed of slavery and the slave trade—no longer the home of the duelist, the gambler, and the assassin—no longer anchored to a dark and semibarbarous past, but a redeemed city, beautiful to the eye and attractive to the heart, a bond of perpetual union, an angel of peace on earth and good will to men, a common ground upon which America of all races and colors, all sections North and South, may meet and shake hands, not over a chasm of blood, but over a free, united, and progressive republic."

The Case of Tom Smothers

There is no record of a lynching having ever occurred within today's city limits of Washington, D.C. If the malediction of a lynching was ever to befall Washington, potentially precipitating a riot far beyond the effect of the Snow Riot or the violence of the Pearl Affair, where a mob threatened to raid the offices and destroy the presses of the abolitionist newspaper the *National Era*, it almost happened on the watch of Marshal Frederick Douglass.

On Saturday, February 28, 1880, the *Evening Star*, continuing its coverage of the murder trial of George P. Hirth, reported, "A White Lady Outraged by a Negro. Knocked Down on Her Way to Church. Her Life in Danger." The short article read, "The worst feature of it is that she cannot identify the perpetrator, as it was too dark when it occurred, and there is very little probability that he will ever be known." On Saturday evening, detectives, after receiving eyewitness accounts, "proceeded by back streets to the corner of 7th street and Maryland avenue northeast." They were joined by an additional police squad and excitable citizens of a recently formed "vigilance committee." A lieutenant warned the citizens to "go home and keep quiet." They refused to disperse.

No signs of the accused were found, and the crowd seemingly went home. "Several ropes were carried in the crowd," noted an *Evening Star* reporter, "and it is pretty safe to say that had the right party been discovered that night all expenses of a trial would have been saved the government." Clandestinely canvassing the neighborhood, searching homes known to

house blacks, the police found their man. But he was the wrong man; he was too short, according to witnesses. A further description of the assailant satisfied detectives that they were looking for Tom Smothers, "suspected of being the guilty one" in "similar cases of outrage two years ago."

Early Sunday morning, the police arrested Smothers without incident on Eleventh Street Northeast, between F and G Streets, taking him to the Seventh Precinct. Several witnesses had positively identified Smothers; he claimed he had been at home with his wife during the time of the alleged crime. Staying one step ahead of the clamoring bloodthirsty mob, police took Smothers at sundown through a back exit and transferred him to the Sixth Police Precinct on Massachusetts Avenue, where he was photographed. In the morning, he was taken to the police court and charged with rape. He was denied bond.

Meanwhile, with rumors circulating that the young woman had died, separate mobs gathered en mass outside the police court and police headquarters on Monday. The *Washington Post* reported, "Threats of lynching Smothers were freely made, and in this feeling the colored people fully concurred." With calls for popular vengeance administered with a hangman's cord reverberating through the streets of both black and white Washington, demonstrators "anxious to know every particular" were playing catch-up. By one o'clock on Monday afternoon, nearly one thousand men had gathered around the police court with pronouncements that "a large gathering of both young and old men at different points on the hill" was ready to intercede with Smothers's jail transfer. According to the *Star*, "Even members of the bar who heretofore have been opposed to capital punishment openly advocated the immediate procurement of a rope and its prompt use."

Mounted police were summoned and helped scatter the crowd. The crush of the surge was so intense that a railing in front of the steps of the courthouse gave way. Along with "some other jail birds," Smothers was loaded into the prison van, "and in a minute the horses were off in a gallop up Louisiana avenue [*sic*], the vehicle being surrounded with mounted police."

In pursuit of the van was a crowd of several hundred "rough-looking men," while the remaining assemblage milled around the courthouse in disgust at "the sudden and effective manner in which the prisoner had been snatched from their grasp." The police had hoodwinked the cabal and were cursed "for doing their duty so well." Smothers arrived at the jail without incident, the cool and deceptive hand of the police and marshal's office keeping the lynch mob from knowing where Smothers was at the most

A jail transfer signed by Marshal Douglass, November 28, 1880. *Lorton Prison Workhouse Museum.*

sensitive times. According to standard procedure, on Smothers's jail transfer was the signature "Fredk Douglass, U.S. Marshal, D.C. "

A meeting at McCauley's Hall on Capitol Hill, where "violent speeches were made" with one of the "speakers illustrating his remarks by displaying a rope," adjourned just before ten o'clock that night. Under the lead of an ex-policeman, a party of a couple hundred men put on their coats and hats and started out for the city jail at Nineteenth and B Streets Northeast. "On the way constant accessions were received," and by the time the group arrived at the jail, their numbers had swollen to nearly one thousand.

The crowd demanded that the warden turn over Smothers. They were denied. The warden made it clear that "Smothers was now in the hands of the law, and should be legally tried and punished." Exasperated, the mob, "after looking at the jail for about ten minutes," returned to the city, pledging to make a late-night return. An extra police detail was posted at

the jail; the group failed to regather. An editorial in the *Evening Star* stated flatly, "The people of Washington must keep up their reputation as a law-abiding community even under the present terrible provocation." There was confidence that Smothers would "not escape punishment in our courts; and there is no danger that he will fail to receive the full penalty of the law."

In speaking with a reporter, Marshal Douglass advised "the colored people to form vigilance committees in every district." Douglass had a unique and personal perspective on the value of vigilance committees. It was David Ruggles, secretary of the New York Vigilance Committee, who more than four decades before had received and sheltered Frederick Douglass, fresh from his escape from slavery in September 1838. Douglass, speaking for middle-class, propertied, black Washingtonians, said if the black communities of Washington "did not put an end to these crimes" that "white people would rise and massacre them." Speaking forcefully, Douglass, in his official position as marshal, "could not identify himself with the vigilance committees but he intended to make it a point" in his personal affairs about town to "tell the leading colored citizens here that they must take some decided action deprecating the brutal acts, which have been committed by those of their race, or look with quietness on any acts of violence which the white people may be led to commit."

The *People's Advocate*, the city's leading black newspaper at the time, reprinted Douglass's remarks under the heading, "Fred Douglass to the Rescue." In late April, Associate Justice Charles P. James sentenced Smothers to thirty years of hard labor in the penitentiary—the maximum sentence.

In the ensuing decades, up until the era of the Vietnam War, more than 4,700 Americans, nearly 3,500 black, would be lynched. Initial investigations led by intrepid journalist Ida B. Wells, a confidante of Douglass, and later funded by the National Association for the Advancement of Colored People, determined that no documented murders or attempted murders without trial were led by lynch mobs in Washington.

Let Him Alone

Days after Smothers's sentencing to the penitentiary in Albany, New York, Marshal Douglass was incorrectly accused of trying to influence the outcome of a criminal case in the Empire State. In June 1879, socialite Jane Lawrence De Forest Hull was the victim of a home invasion; jewelry was taken, and she was killed in the process. The suspected murderer, the "negro man" Chastine Cox, a one-time waiter at the Hull house, was arrested in Boston and soon confessed. Headlines of his trial, conviction and sentencing to death by hanging flashed across front pages of newspapers throughout the East Coast, including Washington's papers.

In late April 1880, after Cox's execution date had been set, a rumor was printed that Douglass was the head of a lobbying effort to persuade New York governor Alonzo B. Cornell for a commutation of Cox's sentence. On April 29, the *Post* weighed in on the rumors, saying, "But the report that Frederick Douglass is urging this application is probably incorrect." With the case of Tom Smothers fresh in mind, the *Post* affirmed that "Mr. Douglass has been active in his efforts to bring the scoundrels of his own race to justice, and he is not at all likely to make an exception in favor of so guilty a wretch as Chastine Cox."

That evening, an intrepid reporter met Douglass at Willard's Hotel in D.C., showing him the news item. The marshal scanned the paper and replied, "It is difficult to conceive of a statement so entirely untrue as this." Although Douglass had been toughened by decades of salacious rumors printed in newspapers going back to his mentor William Lloyd Garrison's the *Liberator* insinuating an affair, this story invoked his fury. "I have never been asked, nor have I ever consented, to act in such capacity. I may say further that if there ever was a cold blooded murder or a man who richly deserved to be hung Cox is that man," Douglass stated without equivocation. The young reporter inquired about Douglass's connection with the case. "No, sir; none whatever," the marshal affirmed. "I have never said, thought or felt like taking any part in it." Asked if he thought the law should take its course, Douglass stated unflaggingly, "Certainly. He has committed a deed, which deserves the fullest penalty of the law and it be promptly executed."

Answering fact with fact, adhering to expected standards of professional decorum on the matter, the reporter asked Douglass a question that cut to the core of his manhood: "His color, then, had nothing to do with the matter?"

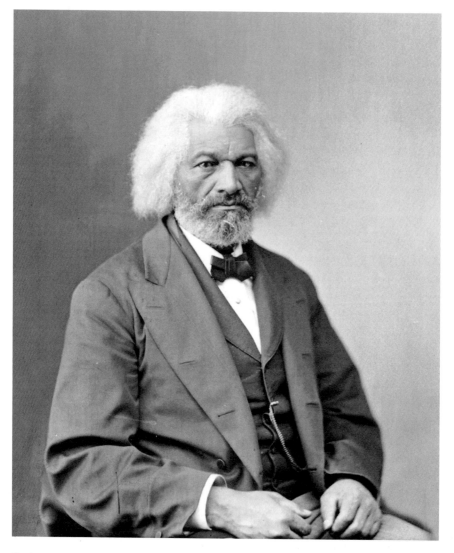

Frederick Douglass. *Library of Congress.*

As marshal, day in and day out, Douglass stared the hard realities of the struggle of his countrymen dead in the eye. His responsibilities as marshal put him on the street to enforce laws without favor or preference. "Not in the least. It does not make any difference what his color was," Douglass replied. Repeating a theme that Douglass had first shared on Independence Day 1875 in Hillsdale, he closed by saying, "All I ask for the colored man is fair play. Let him alone."

Integration of the D.C. Police Force

From Frederick Douglass's confirmation as marshal in March 1877 to 1890, only one black American was appointed to the Metropolitan Police Department, which was constituted in 1861, according to trailblazing researcher Sandra Schmidt. There is no evidence that black Washingtonians applied for the initial call of 150 privates and 10 sergeants to fill the ranks of the police department in 1861, although free blacks and mulattos accounted for 15 percent of the 61,000 Washingtonians enumerated in the 1860 census.

Many of those citizens freed on April 16, 1862, by D.C.'s Compensated Emancipation Act along with the city's established black middle class supported the local Republican Party, which by 1868 had matured. Legislative support from Radical Republicans elected to Congress and the Senate eased reforms in the city from enfranchisement to the integration of public accomodations. The Republicans fielded Sayles Bowen as mayor. A high voter turnout among black voters had helped secure his election in 1868.

The D.C. police department did not include any African Americans for several years. According to Schmidt, on "July 8, 1869 the Board of Police Commissioners, of which Sayles Bowen had formerly been a member, approved the appointment of the first three African Americans to the Metropolitan Police Department." They were distinguished by their previous military service, education and activity in local politics. Between July 1869 and July 1876, sixteen blacks were appointed to the police service. Richard Anderson, Joshua McNeal, William T. Clinton, Joseph F. Amos, Thomas J. Clark, Philip Thompson, John Wesley Bailey, William J. Jackson and Frank Jannifer were the nine black officers who served during Douglass's marshalship. One black officer, Robert Fleet, a neighbor of

John F. Cook, died in the line of duty on the morning of August 20, 1874, after discovering a house fire and running to the nearest call box. He presumably had a heart attack.

Washington's police force, in fact, integrated before Chicago (1872), Memphis (1878), Boston (1878), Philadelphia (1881), Cleveland (1881), Los Angeles (1886), Cincinnati (1886), Detroit (1890), Brooklyn (1891) and New York (1911). Of Washington's earliest black officers, most "had been active members of the Republican clubs of the city's wards and added their voices to the struggle for veterans' rights and the right to vote." Black officers often partnered with other black officers and worked black neighborhoods and slums, such as "Murder Bay," "Hell's Bottom" and "Pipetown."

An act passed by Congress in 1867 restricted black Washingtonians' entry into the police department; it required all policemen to have served in the army or navy and to have received an honorable discharge. It was strictly enforced. By the late 1870s, and especially through the 1880s, annual reports of the police commissioners asked for the law's repeal because of the increasing difficulty finding suitable candidates satisfying that requirement.

Demands to increase the size of the police force came not just from the police board and citizens but also from the press. A *Post* editorial from January 1878 simply stated, "[T]his city is poorly guarded, the number of men on duty at one time as patrolmen being about thirty, while the average beat of a policeman is about ten miles." An analysis determined, "The whole number of patrolmen is now 176, and, by reason of the deficiency in the appropriations, this force will be still further reduced to 123." On the Southside, it was more drastic: "For the whole county east of the Eastern Branch there are only two mounted men and one foot man stationed at Uniontown."

Later that summer of 1878 with the written support of more than 1,700 leading citizens representing the merchant and banking class, which held an estimated $60 million in property, members of the police force organized against a reduction in their pay in the summer of 1878. On a muggy August morning, beat officers who worked the understaffed streets awaited the Board of Commissioners at their offices to present their petition. They were accompanied by a number of prominent citizens, ex-commissioners, Superintendent A.C. Richards and Marshal Douglass.

There were other concerns. When Major William G. Moore, chief of police, submitted his annual report to the Board of Commissioners in 1887, he urged a pay increase, improvements in equipment and the construction of new station houses, but paramount was his support of "the repeal of the present law making discharged soldiers or seamen

alone eligible as metropolitan policemen." Additionally, William C. Chase's the *Washington Bee* was especially vocal in demanding the law's repeal because it was seen as being especially prejudicial to potential African American candidates.

After announcing that Lewis H. Douglass had been appointed a notary public for the District of Columbia by President Harrison, taunting that there were "two or three more of the Douglass family to be provided for and then other colored men will stand a chance," the *Cleveland Gazette* noted the composition of the police department. "There were fifty-six new police appointed in Washington, D.C., July 1, and not withstanding many colored men applied all were rejected. The colored people are about one-third the population of the District and pay taxes on $10,000,000 worth of real estate." Similar problems with integrating the police force were mentioned in Cleveland and Detroit.

In 1890, the *Washington Bee*, the leading black newspaper of its day, had stings for its enemies, the police: "The great mass of the police force are strangers to this community." Suspecting the impartiality of beat cops, the *Bee* demurred, "But by virtue of their former teachings and natural inclinations they have, as a general take, one feature of an education that has certainly not been neglected and that is their hatred to the race and of the Negro." The *Bee* highlighted the hypocrisy of the police force "let it be told aloud and heard among men, that the doors of all institutions to 'reform and save,' are turned against the race in this city."

Taking a hard position, the *Bee* advocated, "The law should be amended so that the city should be patrolled by citizens and not discharged soldiers and sailors and marines." This practice led to the "colored people who are of lower or middle classes made to feel the race prejudice by the very actions of the police force and it is but natural *that they hate each other*." In summation, the *Bee*'s editorial said, "We claim that the force is not practical in dealing with the undercurrent of our population."

Although black Washingtonians faced difficulties joining the ranks of the police force, the Washington Cadet Corps and Capital City Guards were two black infantry militias that by 1891 were combined to form the new First Separate Battalion. Medal of Honor recipient Christian A. Fleetwood had served as a commander with the Washington Cadet Corps from its organization in 1880. The Washington Light Infantry Battalion was composed of the city's white social elite. When the First Separate Battalion held its grand review in the summer of 1891 in Collingwood Beach, Virginia, Frederick Douglass was one of 1,200 onlookers.

The restrictive law was finally repealed in 1892 by a Supreme Court decision, which upheld the opinion of the Supreme Court of the District of Columbia. Associate Justice of the Supreme Court Lucius Quintus Cincinnatus Lamar II rendered the opinion in this "test case," which "finally and conclusively" gave the Board of Commissioners the right to "select whomsoever they think best for the police force regardless of service in the Army."

The *Bee* offered honey for its new friends: "The action of the District Commissioners in inaugurating a reform in the police department of the government is to be commended by all classes of citizens." Reflecting the sentiment of the community, as well as its own feelings, the *Bee* expressed gratitude to the commissioners and "hoped that the recent changes that have been made will result in some good." In the last decade of the nineteenth century, mostly under Chief Moore's guidance, twenty black men were appointed to the police force.

Schmidt's exhaustive research into the early years of the Metropolitan Police Department provides fresh insights into the pace of social change in Washington, D.C., through the securing of civil and employment rights on the most basic street level: the integration of Washington's finest. After Frederick Douglass's resignation as marshal, Washington, D.C., did not have another black marshal until President Kennedy appointed Luke C. Moore, whose name now adorns a charter school in Northeast Washington.

5

Old Uniontown

Anacostia can at least boast of one historic character among her citizens—a man whose name and fame are probably world-wide. Frederick Douglass, the foremost man of his race in the country, lives in the old Van Hook house, built by one of the founders of the town, on Cedar Heights, between Pierce and Jefferson streets. The house, which is quite attractive, stands on a beautiful knoll, from which one of the finest views of the city of Washington found within the District, is presented.
—Evening Star, *December 5, 1891*

In the riverbed of the Anacostia, eastern branch of the Potomac River, rest hundreds of cannonballs undisturbed for more than 150 years. During the 1850s, the thunderous explosion of cannon fire regularly rang out from the Washington Navy Yard side of the Anacostia River. The echo of the blast ricocheted in all directions, followed by a splash.

It all started with U.S. Navy lieutenant John Dahlgren's arrival in January 1847 to oversee the manufacture of rockets recently developed by British inventor William Hale. By April, Dahlgren was leading the Bureau of Ordnance; the U.S. Navy approved a new and larger workhouse. "Because there was not sufficient level ground available for ranging the guns, [Dahlgren] proposed to use the river," says *Round-Shot to Rockets; A History of the Washington Navy Yard and U.S. Naval Gun Factory.* "No such experiment for accurate results had been previously tried over the water, and it became necessary to develop a method by which the splash made by the fall of the shot might be precisely located. This [Dahlgren] quickly

U.S. NAVY YARD.
WASHINGTON.D.C.

A view of the Washington Navy Yard during the time of Lieutenant John Dahlgren. *Library of Congress.*

devised by a system of triangulation. The Dahlgren test battery at the Navy Yard came thereby into existence."

Another contemporaneous turn of events was the repeal of the prohibitive toll civilians and merchants had to pay every time they traveled the Navy Yard Bridge. "Over time, Maryland's legislature stridently prodded Congress to remove the tolls on the Eastern Branch bridges," according to journalist-researcher Steve Ackerman, "to benefit 'persons who frequent the markets of Washington and Georgetown, for the sale of their productions' by removing the 'heavy tax in the form of bridge tolls on their produce' as an 1844 resolution in the Maryland legislature stated." In 1852, Congress bought the Navy Yard Bridge that was built at the terminus of Eleventh Street in 1818 and removed the tolls, opening Washington's markets to farmers coming up from Southern Maryland and generating the earliest development prospects for Washington's first planned suburb: Uniontown. According to news stories and official reports of the secretary of the navy, by 1855, the Washington Navy Yard's workforce was upward of 1,100. The most preeminent positions were filled by 300 ship carpenters, 200 machinists, 150 blacksmiths, 50 joiners, 60 plumbers, more than 100 iron and brass foundry workers, 85 civil engineers and nearly 100 laborers.

Off a graveled walkway in Congressional Cemetery, past some young trees, about halfway down a path worn in the grass rests the simple headstone "John W. Van Hook 1825–1905," without any mention of his

The headstone for Uniontown developer John Welsh Van Hook in Congressional Cemetery, 1801 E Street Southeast, Washington, D.C. *Author's collection.*

role in developing present-day Anacostia. Born in Philadelphia in 1825, Van Hook and his family soon moved to Baltimore, where Van Hook lived until 1852, when he came to Washington. By 1854, after the dissolution of at least one real estate partnership in Baltimore, Van Hook partnered with John Fox and John Dobler to purchase 240 acres of farmland on the outskirts of Washington, just beyond the Navy Yard Bridge, from Enoch Tucker for $19,000. Tucker's farm was part of the larger Chichester tract and had once been owned by William Marbury.

"The proximity of the Navy Yard to the bridge no doubt, gave the promoters the belief that many of the employees would take advantage of having a home, with country life adjunct, near their place of business. Uniontown is the first suburban subdivision and because of the river separation is not likely to lose its suburban identity," historian Charles Burr writes in the Records of the Columbia Historical Society. Across the water from the Washington Navy Yard, within the city's limits, outside L'Enfant's

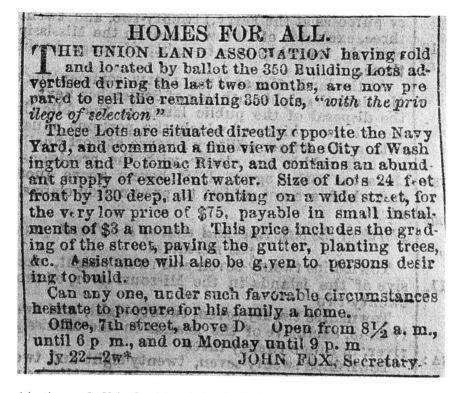

HOMES FOR ALL.

THE UNION LAND ASSOCIATION having sold and located by ballot the 350 Building Lots advertised during the last two months, are now prepared to sell the remaining 350 lots, *"with the privilege of selection."*

These Lots are situated directly opposite the Navy Yard, and command a fine view of the City of Washington and Potomac River, and contains an abundant supply of excellent water. Size of Lots 24 feet front by 130 deep, all fronting on a wide street, for the very low price of $75, payable in small installments of $3 a month. This price includes the grading of the street, paving the gutter, planting trees, &c. Assistance will also be given to persons desiring to build.

Can any one, under such favorable circumstances hesitate to procure for his family a home.

Office, 7th street, above D. Open from 8½ a. m., until 6 p. m., and on Monday until 9 p. m.

jy 22—2w* JOHN FOX, Secretary.

Advertisement for Union Land Association, *Evening Star*, June 10, 1854. *Washingtoniana Division, D.C. Public Library.*

original plan, Uniontown was ripe for development—or so it seemed. Maps were prepared dividing the property into seven hundred building lots. The names of the streets were taken from the presidents. Uniontown was bound by Monroe (present-day Martin Luther King Jr. Avenue), Harrison (present-day Good Hope Road), Taylor (present-day Sixteenth Street) and Jefferson (present-day W Street) streets. One of the city's first twenty-six post offices, the Anacostia post office, opened in February 1849, giving the area a formal name. Dobler, Fox and Van Hook rebranded the area "Uniontown" and placed restrictive covenants that precluded equally pigs, Irish and those of African descent.

Uniontown got off to an unfortunate beginning. Plans to hold a drawing on the evening of June 7, 1854, per "the request of many persons interested," in available lots "24 feet front by 130 feet deep, situated in the most beautiful and healthy neighborhood around Washington," were

canceled. On June 5, a fire had broken out at the offices of the Union Land Association, which "destroyed our Office, Papers & c. renders it necessary to postpone the drawing for the Union Town Building Lots." The drawing was rescheduled in a new office on Seventh Street "a few doors above Odd Fellows Hall"; the lots would be put up at "the present very low price" of sixty dollars, which could be financed over five years at monthly installments of three dollars. On receipt of cash, deeds "guarantied [*sic*] clear of all and every incumberance [*sic*]" were provided. By late July, the Union Land Association had reportedly "sold and located by ballot the 350 Building Lots advertised during the last two months" and was now ready to sell the remaining 350 lots "with the privilege of selection." The sales description for lots had improved over the two months, and lots were now described as being "situated directly opposite the Navy Yard, and command a fine view of the City of Washington and Potomac River, and contains an abundant supply of excellent water."

Speculation had driven the "very low price" for the same 24- by 130-foot lots up to seventy-five dollars, still available "in small installments of $3 a month." The cost of "grading the street, paving the gutter, planting trees, & c." was not hidden; it was included in the sale price. As a further incentive, the ad stated, "Assistance will also be given to persons desiring to build." John Fox, the secretary, closed by declaring, "Can nay one, under such favorable circumstances hesitate to procure for his family a home." The sale of Uniontown lots was mostly speculative. Over the next two decades, lots were continuously listed in newspaper tax sale supplements. However, despite the frequent turnover of lots, a community slowly developed.

Until the Civil War, buildings were few and far between in Uniontown, but by April 1860, before Abraham Lincoln's election, the *Baltimore Sun* took notice. "Some time since *The Sun* noticed that within the last few years a new and flourishing neighborhood had sprung up on the margin of the Eastern Branch, immediately opposite the Navy Yard. For reasons that place is known and recognised [*sic*] as 'Uniontown.'" The story also tells of the laying of a cornerstone for a new Methodist Episcopal Church. The land being on "three of the most eligible lots" was donated by developers John Fox and John Van Hook. A little more than a year later, as troops flooded into the city on the verge of the Civil War, the Seventy-first New York gave a matinee concert before a sizable and distinguished crowd assembled at the Navy Yard, according to Margaret Leech's Pulitzer Prize–winning *Reveille in Washington*: "One of the great cast-iron Dahlgren guns was fired at targets in the river, and the Seventy-first New York marched in dress parade."

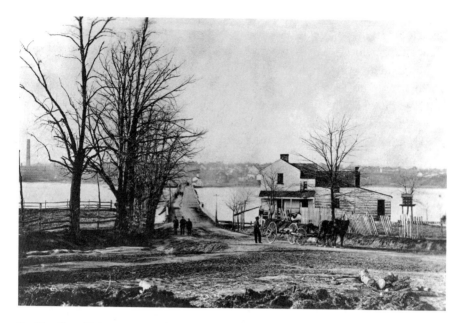

Looking from Uniontown over the Eastern Branch of the Potomac (Anacostia River) toward the Washington Navy Yard, circa 1865. *Library of Congress.*

Uniontown, sandwiched between the nation's capital and the Confederacy, was a morass of conflicting loyalties in the 1860s. Van Hook's role in the Civil War headlined his obituary. "During the Civil War," the *Washington Post* remembered, "Mr. Van Hook was commended by President Lincoln and Gen. U.S. Grant for signal bravery in carrying dispatches to this city via Baltimore at the time when the latter city was the hotbed of Confederate sympathizers," as was Uniontown. With the formation of the Metropolitan Police Department in 1861, there was an immediate tension between the flood of military recruits in the city and the newly constituted municipal force. One of the first policemen was Anacostia native Lingarn B. Anderson, attached to the Anacostia precinct his whole career. The Anacostia substation, originally the first precinct, "was a converted coal office with a part of the room roped off, and we had to keep guard there all the time or prisoners would step over the rope and walk out of the front door."

Talking to a newspaperman and an early twentieth-century police chief, Anderson reminisced about the "devilment" that crawled in the city during the war. "Then there were Southern sympathizers," he remembered. "They'd get busy in barrooms with a gang of abolitionists, and the first thing

you knew there would be artillery play, and some of those boys could shoot." He had a bullet wound in his left thigh to prove it. "I hunted for him," Anderson said, his memory shifting to John Wilkes Booth's escape from Washington, which took Booth over the Navy Yard Bridge. In Uniontown, Booth waited for Davy Herold, where they met and regrouped before making their escape toward Southern Maryland. "We heard for a while that he was around Anacostia." Suspicions that John Wilkes Booth might be hiding out in Uniontown were not unfounded, as testimony at the Lincoln Conspiracy Trial revealed that Dr. Samuel Mudd, Mary Surratt and others associated with Booth had been seen in and around the area in the immediate weeks leading to and even a few days before President Lincoln's assassination.

Robert F. Martin's Farmers and Drovers Hotel, at the junction of Monroe and Harrison Streets in Uniontown, about one hundred yards from the Navy Yard Bridge, was a frequent point of rest for Marylanders from Upper Marlboro in Prince George's County, Bryantown in Charles County and Leonardtown in St. Mary's County bringing their products to the markets of Washington. In March 1865, Martin was appointed postmaster for Uniontown, in Washington, D.C. The *Baltimore Sun* commented that the "post office there will be of great advantage to the large number of mechanics and other workmen, soldiers." During the trial, Martin testified that he had seen Dr. Mudd in the market on Christmas Eve 1864 and that in March and April 1865, he had stayed at his hotel. Martin could not verify if Mudd was or was not up from his farm to meet Booth in Washington. Years later, Frederick Douglass would keep an account with Martin for the purchase of household provisions and supplies for his stables.

When Frederick Douglass moved to Uniontown, horse thieves, wild animals and escapees from the Government Hospital for the Insane roamed the pastoral roadways. In just over twenty years, the suburban subdivision of Uniontown and the adjoining villages had seen the construction of schoolhouses, churches, stables, new homes and businesses and meeting halls. Douglass was no stranger to this community.

The next neighborhoods over from Uniontown were known as Potomac City, Hillsdale and Barry Farm (developed by the Freedmen's Bureau); the latter two names remain in currency today. With more than $50,000 set aside by General Oliver Otis Howard, head of the Freedmen's Bureau, in a trust to develop "normal collegiate institutions or universities," these funds were used to purchase 375 acres from the descendants of James D. Barry in 1867. Sitting just south of the Government Hospital for the Insane, which saw its first patient in 1855, the sale of lots would help relieve "the immediate

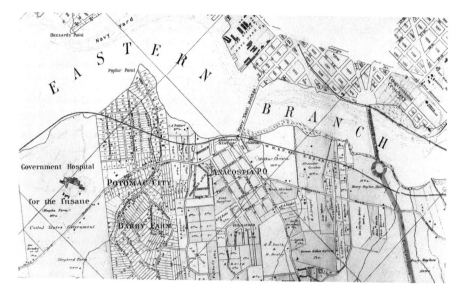

An 1894 Baist Map of the Greater Anacostia area. *Library of Congress.*

necessities of a class of poor colored people in the District of Columbia." Within two years, more than 260 families, the Douglass boys included, had made Barry Farm their home.

Writing in his autobiography, General Howard recalled, "Some of those who bought one-acre or two-acre lots were fairly well off. I found it better to have a few among the purchasers who were reasonably educated, and of well-known good character and repute, to lead in the school and church work, and so I encouraged such to settle alongside the more destitute." Howard would often bring government officials to Barry Farm to show off the self-sufficient community, largely made up of freedmen. "Everyone who visited the Barry Farm and saw the new hopefulness with which most of the dwellers there were inspired, could not fail to regard the entire enterprise as judicious and beneficent."

Testifying before a Congressional Committee in 1870, lawyer Edgar Ketchum offered a sketch of a Barry Farm homestead. "You may see another (man) some thirty-six years of age, very black, very strong, very happy, working on his place. His little house cost him $90. You see his mother; that aged 'aunty,' as she raises herself up to look at you, will tell you that she has had eleven children, and that all of them were sold away from her." Ketchum continued, "She lived down in Louisiana. The man will

tell you that he is one of those children. He went down to Texas, and when he came up through Louisiana and Alabama he found his old mother and brought her up with him, along with his wife and son. And there they live."

And there, all three Douglass sons initially settled upon moving to Washington in the late 1860s, a testament to the family's commitment to being on the frontlines of racial progress. Charles and Lewis would move across town, while Frederick Jr. would spend the rest of his life on nearby Nichols Avenue, today Martin Luther King Jr. Avenue. In the early 1870s, when in Washington to run the *New National Era* and serve on the legislative council, Frederick stayed in the Anacostia area with his sons.

Reporting on the community, a column praising "Potomac City" appeared in the pages of the *New National Era* in October 1870. "The colored children of this settlement, (interesting for being mostly composed of families freed by the war) gave their annual exhibition last week, running through two evenings." Despite inclement weather, which muddied the roads, the schoolhouse was crowded. "The hope of the emancipated people should be in their children," the paper suggested. "The time has gone by for the aged, but education is within the reach of the young, and the aged can do much to encourage the young to embrace and improve their opportunities. Herein is real consolation if say one has the heart to feel it—and we certainly felt such consolation while we witnessed the proceedings of the dear children who took part in this exhibition." Solomon Brown, the superintendent of the school, and "the lady and gentlemen teachers connected with the school, are entitled to the warmest of thanks of the whole settlement for their untiring efforts to advance the highest interests of these children."

While the community fully supported an effort to improve its social condition, there was less of a will to support improvements in the area's physical condition. "The inhabitants of Potomac City are not satisfied with the manner in which they have been treated in the plan of comprehensive improvements," wrote the *Baltimore Sun*'s Washington correspondent in the summer of 1872. "The board of public works propose to open streets in the villages and as the residents there have each a deed of one acre of land for his cottage, they are not disposed to surrender any portion of their homesteads for streets or anything else without compensation." When a contractor "appeared in the village to cut up the lots, he was beset, the horses taken from the street plows, the wagons upset, and the laborers driven away. In the afternoon the work was begun under the protection of the police."

On the outskirts of Rochester that summer, Douglass's daughter, Rosetta, and her husband, Nathan Sprague, housesat. A fire broke out in the stable

that destroyed the Douglass family home of nearly three decades. By that fall, Frederick Douglass purchased a three-story home on A Street Northeast in the Capitol Hill neighborhood. The home, which reflected the architectural influence of the French Second Empire, with its prominent mansard roof, was just blocks from the United States Capitol.

Before moving to Uniontown, Douglass was a familiar face in the community. Erected in 1873 by Charles Douglass at the corner of Howard Road and Nichols Avenue, Douglass Hall, a "two-story, rambling structure," was a landmark in Hillsdale and the Greater Anacostia area. The upper floor was used as a dance hall and meeting space, while merchants took up the lower floor. Throughout the years, Frederick Douglass spoke many times at Douglass Hall, from lectures to debates.

To celebrate the ninety-ninth anniversary of America's independence, Hillsdale residents thought big, inviting two of America's leading black Americans, Frederick Douglass and John Mercer Langston, to deliver orations at a picnic "that gave a guarantee for a large gathering," observed the *National Republican*. As the "hour approaches for the exercises to commence the road leading from the bridge over the Eastern Branch was lined with hurrying pedestrians" eager to hear Douglass and Langston, both of whom had recently been vocal in criticizing the administration of Howard University. At around eleven o'clock, a choir of about twenty-five children sang a series of patriotic songs, followed by a prayer.

Langston led the day, denouncing the American Missionary Society for what he said was a persistent paternalism that guided their outreach to black folk. Langston said, "The hour is come when we must manage our own institutions." With calls for black self-determination, Langston called for colored churches with colored preachers, colored banks with colored bankers and colored schools with colored teachers, and "if we have colored colleges, we demand that we have our own officers. We have played second-fiddle too long." After the hearty applause had subsided, Frederick Douglass was introduced to a crowd of his neighbors.

Acknowledging Langston, recalling their first meeting nearly twenty-eight years before, Douglass spoke on "the great question of the hour." Douglass observed, "The glorious deeds of the revolutionary fathers have been declaimed at every fireside, upon every mountain top, on every plain and in every school. They are familiar to every school-boy; they are facts of history." If asked what colored men have to do with the Fourth of July, Douglass was waiting with an answer. "They were at Lewisburg, Ticonderoga, Quebec, Lexington, Concord, and Bunker Hill. The manly form of Major Pitcarine,

the very incarnation of English hostilities, was brought down by a musket in the hands of the colored soldier Salem." From the Battle of New Orleans in the War of 1812 to Pillow, Petersburg and Richmond from the late war, Douglass disclosed, "We have never deserted the white man. We have stuck to him through evil report and through good report, in years of peace and plenty and in years of war and scarcity." The crowd applauded.

At the end of the war, "more than four million of us were sent forth empty. We were friendless, homeless, penniless, naked, hungry, and thirsty," Douglass maintained. "The South wouldn't have us; the North didn't want us. We were strangers in a strange land." A reporter took note of how Douglass's phenomenal voice touched not only the adults but also the children. He carried on: "But fellow citizens, we have no time to shed tears."

Thrown upon their own resources, Douglass let the community know that if no one believed in them, he did. "You will be the architects of your own fortune. All we ask is a fair field to work in and the white man leave us alone," he said. Becoming more stern and serious, Douglass warned against schemers looking for new victims: "We have been injured more than we have been helped by men who have professed to be our friends. They are lawyers without clients; ministers—broken down ministers without churches, wandering teachers without schools."

Never known to pull a punch, Douglass proclaimed for all to hear: "They are great beggars. They have the science of begging down to a nicety. They are great at getting out circulars. They scatter them over the land, as leaves before autumnal gales. If you are worth anything they will find it out where you live; and if you never got a letter before you will get one now." The crowd in tow, it responded with a roar of laughter. With the failures of the Freedman's Bank and of his newspaper fresh in his mind, Douglass bellowed, "Fellow-citizens, we must stop these men from begging for us! They misrepresent us, and cause the country to look upon us as a poor and helpless people." He had heard it often enough to recite: "They say, 'Please give something to help educate the poor black people but do, pray, pay it to me.' And if it is a hundred dollars it is reduced to about a hundred cents when it gets to the 'poor black people.' We do not want—we will not have— these second rate men begging for us!"

In closing, Douglass offered, "Allow me to add that we must stop begging for ourselves. If we build churches, don't ask white people to pay for them. It we have banks, colleges and papers do not ask other people to support them. Be independent." Douglass continued, saying that the "scourged shoulders, the bowed form, the beseeching look, the outstretched, suppliant hand are

among the things of the past. We must stand erect and tread to duty with martial step. Then our white friends will respect us the more, and we will respect ourselves and one another more thoroughly." The time had come. "And we now bid an affectionate farewell to all these plunderers, and in the future if we need a Moses we will find him in our own tribes." Applause and cheers resounded.

In March 1873, *Lippincott's Magazine* published the following in an article titled "New Washington":

> *A stranger visiting the national capital should begin by leaving it. He should cross the Anacostia River at the Navy-yard, climb the heights behind the village of Uniontown, be careful to find exactly the right path, and seat himself on the parapet of old Fort Stanton. His feeling of fatigue will be overcome by one of astonishment that the scene should contain so much that is beautiful in nature, so much that is exceedingly novel if not very good in art, and so much that has the deepest historical interest.*

According to family lore, after Frederick Douglass secured the purchase of a palatial estate in Uniontown, complete with a hilltop Southern Victorian mansion in September 1877, he took his wife, Anna, on a carriage ride to show her their new home. With an ever-present bundle of grandchildren at their Capitol Hill home and frequent guests passing through, the home across the Eastern Branch afforded new comforts and privacy. However, moving out of the interior of the city for the more bucolic life found in Uniontown had its slight drawbacks, including runaway and wild dogs.

Despite the city pound master claiming to the Board of Commissioners in 1878 that his operation was both more efficient and "certainly far superior to that of any of the large Eastern cities," Uniontown citizens were incessant in complaining "of the depredations committed upon both public and private property by animals running at large." In an attempt to exert some sort of control on the problems caused by dogs, the city now made dog owners pay two dollars for a tax tag. Instead of helping to impose order, many owners were now inspired to let man's best friend loose. Besides dogs, horses, cows, goats, the occasional sheep, mules and hogs were also pursued. More than 14,000 animals had been impounded since Frederick Douglass became a city taxpayer. In 1877 alone, the pound master took more than 2,800 dogs off the streets.

It was in these streets that Frederick Douglass could be found on foot. "Frederick Douglass, in spite of his age, walks about Washington as briskly

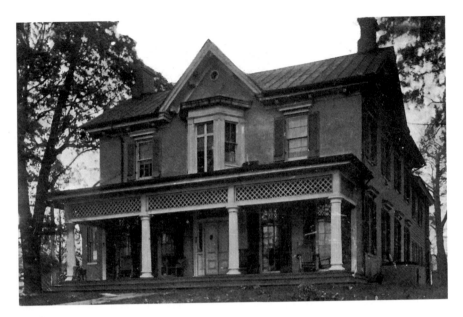

Postcard of Cedar Hill, circa 1910. *Collection of John DeFerrari.*

as a boy," observed the *New York Tribune* in early 1884. Approaching seventy years old, Douglass, standing slightly over six feet tall, "weighs more than 200 pounds, his hair is white, and his health is perfect." Two years earlier, Douglass had told a friend, "I have not felt in better health at any time during the last five years. I now walk every morning from 'Cedar Hill' to the City Hall and am less fatigued than when I adopted the practice."

While holding the office of marshal for the District of Columbia and later as recorder of deeds, Douglass was known to rise before the rooster's crow. At five o'clock, he would awaken and often walk his property, inspecting the stables, picking up loose branches and taking note of any needed repairs to the two walkways leading to the home. Returning inside, Douglass would then sit at his desk and either answer letters or compose new correspondence. In the fall of 1878, Douglass wrote two letters to the Board of Commissioners on behalf of one of his new neighbors, Francis Allen.

By the late 1870s, Uniontown had begun to see a merchant class develop, with barbers, pharmacists, grocers, carriage builders, coach painters, feed dealers and blacksmiths. These Uniontown business owners were among the many individuals who advocated for a larger police force. While neighborhoods lining L'Enfant's original plan of Washington, such

On September 24, 1878, Marshal Douglass sent a support letter for Francis Allen's application to the Metropolitan Police Department to Seth Ledyard Phelps, president of the Board of Commissioners. *Sandra Schmidt via National Archives.*

as Swampoodle, Murder Bay, Hell's Bottom, Cowtown and Pipetown, contributed many warm bodies to the city jail, with fewer police on the local beat, Uniontown merchants were left more or less defenseless. They wanted protection, too. Francis Allen was known in the community and thought to be an ideal candidate to join the police force. He was born in Maryland in 1845 but had moved into the District during the war, where he served with the D.C. Volunteers for three years before being honorably discharged. He was thirty-two and employed as a streetcar driver when he filled out his initial application in 1877 to join the force.

"I wish to add my good word for Mr. Allen," Douglass wrote to Major Thomas P. Morgan, superintendent of police, on letterhead from the U.S. Marshal's Office on September 11, 1878. "I am not very well acquainted with him but I am with those who are. From them I learn that Mr. Allen is a man of excellent character." Less than two weeks later, on September 24, Douglass wrote to Seth Ledyard Phelps, president of the Board of Commissioners, restating what he had written to Major Morgan: "I am personally but slightly acquainted with Mr. Allen but have intelligent friends in Uniontown who know him well as a temperate, orderly, industrious young man." Joining Marshal Douglass in an undated letter to the Board of Commissioners supporting Allen's application to join the police force were local postmaster and hotelier Robert F. Martin, real estate investor Henry A. Griswold, druggist Samuel F. Shreve, fancy goods merchant James Grimes,

feed dealer Charles Jenkins, clerk William Green and other notable citizens. According to scholar Sandra Schmidt, Allen was finally appointed on March 8, 1879, serving nearly twenty years. According to city directories, Allen was assigned the Uniontown beat.

Reviewing newspaper records and police reports, crime in Uniontown and the surrounding area was a part of everyday life but rather tame compared to the vice and murder that dominated many crosstown sections. However, murder was not unknown. In 1886, a confrontation between a citizen and business owner turned deadly when John A. Owens, a merchant on Harrison Street, struck a man "in the head with a stone or a weight, and depressed his skull." Allegedly, the man Owens struck had testified against him in the police court for violating the liquor license law, which, among other restrictions, prohibited Sunday sales. Owens was tried and later convicted of manslaughter. Furthermore, accidental shootings with rifles and pistols were common in Uniontown, owing to residents' proclivity to hunt. Sometimes these accidents were fatal, on more than one occasion involving a young child.

By the time Douglass settled in Uniontown, the area had begun to sprout new churches, an indicator of its growth. Today, at the northwest corner of Thirteenth and V Streets in Historic Anacostia, is Saint Teresa of Avila, the oldest Roman Catholic Church in Washington, D.C., east of the Anacostia River. It was originally part of the Archdiocese of Baltimore because the Vatican did not make the city of Washington a separate archdiocese until 1939. St. Teresa, in fact, is older than the Archdiocese of Washington by more than half a century. In April 1879, then at the corner of Fillmore and Washington Streets, the cornerstone was laid. Diagonally across the street, at the southeast corner of Fillmore and Washington Streets, was Emanuel Episcopal Church, Washington, D.C.'s easternmost outpost of the Episcopal Church. (Today, the church is the Delaware Baptist Church.) The procession of the celebratory parade for St. Teresa was captured by the *Post*:

> *The route was determined on as follows: from City hall, down Four-and-a-half street to Pennsylvania avenue, thence to St. Peter's church, where the visiting clergy and others will join the procession, thence across the navy yard bridge to Uniontown. With regard to the formation of the line, it is thought that it will be the same on St. Patrick's day, except that there will be five divisions instead of four, the colored societies making the fifth.*

St. Teresa opened its door in the fall of 1879. However, by the turn of the twentieth century, black parishioners were relegated to attend Mass in the church basement and left to establish their own parish.

Uniontown church services advocating the temperance cause could draw two thousand people at a time with song and prayer. The Uniontown Temperance Union actively held rallies in its own neighborhood and up Asylum Road, near the Government Hospital for the Insane. By 1882, there were no barrooms within Uniontown. Residents actively opposed and "voted against the establishment of any institution of the kind" throughout the nearly two decades Frederick Douglass was a neighbor. George F. Pyles ran a successful temperance grocery store in Uniontown, with Douglass among his customers. As an enslaved person, Douglass knew all too well the debilitating effects of alcohol. Speaking in Scotland in 1846, Douglass said, "I have had some experiences of intemperance as well as of slavery. In the Southern States, masters induce their slaves to drink whisky, in order to keep them from devising ways and means by which to obtain their freedom." He could speak from experience. "I lived with a Mr. Freeland who used to give his slaves apple brandy. Some of the slaves were not able to drink their own share, but I was able to drink my own and theirs too." Douglass's mind was blown. "I took it because it made me feel like I was a great man. I used to think I was a president." As a free man, Douglass would make temperance one of the many issues for which he advocated on the lecture circuit, in his newspapers and in his private life.

The last month of 1887, a little more than three decades before the ratification of the Eighteenth Amendment would attempt to prohibit alcohol from 1920 until 1933, Frederick Douglass closely watched the Supreme Court. On December 5, 1887, the court, led by Associate Justice John Marshall Harlan, affirmed in *Mugler v. Kansas* that the Kansas legislature's passing a series of laws prohibiting the manufacture and sale of alcohol within its state boundaries did not violate the Constitution. Douglass wrote to Justice Harlan: "The Supreme Court has never given an opinion more in harmony with justice, civilization, and the Constitution of which reflects more honor upon itself. I wish it could have seen as clearly in the case of the civil rights." Douglass, speaking as "one of the proscribed," would not lose faith; he would "hope on and ever" that the "time will yet come when the Supreme Court will find some legal and constitutional way to do as much for Civil Rights as it has now done for the cause of temperance."

In 1884, along with petitions submitted by citizens of the District of Columbia for a woman deputy warden at the District jail and greater

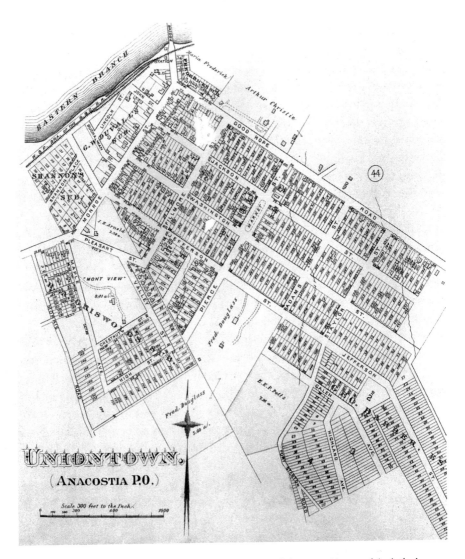

An 1887 Hopkins Map, City of Washington, Plate 41, Uniontown (Anacostia). *Author's collection.*

protections for orphan and street children, property owners in Uniontown asked Congress to change their town's name back to "Anacostia." Failing to move past a committee vote in previous years, by 1886, the legislation to change Uniontown's name back to Anacostia had cleared the House Committee on the District of Columbia and passed the House and Senate, ready for the president's pen. Grover Cleveland, the twenty-second president, got lost in Anacostia with his trusted adviser Colonel Daniel S. Lamont earlier in the year after venturing over the Eastern Branch, possibly a deliberate effort to be out of earshot of official Washington as he discussed his upcoming marriage to Frances Folsom. Lost in conversation, the president didn't notice when his carriage turned "into a side road for the purpose of making a short cut," inadvertently pulling up "before a modest country house, where the road ended."

Lamont leaned over the side of the carriage to a "little boy who was gazing in wonder at the handsome equipage which had so suddenly appeared." Lamont inquired of him, "Who lives here?" The young chap kicked back, rocking on his heels and, with assurance, replied, "Mr. Fred Douglass." Any and every young lad of course knew this. Cleveland signed the bill, and Uniontown was no more. Anacostia it has been ever since.

Before Douglass fulfilled a long-held desire to return to Europe, this time planning to visit Paris, Greece and Egypt, a family friend from Rochester paid a visit to him and Helen Pitts at Cedar Hill. Historian and journalist Jane Marsh Parker had known Douglass since she was a child, when they were next-door neighbors. Parker was known in Rochester for her extensive writing on local history. She contributed an article about her visit to Douglass in Washington that was reprinted in papers across the country.

Walking around Cedar Hill, Parker and Douglass ran into "an old colored man" who called Douglass "Fred." The man had been enslaved with Douglass. He had come to Washington and secured a job tending a furnace in the Capitol; Douglass was the recorder of deeds for the District of Columbia. Parker, ever the inquiring journalist, asked about memories he had of a young Douglass, to which the old man said, "No, I don't remember anything special that Fred used to do in them days, only he jes wouldn't be put upon and wanted to boss everything."

"Uniontown, although without sidewalks, or street pavements, these being graveled, was becoming a thriving place. Many stores of all kinds [have] sprung up to accommodate the trade coming from lower down in Maryland both by Harrison Street and Monroe Street," Charles R. Burr wrote in the Records of the Columbia Historical Society in 1920. By

the late 1870s, demand in the community had grown not just for better infrastructure but also improved transportation. The downtown streetcar line terminated at the foot of the Navy Yard Bridge at M Street, requiring residents of Uniontown to walk the rest of their way home over the bridge. The existing streetcar companies showed no interest in extending their line across the bridge. It would take one of Uniontown's leading figures, Henry A. Griswold, a transplant to Washington from Wethersfield, Connecticut, to raise the capital and navigate the permit process to open a streetcar line that originated across the river to bring people downtown. One of Griswold's earliest investors was Frederick Douglass. Years before Griswold's name would be widely known throughout the city, he was introduced to Vermont senator George F. Edmunds by his neighbor, Frederick Douglass. Heavily invested in real estate, Griswold was a "gentlemen with whom I am well acquainted," Douglass wrote in January 1880. The Anacostia Street Railway Company had applied for an extension of its route, which Douglass thought to be "conclusive." Exerting his national influence into local matters, Douglass asked that Edmunds "give Mr. Griswold a hearing before you decide anything affecting the extension of the Anacostia Road."

Griswold would "eventually make a fortune out of the Anacostia railway," according to the *New York Times*, by connecting Uniontown to the center city. "This fortune he invested in real estate, and at one time he was practically the sole proprietor of the thriving town." Many of the earliest homes Griswold developed can still be seen in Historic Anacostia, such as five detached wood frame houses on Valley Place Southeast, developed in the 1880s. (At publication, four of the five are occupied, with the front half of 1326 Valley Place Southeast just barely standing.) Frederick Douglass was a frequent visitor to Griswold's office. When Douglass died, he was a stockholder in Griswold's streetcar company.

Death did not meet Griswold as peacefully as it met Douglass. On a March day in 1909, Mrs. Griswold returned to her large house on Mount View Place from a day of shopping downtown. She had not seen her husband and asked the home's servant where he was. Together, they went looking for him. To their utter shock, Griswold was in the attic, shot through the chest, with an "old-fashioned shotgun" lying beside him. The police, finding "many suspicious circumstances," such as the "position of the body and the weapon" and the fact that Griswold was known to keep large sums of money in the house but "practically nothing of value had been touched," did not agree with the coroner's conclusion of suicide. If Griswold was, in

Homes developed by Henry A. Griswold on Valley Place in Uniontown, circa 1885. *Library of Congress.*

fact, murdered, his killers were never caught and tried, and their ghosts are still haunting the streets of old Anacostia.

While the residents of Anacostia and the surrounding villages played a waiting game with the Board of Commissioners and the city water department to lay a water line "carrying the water across the Eastern Branch," Cedar Hill had its own source. "A large spring at the foot of the hill in the rear of the house, yields a plentiful supply of pure water, and a pump in the rear of the stable supplies the stock," observed the *Evening Star* in 1889. It was also noted that "Mr. Douglass' horses are unexceptionally fine, and are kept in the best manner."

Visiting Cedar Hill unannounced on a Sunday in 1886, George Alfred Townsend, the *Cincinnati Inquirer's* Washington correspondent, noted that Frederick Douglass "does not inhabit a mere house, he lives in a respectable mansion. Having been an industrious and methodical man, aware of the value of money, he has saved his earnings, whether procured by authorship, or

lecturing, or manual labor, or office-holding, and his residence at Anacostia, or Uniontown, is the best house there." In closing, Townsend wrote, "It is a remarkable exhibition of our comparatively new times that right at the city of Washington, in the midst of fine landscapes, should have come to settle this man, who more than fifty years ago, with his life in his hand, undertook to establish himself and procure some of the benefits of civilization."

There was no more prominent citizen of Uniontown than Frederick Douglass. He was not a passive member of his community, befriending real estate developers, shop owners, temperance leaders, church pastors, officers of the Metropolitan Police Department at the Uniontown substation and local children. Douglass was in and of his neighborhood. When Douglass lived at Cedar Hill, baptisms were regularly performed in the nearby Anacostia River, gas lamps lit the street corners at night and the nearest fire engine house was across the river on North Carolina Avenue. In the nearly 120 years since Anacostia could last count Douglass as one of its living, the area has been beloved for still having the feeling of being a small village in the city.

6

Howard University and Frederick Douglass, Esquire

I never knocked my head against college walls like you youngsters.
We had few books, and dared not read.
—*Frederick Douglass*

Years after Frederick Douglass's death, Richard T. Greener, the first black American graduate of Harvard University, offered a remembrance of his friend who served as a mentor for the critical first generation of freedmen and their progeny. This generation, struggling to make the transition from slavery to freedom, "saw, heard, and handed down the tradition to their children, of the supreme capability of Negro manhood" that Douglass exemplified. Douglass epitomized manhood through a dignity of learning, education and an intellectual curiosity that knew no rest.

While dean of Howard University's Law School, Greener often visited Douglass at Cedar Hill for Sunday afternoon salons with his fellow "college fledglings," including Kelly Miller, dean of the College of Arts and Sciences, and James Monroe Gregory, Howard University Latin professor. Included as well were young women from Miner Teachers College who, from the 1870s through World War II, taught almost every black elementary school student in Washington's public school system. By the 1880s, Howard University had survived a rough-and-tumble beginning to emerge as the premier higher education institution for black Americans and black Washingtonians; it produced educators, physicians, lawyers, ministers and professional tradesmen.

Howard University in *Harper's Weekly*, March 20, 1869. *Library of Congress.*

However, in its earliest years, the simple construction of buildings was an issue that drew untoward attention from the local and national press and investigations from Congress. In November 1868, construction began on a $50,000 hospital intended to accommodate up to one thousand people. Instead of using traditional brick, a composite block made of "sand taken from the ground, mixed with lime" and manufactured in New York City was used. Soon thereafter, the hospital collapsed; an inquiry was made that received the attention of the secretary of war, architect of the Capitol and other prominent figures in official Washington.

According to *Harper's Weekly*, General Howard and other investors controlled the local patent for this new type of construction material. "The result has been a failure," declared the *Journal of Civilization*. "The material does not answer its purpose. Portions of the buildings constructed have crumbled and none of them are considered safe." "Since the accident it has transpired," wrote the *Baltimore Sun*, "that the negroes have long been aware of the wretchedness of the material and some of them say they have amused themselves by breaking the composition bricks by butting them with their heads."

Decades later, opening his Cedar Hill home to host young men and women from Howard University, Douglass marveled at the many disparate talents and ambitions of his young visitors. He would reflect on his own intellectual

origins (perhaps remembering the bad brick episode): "I never knocked my head against college walls like you youngsters. We had few books, and dared not read."

The Early Years, Trials and Progress of Howard University

"Relief from what?" Secretary of War Edwin M. Stanton asked Union general Oliver Otis Howard, Commissioner of the Bureau of Refugees, Freedmen and Abandoned Lands, known as the Freedmen's Bureau, after Howard claimed "education of the freedmen's children, and of adults, as far as practicable, was the true relief." Howard replied, "Relief from beggary and dependence." The general, who helped lead a wing of General Sherman's March to the Sea, held a similar view regarding the large number of "white refugees" of the South but "believed that they would naturally be incorporated in ordinary schools there without such prejudice to their interest as existed against the negro population."

Established in March 1865 by the Federal government, the Freedmen's Bureau sought to aid the transition of former enslaved persons into the fulfillment of their rights as new citizens. The agency was unable to facilitate widespread land distribution to freedmen in the defeated Southern states, but the bureau's effective organization with the American Missionary Association and other benevolent efforts to erect schoolhouses and to charter institutions of higher learning throughout the country have stood the test of time—Hampton University in Virginia to Fisk University in Tennessee to Lincoln University in Missouri to Shaw University in North Carolina to Howard University in Washington, D.C.

A 1918 article in the *Journal of Negro History* offers some necessary background to understanding the importance of Howard University to black Washington: "The abolition of slavery in the District of Columbia and later throughout the South resulted in a large influx of freedmen into the National Capital until they formed one third of its population, thus constituting the largest urban group of negroes in the world." This new reality created new demands on the metropolis. Freedmen's aid organizations, including those started by Washington's black churches and philanthropic citizens, quickly established both day and night schools. In the early 1870s, Charles Douglass

(Frederick's youngest son) was a night school instructor in Barry Farm, a community east of the river developed by the Freedmen's Bureau.

Washington became a "promised land," according to Howard University historian Walter Dyson. Freedmen from all over the country swelled the city. "In the first place, it was the capital of the nation—that is, of the North that had set them free," observes Dyson. "There, too, slavery had been abolished since 1862," by the District of Columbia Emancipated Compensation Act, the only such occurrence in American legislative history, "and there by 1863 schools for blacks had been opened." As General Howard argued, "You cannot keep up the lower grades unless you have the higher." This is the genesis for Howard University, officially charted by Congress on March 2, 1867, and similar universities established to serve the newly emancipated Americans.

In June 1871, at the seventy-eighth meeting of the Howard University Board of Trustees, a ballot was advanced to add four new members; Frederick Douglass was among them. Two weeks later, at the seventy-ninth meeting, a letter was read: "A communication was received from Hon. Frederick Douglass accepting the appointment of Trustee with conditions." Just days before, Douglass had submitted his letter of resignation to the city's legislative council, newly formed by the District of Columbia Organic Act. This reduced Douglass's busy schedule sufficiently that he accepted the Howard invitation. On the secretary's motion, it was decided that the Howard Board desired that "he should remain a Trustee although he may not be able to attend all the meetings." True to his word, Douglass would miss every meeting over the next ten months.

But when he attended his first meeting, it was not to relax and bask in the scenery. At the ninety-fourth meeting of the board in April 1872, Douglass's personality filled the room as he presented a protest letter from the dismissed first matron and principal of the Normal Department "asking permission to appear and make a statement to the Board." The board of trustees had recently reorganized the Normal and Preparatory Department, dividing the two, creating separate curriculums with separate instructors and administrative oversight. On the strength of Douglass's request, the board invited Mrs. Mary T. Corner, a veteran educator reared in Ohio, to the president's house the following Saturday to present her statement in person.

Two weeks later, the board met, with Douglass in attendance, and issued a resolution stating "that the recent changes made in the University were intended in no way as a reflection upon Mrs. Mary T. Corner but

were carried out in order to relieve her of a portion of her too arduous duties." As the city's third institution of higher learning, after Georgetown and Columbian College (later George Washington University), the board knew while in its infancy that the retention of committed professionals and instructors was paramount to the success of the university and its graduates. The resolution continued, "[T]his board takes pleasure in recognizing her great ability and worth as a teacher and peculiar fitness for the position she fills in the university."

However, according to Rayford Logan's history of Howard University, Corner was replaced, her efforts and Douglass's notwithstanding. The noted suffragist promptly retired. With the matter seemingly settled, Douglass did not attend the board's next meeting, the ninety-sixth meeting, on June 3, 1872, when, along with Senator Samuel C. Pomeroy of Kansas, one of the first board members, it was voted unanimously to confer on Douglass an honorary doctorate of law. By mid-summer, "Frederick Douglass, Esq." (a title previously used on occasion when addressing Douglass) began appearing regularly under the editor's name in the pages of the *New National Era*.

On Sunday morning, June 22, 1873, the inner workings of the board of trustees and their decision to compensate General Howard, elected president of the university in April 1869, became ripe for public speculation. George Alfred Townsend's the *Capital* published a scathing column under the headline "The Profit of Godliness—A Pious Brigadier." Supplied with insider information from one of the university's board members, the article claimed, "merely nominal salary was allowed to [Gen. Howard] when he was elected president of the university, but that after a few months he managed to have a special compensation voted him for some pretended special service." Asserting that members of the First Congregational Church, of which Howard was a founding member in Washington, had unduly influenced the board and decided to advance compensation to General Howard, knowing it would be returned to the church, the article was not well received by members of the board.

As the historian Logan states and the board's minutes indicate, Frederick Douglass took the lead addressing the published charges against the financial management of the university; Douglass was appointed chairman of the special committee to issue an official response. In the last days of 1872, the board approved back payment of $13,083 to General Howard. Along with other financial shortfalls, this caused salaried officers and professors to "retrench," taking drastic pay cuts. The report of the

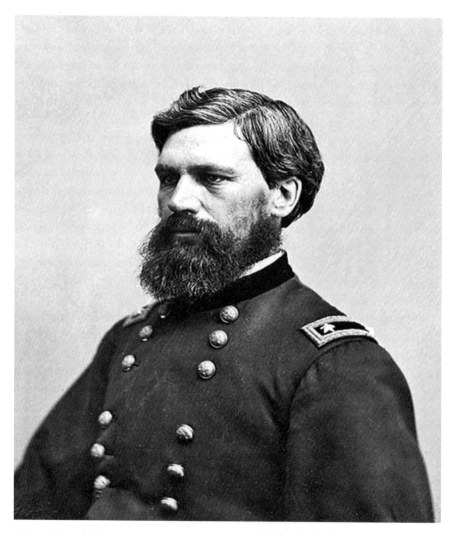

General Oliver Otis Howard, president of Howard University, 1869–1873. *Library of Congress.*

special committee labeled the "anonymous communication" printed in the *Capital* as "anonymous because cowardly, and cowardly because lying." Explaining Howard's "double pay," the report said, "we believe that a general of the United States army, when not upon active duty, is at liberty to employ his time and talents in any way he may elect as freely as any private citizen." For all these labors, compensation should be provided, the report declared. General Howard's close affiliation and promotion of "a school where all may be educated" had unleashed the "sleepless malice of an old and relentless persecution."

In summary, the report signed by Frederick Douglass and George E. Baker defended General Howard with the assertion that he had "virtually contributed more than he has received." All figures of the report were certified on Independence Day 1873, the same day that only Douglass and General Howard showed up for a scheduled board meeting. By the winter, the soldier-educator General Howard, who had helped purchase Howard University's land, establish the early departments and construct the first campus buildings, wanted out. General Howard wrote to General Sherman to request army duty. He was accommodated.

From letters, receipts, deeds and newspaper articles, it is clear Frederick Douglass was often entangled in money matters. His accumulation of wealth was prodigious for his time. He was an industrialist of the mind, paid from his mastery of both the written and spoken word. His earning became a matter of public commentary—newspapers reported Douglass was worth $200,000, nearly $4.5 million today. He replied he was hopeful that he was.

By Douglass's own accounts, he put more than $100,000 (much coming by way of lifelong friend Gerrit Smith) toward the support of the three newspapers he ran for over fifteen years while living in Rochester, New York, his home for nearly twenty-seven years. While in Washington, to keep the presses of the *New National Era* running, by his estimates Douglass advanced at least $10,000 over the paper's nearly five-year run. During his short four-month tenure as president of the doomed Freedman's Savings & Trust Bank, Douglass loaned the bank $10,000 of his own money to help buoy the bank's depositors, after at one time having $12,000 in deposits, "for the more millions accumulated there, I thought, the more consideration and respect would be shown to the colored people of the whole country." Considering the financial hit that Douglass took in 1874 alone, he still found a way to tithe $1,000 to an institution in which he believed and to which he was faithful: Howard University.

In February 1878, Colonel Thomas Wentworth Higginson, once a militant abolitionist; U.S. marshal Frederick Douglass; President Hayes; and First Lady Lucy Webb Hayes joined students at Howard University for the "ostensible occasion" of the "presentation to the college of a fine large engraving" of Francis Bicknell Carpenter's famous painting, *First Reading of the Emancipation Proclamation of President Lincoln.*

"Among the faults of my people is their self-indulgence, love of ease, and improvidence," Douglass said, urging future generations to learn to spend their earnings judiciously. "If one can't get up, he will be helped down," Douglass admonished. But he added the encouragement, "You have a fair chance to get up. The colored men have been forced up by abnormal conditions, but they are coming up gradually by their own exertions."

New York Times scribe Sara Jane Lippincott, writing under her nom de plume, Grace Greenwood, praised Hayes's attendance:

> *About the bravest thing which our President has done since appointing Mr. Douglass Marshal of the District, and standing by his man, and one of the best things he has ever done, was to make this visit to the "Black University," just at the time when it was being assailed.*

Echoing Douglass's remarks of self-determination, President Hayes said, "The greatness of the blessing [of emancipation] conferred on the colored race depend on their conduct." The Ohioan and Civil War veteran urged adherence to classic nineteenth-century virtue, "What this requires is the willingness to labor, and the prudence and self-denial to save the fruits of labor." Looking out over the gathering, Hayes said, "My young colored friends, let this, then, be among your good resolutions: 'I will work and I will save, to the end I may become independent.'"

Throughout period newspaper accounts, editorial commentary on Howard University's early years repeated the necessity to develop an endowment that could provide the salaries of its growing faculty. In 1879, during the administration of President Rutherford B. Hayes, Howard received its first congressional allocation, which continues to this day—a unique federal relationship. According to Dr. Muse, Howard University's archivist, during this period federal monies to Howard were donations that could be challenged by any House member (which usually occurred via southern congressmen). In 1928, congressional legislation was adopted providing for "appropriations" to Howard that could not be legally challenged.

Howard University and Frederick Douglass, Esquire

Carrying the ambitious spirit and momentum of the hour, Reverend Charles A. Harvey, Howard University's new financial and educational secretary, traveled to New York City in October 1879 with the anticipation of reaching new philanthropists. When Harvey found "the work slow" and had limited success raising funds, he called on Douglass for a letter of introduction. "There are persons here from whom aid could no doubt be obtained if the facts respecting the institution could be set fully before them," Harvey wrote. "But in order to get proper access to them the right sort of introduction seems to be indispensable."

Prominent men such as *Harper's Weekly* writer George William Curtis; *New York Herald Tribune* editor and later the twenty-eighth ambassador to France and the thirty-fifth ambassador to the Court of Saint James Whitelaw Reid; and abolitionist, social reformer and author Oliver Johnson might not be able to contribute directly, Harvey cautioned. But "strong letters to them would get me into circles where something satisfactory may be accomplished." After requesting that Douglass send letters at his earliest convenience, Harvey, caught in the moment, closed with a postscript: "I want to see Howard U. made the most valuable in the work it shall do of any institution in this land. It ought to be!"

In late February 1886, a banquet was held to honor the first generation of graduates of the colleges of Howard University—law, medical, theological and normal—and introduce the newly constituted Union Alumni Association of Howard University. Professor James Monroe Gregory served as the first president. The setting for the evening was Welcker's, a famous Victorian-era Washington restaurant and hotel, founded by the German immigrant John Welcker, on Fifteenth Street Northwest, just above New York Avenue. According to local historian John DeFerrari, Welcker's large banquet room regularly hosted alumni clubs. The previous year, 1885, it was the site of the founding of the Gridiron Club, recognized as the oldest journalistic organization in the country.

After a series of toasts were offered, Frederick Douglass rose in response to the toast to "self-made men." With a sarcastic wit, Douglass answered, "If you mean to insinuate that I am not a gentlemen and a scholar, like others around this delightful board, I resent the calumny." Douglass looked down at his table, eyeing and calling attention to "the card with 'LL.D.' in large letters, affixed with [his] name." Looking over the crowd of distinguished men and women, leading citizens of Washington from all walks of life and industries, Douglass said, "But, Mr. President I will not, where I am so well-known, attempt to pass myself off for what I am not."

Alluding to the cerebral vapors thick in the air, Douglass downplayed his own role in becoming one of America's foremost black intellectuals. "Properly speaking, there are no self-made men in the world," Douglass said. "They have all begged, borrowed, or stolen," often rising quickly "without favoring circumstances but in derisive defiance of all efforts to keep them down." Ever an egalitarian, a firm believer in the American creed, Douglass noted, "[W]hether we find them at home or abroad, whether professors or plowmen, whether of Anglo-Saxon or Anglo-African origin, are self-made men, and are entitled to some respect because of their manly origin."

Forever a loyal soldier, never discharged from the old abolitionists' army, Douglass, nearing his seventieth year, was a living testament to the power of learning and education, albeit by one's own direction, and how far one could ascend in America, despite its failures to fully accept and recognize all of its sons and daughters. Decades before, Douglass had fervently denounced colonization societies throughout the country that advocated the expatriation of black Americans to the shores of West Africa. For this newer generation, those born on the brink and realization of a Union victory, Douglass represented a love of country that had sustained him in the hard and long years leading to America's apocalypse: "It is the glory of the United States that such [self-made] men are abundant. America is the nursery of such men," the perspicacious Douglass said to the youth in attendance. "The explanation of the abundances is found in two facts: First, the respectability of labor, and secondly, the fact we have no privileged classes. We throw every man upon his own resources. We care not who was his father, or who was his mother." Douglass closed with his own hymn to self-made men:

We ask not for his lineage,
We ask not for his name;
If *manliness be in his heart,*
He noble birth may claim.

We ask not from what land he came,
Nor where his youth was nursed;
If pure the stream, it matters not
The spot from whence it burst.

In capping the night, University president William W. Patton spoke on the accomplishments of the university on the brink of the twentieth year since its charter by Congress. It had survived the "danger of infancy, the

Old Main Building. *Author's collection.*

opposition of foes, the indifference of the prejudiced, and the reverses of financial disasters." Three thousand students, whites and blacks, men and women, freedmen and their children, had been admitted to the university; 250 Christian ministers from Howard went out into the world alongside an equal number of lawyers and more than 400 physicians. These graduates were becoming the bedrocks in their respective communities all over the country from coast to coast. President Patton reminded his listeners that, of Howard's current student body of 420 students, thirty states were represented, and of course the federal District of Columbia, in a Union now comprising thirty-eight states.

As the fall semester in 1882 approached, the *Washington Post* pointed out that through the "very liberal appropriation of Congress," Howard University had placed "its buildings in excellent repair. To the main building the ladies' dormitory and the gentlemen's hall many additions and improvements have been made." Before the close of 1884, the university's property devoted to education purposes was approved for its tax exemption. However, the district commissioners made it clear that "so far as it holds property for speculative purposes in the future it should be assessed on the same terms as that held by private parties."

Douglass and the Presidency of Howard University

It is not known which member of the Howard University Board of Trustees cast the lone vote at the June 16, 1875 meeting for Frederick Douglass to assume the presidency of the university. Reverend George Whipple, the longtime secretary of the American Missionary Association, was selected, to the discomfort of Douglass, who was not quiet in voicing his opposition to what he felt was a misstep by the university. Writing to the *New York Evening Post*, in response to its inquiry, Douglass said he and the three other "colored members of the board" felt that the position "should be given to a colored man." Although "there was no declaration of purpose to change the character of Howard University, to make it any measure a mere tender to either the American Missionary Association or to the Congregationalists, I will not deny that the colored members of the board that thought they saw in the election of Mr. Whipple, and in the influences by which he was elected, a tendency in these directions." Douglass stated that Howard University "was designed to afford the means of a classical education to the colored youth of the country, and of course was not intended by any means to be either sectarian in character or in management." He closed his letter, "My course in respect to Howard University hereafter, it is needless to declare." Douglass maintained his commitment to Howard University. In the fall of 1877, Reverend William Weston Patton assumed the presidency, serving until 1889, the year he died.

During Patton's dozen years as president, Howard University matured, firmly established as not only a national destination for young black Americans, male and female, seeking to become surveyors, doctors, scientists, educators and lawyers but also a local destination, uniquely capturing the entrepreneurial spirit of the District's leading black citizens. Patton was not free from detractors, including the black press. In June 1883, the *People's Advocate* stated its opposition, in no unclear terms, going so far as to demand that Patton "tender his resignation to the Trustees, and request them to elect Frederick Douglass as his successor."

There were three reasons that Douglass, still mourning the death of Anna Douglass, would be an ideal president. First, "Mr. Douglass could secure a million dollars for the endowment of the University by presenting

Frederick Douglass, a self-educated man, reading. *National Park Service, Frederick Douglass NHS.*

the necessity for the education of the Negro to the country with the same matchless eloquence that he successfully advocated their emancipation." Second, "Douglass would be a magnet that would draw colored young men from every part of the country." Surely, President Douglass would be "surrounded by an able and efficient corps of colored Professors in every department," which "would do more to demonstrate the capacity of colored men than anything we can think of." Lastly, the *People's Advocate* said, "We think Mr. Douglass is out of place in an executive office," alluding to his past role as marshal and current position as recorder of deeds. The column closed:

> *Mr. Douglass is in full vigor of his powers, as shown in the recent masterly and phlisophical* [sic] *productions he delivered at the emancipation celebration. He is good for ten years of intellectual work yet. What an apprepriate* [sic] *close it would be to one of the most remarkable lives ever lived, if he would spend the evening of his day in dispensing the riches of his genius and knowledge on the children of those who emancipation he aided so greatly in securing.*

Patton could keep the job; Douglass did not want it, nor did he consider himself a candidate. He was, in fact, embarrassed at the suggestion. In a letter to the paper dated July 6, 1883, Douglass said, "[A] feeling crept over me while reading" the "well-meant commendations" that "without any such intention on your part, you were simply making me appear ridiculous in the eyes of the public." Douglass contended that just because "a man can do some things well, it does not follow that he can do every thing well." The equivalent of the salary of the president of the United States could not change his mind. "I have no taste for being a pigmy among giants, or an egg-shell among cannon balls. The President of an university should be 'up' in all the knowledges—should, in fact, be a small college in himself." Douglass said, last of all, "you know, I know, and a considerable number of other men know that I have never had a day's schooling in my life and am no more to fit to be President of that school than a man without any knowledge of navigation is to fit to be a captain of a 'man of war.'"

Mechanical Arts

By the end of his life, Frederick Douglass had schools, meeting halls, military outfits, debating societies, Republican clubs and youth groups organized in his name throughout the country. In 1902, Mifflin Wistar Gibbs, a black American abolitionist and statesman, wrote that it was fitting that a "Frederick Douglass Hospital and Freedman's School" open in Philadelphia because "the assuaging of suffering and the giving of larger opportunity for technical instruction were cherished ideals with the sage of Anacostia." Nearing his seventy-fifth year, Fredrick Douglass went down South to deliver the commencement address at the Tuskegee Normal School. Word of his pending arrival spread throughout the black communities of Alabama, which had long desired to see and hear from the distinguished representative of their race "but had little hope their desire would ever be realized." On his way to campus, Douglass saw "acres of mules and miles of people." More than eight thousand came to hear him speak.

Of the more than 750 students who attended the Tuskegee Normal School during the academic year, ceremonies held on June 1, 1892, recognized fifteen graduates. Students partially financed their educations through manual labor, which helped construct a "complete system of waterworks" and improve existing buildings. More than five hundred acres were under cultivation with guidance from the agricultural department, and the brickyard had recently been enlarged and improved. The *New York Evangelist*, reporting on Douglass's speech, noted, "Many of the students remain during the summer, and will attend night school while working, during the day, on Cassidy Hall, to be used for industries, or Phelps Hall, for the Bible training school."

Douglass "felt that John's apocalyptic vision was realized, and that he looked upon a new heaven and a new earth," reported a letter to the editor of the *Christian Union*. "He said that he saw on his visit the first bright side to the great Southern problem." Less than a year later, the *Cleveland Gazette*, usually biting in their criticisms of Douglass, offer praised for his new role as president of the Freedom Manufacturing Company. Citing "thousands of unemployed, intelligent and competent youth" in need of a "grand industrial enterprise," the paper offered its "heartiest wishes for success." Planned to be a textile-manufacturing plant near Norfolk, Virginia, with ambitions to train and employ nearly three hundred black Americans, the effort failed. Similar to his experiences two decades earlier as president of

Students on the steps outside Frederick Douglass Memorial Hall, Howard University, 1942. *Library of Congress.*

the Freedmen's Bank, Douglass was victimized again by those attempting to use his name and prestige for their own benefit.

"Some months before his death, Frederick Douglass was before the Committee on Appropriations of the House asking that provision be made for workshops in Howard University, so that the young men may be read the mechanical arts," said Texas congressman Joseph D. Sayers on the House floor in April 1896. Sayers had previously mentioned that in his district "we have colored ministers, and teachers, colored lawyers and physicians; and in the various trades and handicrafts the colored race has its representatives." During Douglass's testimony, Sayers recounted, the long-ago ship caulker spoke about his travels through "Georgia and other Southern States, where he had seen colored carpenters, blacksmiths, and mechanics of every kind doing well whenever they were industrious and economical." Committee members asked Douglass if similar occasion for a trade education existed in the North. "The venerable man bowed his head and replied, in despondent tones, that colored men had but little opportunity to engage in such pursuits in the North," Sayers said. Speaking from his own experiences struggling to find work on the docks of New Bedford fifty years ago and Lewis's struggle to join—and subsequent rejection at the hands of—the Columbia

Typographical Union, Douglass said, "[T]he rules and regulations established and enforced among the trade unions [keep] the colored man in the background."

Today, Douglass Hall on Howard University's campus is a lasting physical legacy of Douglass's contribution, but his impact on education manifested itself in the one-room schoolhouses, Sunday school classes and exhibitions he visited. No stranger to Howard University activities from graduation proceedings and recitals of the medical school and law department to joining the sophomores and freshmen in delivering an address as part of the public oration and rhetorical exercises, Douglass was a known presence in and around campus, ready to provide a letter of introduction or encouraging word of support to nearly all students associated with the university. Many of the early Howard graduates and educators of the first civil rights generation were helped along by Douglass. In newspapers throughout the country in the years following the Civil War, announcements and calls would appear, asking aid for the formation of a colored school by a recent graduate of Howard University. One of those individuals was Rhoden Mitchell in New York City in 1883, looking for help starting a school in Windsor, North Carolina, the county seat of Bertie County. He had letters from Senator John Logan, journalist George William Curtis, secretary of the Home Mission Society Henry L. Morehouse (for whom Morehouse College in Atlanta, Georgia, is named) and Frederick Douglass, who "amply vouched for" his honesty. The short item, which ran in the *New York Times*, noted, "The school facilities of that county are so poor that the colored people there resolved upon doing something for themselves."

From lending his support for the construction of schoolhouses in the rural South, to his advocacy of the Howard University Board of Trustees in 1873 hiring a permanent Latin instructor, to his later advocacy of technical and trade instruction, Douglass adroitly adapted to the demands and necessities of the times. The impact of Frederick Douglass's advocacy and service to Howard University and the education of the freedmen and his descendants in the decades following the war have been, and largely remain, hidden.

Frederick Douglass's Wives

ANNA MURRAY DOUGLASS AND HELEN PITTS DOUGLASS

There were rumors afloat in the community that he was interested in one of two prominent women of the race, and that one or the other, if he ever got married, would be his choice. I was curious to know which of them. But to my surprise, neither of them was mentioned. He said, "Did you see the lady that was sitting by me when you came into the room?" I said, "Yes. She is the one."
—*Reverend Francis J. Grimke*

Mother had a paralytic stroke yesterday," read the two-sentence postcard Amy Kirby Post, a close family friend, received in her Rochester home on July 8, 1882. "She is dangerously ill," Frederick Douglass Jr. confided. The matriarch of the Douglass family, Anna Douglass, was dying. "Although perfectly helpless, she insisted from her sick bed to direct her home affairs," Rosetta Douglass Sprague, the eldest daughter of Frederick and Anna Douglass, remembered years later. "The orders were given with precision and they were obeyed with alacrity. Her fortitude and patience up to within ten days of her death were very great. She helped us to bear her burden."

It had been nearly a half century since Anna Murray first met a young and enslaved Fred Bailey in Baltimore, Maryland. "The story of Frederick Douglass' hopes and aspirations and longing desire to freedom has been told—you all know it," Rosetta declared to a meeting of the Women's Temperance Christian Union gathered in Washington, D.C., in May 1900. "It was a story made possible by the unswerving loyalty of Anna Murray."

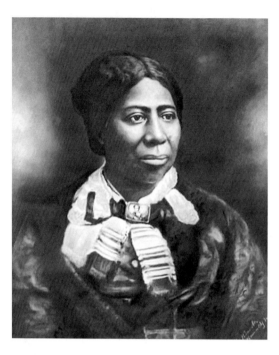

Anna Murray Douglass. *National Park Service, Frederick Douglass NHS.*

The eighth child, Anna, of Bambarra and Mary Murray, recently freed, was their first born free. The exact date of her birth in 1813 in the town of Denton in Caroline County, Maryland, is unknown. As a teenager, Anna moved to Baltimore, where she began working for a French family, earning the "reputation of a thorough and competent housekeeper." After two years, she left to work for the Wells family on South Caroline Street. By now the audacious Frederick Bailey had been welcomed into the circle of free people of Baltimore, which included Anna, "a circle a little more exclusive than others." Through this freed community, Anna and Frederick began their lifelong bond.

It was Anna who financed Frederick's escape from bondage. Camouflaged in a sailor suit, Bailey took flight to New York City in the fall of 1838. Upon arriving in New York, Frederick sent for Anna, who arrived soon thereafter. On September 13, 1838, Frederick "Johnson" and Anna Murray were married by Reverend James W.C. Pennington, at the time a runaway slave from Maryland who had audited divinity classes at Yale University.

As New York City was known to be crawling with constables in search of fugitive slaves, the newlyweds quickly relocated to New Bedford,

Massachusetts. Here the Johnsons became the Douglasses, and three of their five children were born: Rosetta in 1839, Lewis Henry in 1840 and Frederick Jr. in 1842. "The early days in New Bedford were spent in daily toil, the wife at the wash board, the husband with saw, buck, and axe," recalled Rosetta. After the success of Frederick's first autobiography, the Douglass family moved to Lynn, Massachusetts, where "father built himself a nice cottage" before making his first sojourn to Europe. By revealing "the names of the parties with whom he had been associated in slave life," Douglass had "so incensed the slaveholders that it was doubtful if he would ever return" to the United States. Danger would follow Anna, and anyone who had aided in Douglass's flight with the same fervor as Frederick was pursued. "It was with hesitancy that father consented to leave the country, and not until he was assured by the many friends that mother and the children would be carefully guarded, would he go."

"He was absent during the years '45 and '46. It was then that mother with four children [Charles Remond had been born in the fall of 1844], the eldest in her sixth year, struggled to maintain with family amid much that would dampen the courage of many a young woman today," their eldest child recalled. Combining the money Anna earned binding shoes and the earnings Douglass made lecturing overseas, the young family got by. Upon his return as a free man to the United States due to the Richardson family, who negotiated and purchased his freedom for $750 (roughly $20,000 today) from Captain Auld, Frederick once again uprooted his family, this time to Rochester, New York, where Douglass began publishing the *North Star*. At Anna's suggestion, Lewis, eleven, and Frederick Jr., nine, began their printing apprenticeship in their father's office as an alternative to running the streets as their father once had. In 1849, their fifth child and second daughter, Annie, was born. She would die in 1860, just days before her eleventh birthday.

To support his family, Douglass took to the lecture circuit and was away from home for months on end. "Father was mother's honored guest," Rosetta reminisced. "He was from home so often that his home comings were events that she thought worthy of extra notice and caused renewed activity" in the household. Anna was "firm in her opposition to alcoholic drinks" and was a more rigid disciplinarian than her husband. "Perhaps no other home received under its roof a more varied class of people than did our home. From the highest dignitaries to the lowliest person, bond or free, white or black, were welcomed, and mother was equally gracious to all," Rosetta shared in retrospect. "In the early 70s she came to Washington and

found a large number of people from whom the shackles had recently fallen. She fully realized their condition and considered the gaieties that were then indulged in as frivolous in the extreme."

Through "adversity and prosperity, she was the same faithful ally, guarding as best she could every interest connected with my father, his lifework and home." However, only able to "read a little," an entire world, one of the main worlds her husband ran in, was shuttered to Anna. She compensated by being a "good listener, making comments on passing events, which were well worth consideration, altho' the manner of the presentation of them might provoke a smile." In an 1848 letter to Douglass's old master, Frederick revealed, "I married soon after leaving you; in fact, I was engaged to be married before I left you; and instead of finding my companion a burden she is truly a helpmate."

"The first dawn of hope since her prostration by paralysis came last night," Frederick Douglass wrote to Amy Post in mid-July 1882. "She is not out of danger and is very feeble but her mind is clearer and her speech and appearance is better." In the early morning hours of August 4, 1882, Anna Douglas died. She was sixty-nine years old; the official cause of death was "Paralysis-Hemiplegia." In the midst of a blazing Washington summer, an undertaker in Anacostia was called and secured the body as burial and funeral arrangements were soon made.

According to the Washington correspondent of the *Baltimore Sun*, writing on August 7, 1882:

> *The funeral of Mrs. Frederick Douglass yesterday was attended by a large concourse of both white and colored, on foot and in carriages. The funeral procession, a long one, carried the remains to Grace Cemetery, where she was laid to rest by Hon. B.K. Bruce, John F. Cook, Jas. Wormley, Dr. Green, B.D. Woods, and Robert Parker, the pall-bearers.*

In the *Records of the Columbia Historical Society*, Steven J. Richardson writes, "The only predominately *black* cemetery that interred a significant number of whites was Graceland Cemetery, established in 1872. Located just south of Mount Olivet on Bladensburg Road, just beyond the Florida Street boundary, N.E., Graceland was a popular biracial cemetery during its brief existence." Between 1880 and 1894, Graceland buried 4,722 black Washingtonians and 1,073 white Washingtonians. According to newspaper accounts, Anna Douglass was later reinterred at Glenwood Cemetery, also in Northeast Washington. At the time of their father's death in February 1895, Lewis and

Charles sought to move their mother's remains to Rochester's Mount Hope Cemetery, to rest alongside their father. According to forthcoming research by Dr. Leigh Fought, Anna was eventually buried beside her husband in Rochester, in 1898.

Anna Douglass's years of sacrifice and abiding commitment to family had sustained her husband at his highest and lowest. Their journey now over, Frederick was crestfallen. His life partner gone, Douglass turned inward and to trusted friends for comfort. Letters of condolences arrived at Cedar Hill from all over the country and from across the Atlantic Ocean.

"I have never ceased to feel since I met you in New Brighton nearly forty years ago that you had a friendly eye upon me and an interest in my welfare," Douglass wrote in October to his dear friend and journalist Sara Jane Lippincott, who had expressed her sympathies in a letter from Paris. Clearly despondent, Douglass admitted, "About myself I do not feel like saying much. When death comes into ones [sic] home—a home of four and forty years, it brings with it a lesson of thoughts, silence, humility, and resignation." Although his first thoughts following Anna's passing were to "break up my home and possibly go to Europe," upon reflection he "felt it too late in life" to "become a wanderer."

Too many people depended on the former runaway slave for him to run away again, albeit this time under quite different circumstances. "At present I have no plans for the future, except that I propose to keep my home in Washington or rather in Uniontown," Douglass said. He was responsible for a full house. "I have living with me, my daughters [sic] husband's sister, a young woman who has lived in my family during the last ten years, a good and upright person. I have also taken Annie and Hattie my two grand daughters, one 18 and the other 16 years old."

Taking stock, Douglass confessed to his old friend, "I could be of service to a considerable [number] of grand children and other persons by staying here." In his new position as recorder of deeds of the District of Columbia, Douglass could "employ my daughter who has six children to support." Rosetta Douglass Sprague, "Rose" to her father, was no longer a child, now with a husband who "fails to support her and her children" and who was kept a "respectable distance from the door" by the vigilant and protective father. Family kept Douglass in Uniontown, but though "now settled here for the present I do not give up my long intended purpose to visit Europe." Maybe Douglass would one day make it to Paris, where he could be "outside of the whirlpool of American politics." However, on second thought, "There is not much outside of

raising and caring for ones [*sic*] children worth living for." Although he could no longer live for his wife, Douglass could live for the family they had raised.

However, after doing what he could to keep a happy home, Douglass, in his mid-sixties, had to get out of the city—far out of the city to free his mind—as the summer of 1883 approached. Exchanging letters daily with his children and grandchildren from the distance and comfort of Poland Springs, Maine, Douglass could reflect on his life and follow a physician's diagnosis: get some rest. "We are all rejoiced to know that you are improving in health," Rosetta wrote to her father from Cedar Hill in July 1883, conveying the well wishes of his immediate and extended family. Douglass could take comfort that "we"—meaning her, Lewis and Frederick Jr. —were "well at the office" of the recorder of deeds. A new clerk, Mrs. Shelby, had been hired but was "still on her first bundle." Rosetta admitted that "I do not think her fitted for the work though I suppose she needs it," possibly as much or more than Rosetta did. Writing days later, she told her father and reported to her boss, "The work at the office has slackened." However, Mrs. Shelby was quickly falling out of favor: "She treated Miss Pitts very rudely but has since apologized to her. I think she is incompetent for the place."

Problems at the office aside, events of the day would cut short Douglass's bereavement. After attending a convention (against the urging of his daughter) for colored men in Louisville, Kentucky, in September, Douglass was back in Washington by the October 15 ruling of the Supreme Court on the civil rights cases. In an eight-to-one decision, the dissenting vote being Justice John Marshal Harlan, the Supreme Court ruled that the Civil Rights Act of 1875, championed by radical Republican senator Charles Sumner on his deathbed, which forbade discrimination in public accommodations, violated the due process clause of the Fourteenth Amendment as it applied to the rights of private property owners. More than a decade before the Plessy decision upheld the "separate but equal" doctrine, the 1883 ruling signaled the legal endorsement from the highest court in the land of Jim Crow laws increasingly taking effect in the former states of the Confederacy. The decision effectively dismantled what Douglass, and other black integrationists, had worked for since the end of the war.

The decision "came upon the country like a clap of thunder from a clear sky." Within a matter of days, a rally in opposition to the court's ruling was held at Lincoln Hall at the corner of Ninth and D Streets

Northwest. "Color prejudice is not the only prejudice against which a Republic like ours should guard. The spirit of caste is dangerous everywhere. There is prejudice of the rich against the poor, the pride and prejudice of the idle dandy against the hard working man." Although dejected at the ruling, Douglass was a legalist. He recognized the rule of law and authority of the court, saying, "[G]overnment is better than anarchy, and patient reform is better than violent revolution." Sometime, Douglass prophesized, "far down the ages," America would accept and recognize the "power and friendship of seven million people scattered all over the country." It would take more than eighty years for Douglass's foresight to become a reality.

Returning to the Office of the Recorder of Deeds, it was now business as usual for Douglass. However, something was in the air; between two people, it was more than strictly business at the office. The copyist, Miss Pitts, whom Rosetta had defended, had been hired by Douglass in 1882 after clerking for the federal pension office, according to Julie R. Nelson's 1995 master's thesis, "Have We a Cause: The Life of Helen Pitts Douglass."

Helen Pitts, of Honeoye, New York, was no stranger to Douglass. Born on October 14, 1837, into a fierce abolitionist household led by her father, Gideon Pitts, Helen was just eight years old when she first met Frederick Douglass in 1846. Fresh from his return from Europe, where his freedom was purchased, the former slave was lecturing in Honeye and was invited to visit the home of one of the town's leading proponents of abolition, Gideon Pitts. While visiting the home, Douglass was introduced to Gideon's daughter. More than thirty years later, now grown and college educated, Helen Pitts was a neighbor to Douglass and his family. According to city directories, Hiram Pitts, Gideon's brother, lived in Uniontown as early as 1870. Helen stayed at her uncle's house while working for the *Alpha*, a radical feminist and reformist newspaper published by the Moral Education Society of Washington, led by Dr. Caroline Winslow and endorsed by the likes of Clara Barton. Records indicate that in 1877, Helen was the paper's corresponding secretary.

"By 1878, Helen was 40 and could speak to [Douglass] as an intelligent, well-read, educated adult in her own right about interests and agendas they shared in common; women's suffrage, black enfranchisement—even Shakespeare," writes Nelson. In fact, on February 1879, Douglass sent Helen, who was in Indiana on a teaching position, a postcard. In context, it appears Douglass is replying to a previous communication from Helen. "I am glad you are 'so perfectly happy' and doubt not you are getting the

1884–'5

The Monday Night Literary Club

will hold its closing meeting for the season,
at the residence of
Hon. Frederick Douglass,
Cedar Hill, Uniontown, D. C.
Saturday, June 6, at 7 P.M.
to which you are cordially invited.

PLEASE BRING THIS CARD WITH YOU.

An invitation of the Monday Night Literary Club, 1884–1885, to meet at Cedar Hill. *Library of Congress.*

'cherubs' ready to have beautiful wings 'stuck' on when the right time comes," Douglass wrote, also mentioning a recent reading of Shakespeare he had attended. "It has grown to such dimensions that no private house can hold them and meets around at different hotels."

In an unfinished, unsent letter dated December 21, 1877, and addressed simply to "My dear Friend," Douglass wrote, "I spoke to a very [illegible] and elegant audience at Mt. Pleasant Wednesday night, and read with the Uniontown Shakespeare Club last night." Douglass's part was Shylock in *The Merchant of Venice.* "This is my second meeting with the club. I find it very pleasant and entertaining and I have no one at home to go with me and I often fancy that I am losing one half of the happiness of such occasions because in all such matters I am all alone." As Nelson points out, in his 1879 postcard, Douglass shares "with Helen what he had been unable to share with Anna."

In fact, within a matter of weeks following Anna's death, after visiting Amy Kirby Post in Rochester, Douglass was in Honeoye to deliver a lecture

on John Brown. Newspaper records, as documented by Nelson, indicate that when Douglass was in Honeoye in the second week of September 1882, so was Helen. On the same day Douglass delivered his oration, "Miss Helen Pitts has returned to her home in Honeoye from Washington," reported the *Richmond* [New York] *Times Union.* "Mr. Hiram Pitts, one of our old townsmen, now residing in Washington, D.C., is visiting his brother, Mr. Gideon Pitts of Honeoye," read another item in the paper. "That [Douglass] visited with the Pitts family so soon after Anna's death suggested the close bond and intimate tie that Frederick felt towards his friends in Honeoye," Nelson argues. "They rallied together to support him in his time of need." In a little more than a year, Douglass would not be so welcomed in the Pittses' Honeoye household.

In January 1884, Francis J. Grimke, the thirty-one-year-old pastor of the influential Fifteenth Street Presbyterian Church, was passing through the neighborhood of the Office of the Recorder of Deeds and decided to "drop in and pay my respects." Writing in the *Journal of Negro History* nearly forty years after Douglass's death, Grimke recalled the day's events as though they had happened yesterday. "When I entered the room he was seated at his desk eating his lunch, and by his side was a lady seated in conversation with him," recalled Grimke. "In a few minutes she left the room. In seeing me, Mr. Douglass said, 'You are just the man that I want to see. I was just thinking about calling on you.'"

"Well, what's up?" Grimke said in language recognizable today. "I am thinking about getting married, and I want you to perform the ceremony," Douglass said. Grimke, of mixed ancestry, whose aunts were the Southern-born abolitionists Sarah and Angeline Grimke, responded, "I will be delighted to do so." First, Grimke inquired, "[W]ho is the fortunate lady?" Grimke, although yet a young man, was a leading black Washingtonian not only because of his family name but also because of the standing of the Fifteenth Street Presbyterian Church in the city's black community. As a man of the cloth, Grimke's job was to be familiar with people's business, not as a gadfly, but as a counselor and spiritual mentor to those who needed guidance. Grimke knew the pulse of the community and recalled it cogently. "There were rumors afloat in the community that he was interested in one of two prominent women of the race, and that one or the other, if he ever got married, would be his choice. I was curious to know which of them. But to my surprise, neither of them was mentioned." Grimke had already seen the next Mrs. Frederick Douglass, but he did not know it just yet. Douglass looked at Grimke and said, "Did you see the lady

that was sitting by me when you came into the room?" Grimke had. "She is the one."

When Douglass entered the clerk's office in city hall later that afternoon, all eyes were on him. According to the *National Republican*, "He glanced furtively around and after bowing to the clerks and habitués, drew the chief clerk aside and a whispered conversation followed." The clerk reached for the marriage license book. He made a quick entry and handed a certificate to Douglass, who in return paid the one-dollar fee. As soon as Douglass was out the door, "every one in the office" clamored to consult "the license book for an explanation." Within minutes, the news was on the street, although Douglass had, reportedly, asked "that it be kept from the recorder's office." A *Republican* reporter was the first to catch word and immediately sought comment from Rosetta Douglass Sprague. The eldest daughter of Anna and Frederick Douglass "was visibly affected when told" of her father's action. Meanwhile, Douglass returned home to Cedar Hill, remaining there until shortly after 5:00 p.m. Chasing the breaking story, the intrepid *Republican* reporter called on Helen Pitts at 913 East Street Northeast. "[A]fter submitting to persistent questioning for awhile, she admitted that she was to be married to Mr. Douglass. She refused to say when and where, or to answer any further questions." Noting her race, petite figure, eyes, hair and age, the reporter stated plainly, "She is quite pretty."

Douglass came back downtown, arriving at Helen Pitts's residence shortly after 6:00 p.m. "Arriving he entered the house and soon came out with his affianced leaning on his arm. They were then driven to the residence of the Rev. Francis Grimke, No. 1608 R street northwest." Although nearly every account of the ceremony places only three witnesses at the Grimke house— Mrs. Grimke, former Mississippi United States senator Blanche K. Bruce (at the time registry of the treasury) and his wife, Washington socialite Josephine Wilson Bruce, who had accompanied Douglass and Helen Pitts in their carriage—there were two additional parties present: Mrs. J. Sella Martin and her daughter Josie, who were living with the Grimkes. By nothing else other than speculative intuition, the *Republican* reported, "During the ceremony Miss Pitts retained a composure of mien that showed steady nerve, and her answers were clear and distinct."

Back into their carriage and off, all seemed quiet for the moment. Doggedly following the story's scent, a *Republican* reporter was waiting outside of the E Street home. Upon the newlyweds arriving and alighting from their carriage, the correspondent offered his hand in congratulations to the "distinguished

bridegroom," who "wore a benign and comfortable smile." After shaking the journalist's "hand with a hearty grip," Douglass "gave the reporter all the information he could in good spirit." After humoring him, Douglas "hinted that his questioner was rather" impudent.

Later that night, "after we had all retired, there came a violent ring at the door bell" of Grimke's home, as "reporters were in search of the particulars." Grimke was close-lipped, saying only, "Yes, it is true that Mr. Douglass and Miss Pitts were married by me here this evening." In a matter of days, Grimke received a "letter from a white southerner denouncing me for having performed the ceremony." Spitting fire, the letter writer mistakenly thought Grimke was white, saying, "Any white minister who would marry a Negro to a white woman ought to be tarred and feathered." Fortunately, no such form of feudal vigilantism was delivered on Grimke, who "lived to spend many pleasant days with Mr. and Mrs. Douglass in their beautiful home at Cedar Hill, Anacostia."

On January 25, Douglass welcomed a *Post* reporter, who had sent his card in advance, into the parlor of Douglass's Uniontown home. "I don't see why there should by any comment," Douglass said, noting he would make no apology. "It is certainly not an event of public comment. I have simply exercised the right which the laws accord to every citizen, and I am astonished that a city so large as I considered Washington to be should become at once so small." When asked if his interracial marriage compromised his position as a leader of his race, Douglass thought not. "I do not presume to be a leader, but if I have advocated the cause of the colored people it is not because I am a negro, but because I am a man. The same impulse which would move me to jump into the water to save a white child from drowning, causes me to espouse the cause of the downtrodden and oppressed wherever I find them."

Canvassing the city, a *Post* reporter caught up with Helen's former editor at the *Alpha*, Dr. Caroline Winslow. "If Miss Pitts had asked my advice I should certainly have counseled against the marriage. But now that it is done I do not propose to allow it make any change in my relation with Miss Pitts." Knowing that both families "do not like it," Winslow predicted, "I am afraid that these circumstances as well as others will not make her married life a happy one." Winslow knew, "[S]he and Mr. Douglass have been thinking about taking this step for some time past, and do not believe it is hasty on their part."

Richard Greener had a unique perspective on the recent marriage of his friend, mentor and sometime adversary, Frederick Douglass. "When it is a question of office-getting and giving Mr. Douglass evinces a decided

preference for his own race, but when it comes to be a matter a wife selection he begs a question of privilege and gets it." Although Greener felt the marriage was rather "inconsistent" with Douglass's known public positions, "that is a matter for the conscience of that gentlemen to decide. I cannot account for it, however, except by remembering that 'reason ceases when love begins.'"

Home is where the heart is, but for Douglass, his marriage turned his home, which he had worked hard to keep together after Anna Douglass's death, against him. Scholar Frank Faragasso has suggested that Douglass erred in his decision to keep his family in the dark about his intention to remarry. For years, the personal affairs of Douglass's family had been fodder for the press. But for Rosetta to learn of her father's most intimate decision must have been unsettling. For Rosetta, her sister-in-law, whom Douglass had described as a "good and upright person," and Rosetta's husband, Nathan Sprague, the marriage tapped into long-suppressed feelings of resentment. They wanted to hit the man who had taken care of them when they were penniless where it hurt: the wallet.

"Frederick Douglass to day addressed a letter to Nathan Sprague in relation to the bill of $1,965 rendered him for Helen Louisa Sprague for services as housekeeper, cook, seamstress and servant, from October 21, 1872, to January 21, 1884," read the lead to the front-page story in the *State Journal*. Douglass denied ever hiring her. Douglass's letter, dated February 12, 1884, stated, "She lived in my family, not as a hireling, but as an equal member of it, and no one would have resented sooner than she, I think, the allegations that she was but a hired servant in the house. From first to last she was simply an honored member of the family, and was provided for as my own daughter would have been had she remained under my roof."

For the record, Douglass said, "Louisa never, in the whole course of the eleven years she was with me, asked me for money without receiving it." Only "impartial persons, having no personal interest in the matter," Douglass argued, could adjudicate the dispute. Standing pat, Douglass told his son-in-law, both privately and publically, "In conclusion, allow me to say, sir, that I am not favorably impressed with the extraordinary manner in which you have sought to recover from the 'dollars and cents' which you allege to be due." Douglass was justly indignant. After the *Philadelphia Press* published an "utterly false" story that he was worth $200,000, Douglass said, "The whole proceeding" has "the appearance of an attempt to take a mean and cowardly advantage of the supposed

unpopularity of my recent marriage, to malign and blackmail me, to extort money, not for Miss Louisa Sprague but for those who are managing the business in her name."

Without any existing "agreement or contract as to what she should receive," the matter was, presumably, dropped. Nearly a half century later, Fredericka Douglass Sprague Perry, the fifth child of Rosetta Douglass Sprague and Nathan Sprague, wrote in the *Baltimore Afro-American*, "Neither newspapers nor preachers ever found entrance into the privacy of the family of Frederick Douglass." If only it were true. Louisa Sprague "resented the idea of providing housekeeping services for a white woman, even if that white woman was the new Mrs. Douglass," writes Nelson. "The episode revealed keenly the pain that Frederick's marriage caused both within his family and among black Americans."

Reaction to the legal union of Fredrick Douglass and Helen Pitts as husband and wife was as divided in the black community as it was in the white community, although the *Philadelphia Times* reported, "It seems that negroes are more aroused about it than the white people of Washington or elsewhere." The division of thought in the black community is clear in the disparate editorial positions of the *Washington Grit*, a recently launched paper by black nationalist John Edward Bruce, and the *Washington Bee*, edited by the enigmatic, fearless and equivocating William Calvin Chase for nearly forty years.

Although Douglass was often denounced for nepotism and for putting his own interests above that of his race in the pages of the *Bee*, these criticisms were often evened out with praise, literally the next week. Born a free person of color in Washington in 1854, Chase represented the city's established black bourgeoisie. Although dark complected, Chase knew that many in Washington's elite black society weren't—a result of generations of forcible intermixing between master and slave and furthered by intermarrying amongst elite light-skinned blacks. This aristocracy was keenly aware of and, in many instances, not shamed by the closeness of their bloodlines with whites. Furthermore, as did the majority of the city's black elite, Chase believed fully in civil liberties, matrimony included.

Departing from their infamous tag line "Honey for Friends, Stings for Enemies," on February 2, 1884, the *Bee* championed the protection of civil liberties, its editorial on Douglass and Helen Pitts saying as much. "If [Douglass] felt disposed to marry a white lady, it does not prove that he is opposed to the colored ladies of our city," the *Bee* said, offering a rebuttal

to black women who could not help feeling slighted. "Mr. Douglass will be different from other men who have white wives. He will not try to hide his identity with his race, but he will still be Frederick Douglass, the defender of civil and political liberty."

All in the black community were not as understanding and supportive. Born a slave in Maryland, John Edward Bruce was a radical Republican trumpeting Black Nationalism in the spirit of a young Martin R. Delany and decades before Marcus Garvey, with whom Bruce later worked. Fresh on the scene, the *Washington Grit* had launched in late 1883, joining established members of the city's black press, the *Bee* and John W. Cromwell's *People's Advocate*. The *Grit* was the more radical of the three papers, its reporting on Douglass's second marriage reflecting that bias. Two days after their marriage, the paper rendered the decision the mistake of Douglass's life, emphasizing, "It is not only a surprise but a national calamity." Douglass and his white wife "have put themselves beyond the pale of either of the social circles among which they moved respectively." After the wedding being the topic of discussion of black Washington for more than two weeks, the *Grit* was now more acerbic. Following the reprint of a story in a New York paper that warned "black men of minor importance" should be on the alert for "a large number of white men who are continually in the ditch, from whiskey and other causes" and are "extremely sensitive with regard to the dignity of the noble Caucasian," the *Grit* let loose. "We are opposed to colored men marrying second-rate white women," the editorial led. "There has been as much fuss and noise about Helen M. Pitts as if she were the daughter of the Secretary of State or some other dignitary," the editor wrote with a clenched jaw. "Barnum could make a mint of money out of this couple if they would consent to go on exhibition. We do not believe that it adds anything to the character or good sense of either of the two races to intermarry with each other, and when it is done it will generally be found that moral depravity is at the bottom of them."

A review of the *Grit*'s pages in the following weeks show no evidence that a correction or letter from Douglass or Helen Pitts ran addressing the fictitious assertion that Pitts was "second-rate." She was not. Douglass knew this, and so did others in the black community, including Reverend Grimke. "As to [Mr. Douglass'] marrying only a common, poor white woman, I want to say, and say emphatically, and as one who knew Mrs. Douglass well, there is not a word of truth in that statement, which is intended as a slur upon her." Just as the "best women of the colored race

have to do, as teachers, clerks, stenographers" work for a living, it was to the credit of Helen Pitts "that she was not ashamed to work for her living." Furthermore, the chatter of "some colored people" who claimed Helen Pitt was common "knew nothing of her personally, had no contact with her."

Out in Oberlin, Ohio, on the campus of Oberlin College, a young Mary Church, later Mary Church Terrell, a leading black activist and socialite in Washington, D.C., read about the second marriage of Frederick Douglass. Church had been in Washington for the Inaugural Ball of President Garfield in early 1882, at the invitation of Josephine Wilson Bruce, when she first met the "great Frederick Douglass" with his "majestic proportions" and "distinguished bearing" on a chance encounter. Now, reading about Douglass's marriage to Helen Pitts, Terrell had mixed emotions. "I realized that a great hue and cry had been raised against it in this country, simply because it outraged custom and tradition," Terrell writes in her autobiography, *A Colored Woman in a White World.* She observed that the same members of the race who opposed the marriage were the "very people" who "were continuously clamoring for equality, absolute equality."

On the one hand, Church offers, "I was then and there convinced that no sound argument could be produced to prove that there is anything inherently wrong in the intermarriage of the races." Yet in the same breath, Church repudiates herself: "I read the comments made upon Mr. Douglass' marriage, I decided that under no circumstances would I marry a white man in the United States." Terrell recognizes, "At an early age I reached the conclusion that under existing conditions in this country marriage between the races here could bring very little happiness to either one of the parties to the contract." The second marriage of Frederick Douglass stood for eleven years as an exception to Terrell's rule.

After meeting at a convention for black journalists, Frederick Douglass and Ida B. Wells, a woman ahead of her times who had been exiled from Memphis for her editorials assailing lynch mobs, developed a mentor-mentee relationship. Wells, known to carry a pistol in her purse ever since witnessing the lynching of a close friend, was a frequent guest at Cedar Hill. In Wells's autobiography, compiled by her daughter, she writes, "The friendship and hospitality I enjoyed at the hands of these two great souls is among my treasured memories."

Driving to the train station following Wells's first visit to Cedar Hill, Douglass, nearly a half century his protégé's senior, had a somber admission

to make. "I want to tell you that you are the only colored woman, save Mrs. Grimke, who has come into my home as a guest and has treated Helen as a hostess has a right to be treated by her guest. Each of the others, to my sorrow, acted as if she expected my wife to be haughty or distant, and they all began by being so themselves." Wells, just a year or two older than Douglass's eldest grandchild, aware of her "youth and inexperience," asked Douglass, "Why?" Douglass responded, "Well, they seemed to resent her being at the head of my household and felt that they should show her their feelings. Many of them were cordial to me but kept Helen outside the pale, simply because she was white and had committed the crime of marrying me."

Wells, born in Holly Springs, Mississippi, in July 1862, replied, "Oh, Mr. Douglass, I am sorry to hear that the women of my race committed such a breach of good manners." Measured in his feelings, Douglass maintained, "I am not trying to criticize them. I am only trying to tell you why we enjoyed your company so much and want you to come again. Helen appreciated the courtesy and deference with which you treated her and the way you tried to influence Annie [Douglass's granddaughter] to do the same." Reflecting on this conversation, Wells writes, "I, too, would have preferred that Mr. Douglass had chosen one of the beautiful, charming colored women of my race for his second wife. But he loved Helen Pitts and married her and it was outrageous that they should be crucified by both white and black people for so doing." According to Mia Bay's biography of Wells, *To Tell the Truth Freely*, Helen and Ida would maintain a correspondence and develop their own lasting friendship.

In late August 1884, the Douglasses returned to Cedar Hill after an extended honeymoon that took them from Washington "to Chicago—to Battle Creek, Niagara Falls—Rochester, Geneva, Syracuse, Oswego—Thousand Islands, Montreal, White Mountains—Portland, Boston, Fall River—Plymouth—New Bedford—and what is remarkable and gratifying not a single repulse or insult in all the journey." Douglass was delighted to find a letter from his old friend from his days as a conductor on the Rochester stop of the Underground Railroad, Amy Kirby Post. When the newlyweds had passed through Rochester, Post was out of town, although they were received by her two boys, Jacob and Willis, who "were the same and as cordial as ever." Trusting that his letter to Post would be kept in confidence, Douglass shared, "I return home with a higher estimate of the progress of American Liberty and civilization than I started out with. You will be glad to know that my marriage has not

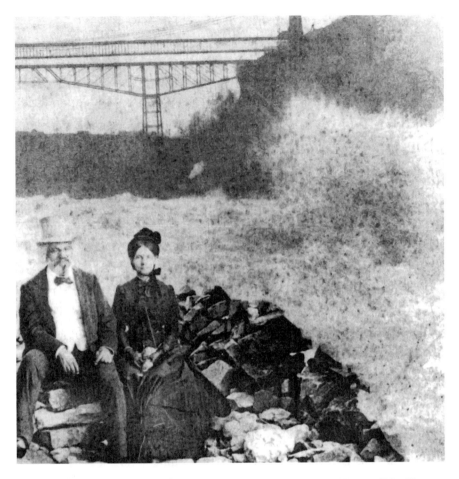

Frederick Douglass and Helen Pitts Douglass on their honeymoon at Niagara Falls, New York. *National Park Service, Frederick Douglass NHS.*

diminished the number of the invitations I used to receive for lectured and speeches, and that the momentary breeze of popular disfavor cause by marriage has passed away." Opening his soul to his old comrade and confidant, Douglass wrote, "What business has the world with the color of my wife? It wants to know how old she is? How her parents and freinds [*sic*] like her marriage? How I courted her? Whether with love or money? Whether we are happy or miserable now that we have been married seven months." Alluding to letters he had received and "newspaper talk on these matters," Douglass affirmed, "I do not do much to satisfy the

public on these points but there is one upon which I wish you as an old and dear friend to be entirely satisfied and that is: that Helen and I are making life go very happily and that neither of us has yet repented of our marriage." Douglass failed to mention that Gideon Pitts, Helen's father and his near life-long confidant, had received them coldly. Pitts would never speak to his daughter again.

Two years later, fulfilling Fredrick's "long-intended purpose" to return to Europe and finally experience Paris, the Douglasses began making preparations for a whirlwind world tour. Entrusting Lewis to handle his affairs, Frederick and Helen departed from Washington to Boston. "Thrice welcome is the sage of Anacostia," wrote the *Boston Advocate*. Before departing, the Wendell Phillips Club, named after the noted abolitionist and lawyer, honored Douglass with a banquet on September 11, 1886. Douglass could not help but reflect on the incomparable circumstances of his third voyage across the Atlantic. In the mid-1840s, Douglass had famously escaped to Europe as a runaway slave. Then in his late twenties, Douglass would build lifelong friendships and relationships, finding his place in an international network of abolitionists. "Almost thirty years had passed since Douglass made his second trip to Europe" in 1859, writes Philip Foner in his essential biography. "At that time he had fled to England for refuge, an outlaw hunted by the government because of his connections with John Brown" and Brown's unsuccessful raid on the Federal Arsenal in Harpers Ferry, Virginia (now West Virginia), to arm and lead a slave rebellion. "Now [Douglass] went as a man who had known Presidents, senators, and congressmen." Although not needing letters of introduction, Douglass had them. "Few men can tell me more of American history for the last half-century than Mr. Douglass can, and no one has been able to see it from the same point of view," read a letter written in Italian. Wishing America adieu, the Douglasses departed for Liverpool on September 15, 1886, aboard the *City of Rome*.

Reconnecting with his truest of friends, Douglass was asked by Julia Griffiths Crofts, his ally in his turbulent early years as editor and publisher of the *North Star*, to address a school for young girls. Douglass obliged. After a two-week stay in London, Frederick Douglass—with Theodore Stanton, the son of Elizabeth Cady Stanton, and Theodore Tilton acting as a guide—finally set foot in Paris. Finding the French "singularly conscious of their liberty, independence, and power," Douglass felt an imposing "double consciousness" that black intellectual William Edward Burghardt DuBois would write about nearly twenty years later in *The Souls of Black Folk*.

Foner writes, "In Paris a few weeks, Douglass began to see himself as the unofficial ambassador of the American Negro." Although the peoples of England and France were liberal enough in thought and philosophy, respecting Douglass as a man, he was deeply concerned about the "distilment of the American prejudice against the Negro." The influence of "Ethiopian singers" of American origin disfigured and distorted Europeans' perception of black folk, their language and their manners. These groups made Americans of African descent "appear to thousands as more akin to apes than to men." Europeans' interest in black American culture continues in Paris today; black American gospel choirs perform regularly to packed cathedrals. Hip-hop music and culture, largely the creation of Jamaican and American peoples of African descent, can be seen in today's Paris; graffiti is seemingly everywhere, and music is heard (in French and English) blaring from the shops of Montmartre and hundreds of headphones on the Métro.

Speaking with octogenarian Victor Schoelcher, a key legislator in the emancipation of enslaved persons in the French colonies, Douglass was disillusioned to learn that the international literary figure Alexandre Dumas, of Afro-Franco descent, "never had one word for his race." Douglass's heart must have been heavy to learn this. He once told Richard Greener, "I imitated him. He was not ashamed of 'fleecy locks and dark complexion,' was he? They did not 'forfeit nature's claim.'" Dumas, unlike Douglass, who never ran from his identity as a black man, forfeited the chance to carry "freedom to his enslaved people." Writing to the States, Douglass was measured in expressing his feelings of disgrace. "I have not seen his statue here in Paris. I shall go to see it, as it is an acknowledgment of the genius of a colored man, but not because I honor the character of the man himself." To Douglass, a man's man, Dumas was not "manly"; he was a fraud and a coward.

Moving from Paris in early January 1887, with stops in Dijon, Lyons and Marseilles, the couple continued on their travels, which took them through the Old World European cities of Rome and Naples. In Cairo, Douglass was dismayed by the "squalor, disease, and deformity—all manner of unfortunate beggary." As a leading advocate of women's rights in the United States, Douglass was taken aback by a sight still seen today throughout the Islamic world: "hooded and veiled women." In his diary, Douglass wrote, "It is sad to think of that one-half of the human family should be thus cramped, kept in ignorance and degraded, having no existence except that minister[ing] to the pride and lusts of men who own them as slaves are owned."

Knowing well the history of Ancient Egypt, Douglass visited the sites of ancient Memphis and the Pyramids of Giza, one of the Seven Ancient Wonders of the World, built through the blood, sweat and tears of slaves, according to Greek historian Herodotus. (A 2010 discovery of a burial shaft prompted Egypt's archaeology chief to say that workers were "paid laborers" rather "than the slaves of popular imagination.")

"One of the first exploits a tourist is tempted to perform here," Douglass wrote in his 1892 version of *Life and Times*, "is to ascend to the top of the highest Pyramid. The task is by no means an easy one, nor is it entirely free from danger." Warning future tourists, Douglass said, "Neither in ascending nor descending is it safe to look down. One misstep and all is over." Now in his seventieth year, Douglass went for broke, although "nothing could tempt me to climb the rugged, jagged, steep, and perilous sides of the Great Pyramid again." With "two Arabs before me pulling, and two at my back pushing," Douglass did the "main work." Making it to the top of the 470-foot Great Pyramid of Giza (the highest pyramid in the Nile River Valley), Douglass could see out over the same landscape where, thousands of years before, thrived one of the most advanced and learned civilizations ever known to mankind. Taking in the panorama, there stirred in Douglass "feelings never thought and felt before."

In June, Helen returned to the United States to aid her ailing mother. Frederick stayed behind, making one last tour of the British Isles before arriving on American soil in August 1887. As Foner writes, although Douglass "had been happy to get away from the colored line," upon his arrival in Anacostia, he "was especially stimulated by the knowledge that his people had missed him and welcomed his safe return." In the words of a "young Negro," in Douglass's "absence we were made more fully to appreciate our great advantage in having you to speak for us and protect our interests."

In the fall of 1887, Edward A. Johnson, then in his late twenties and the principal of the Mitchell Street School in Atlanta, was in Washington and, by a chance encounter, met Douglass for the first time at Reverend Grimke's Fifteenth Street Presbyterian Church. Douglass promptly invited Johnson and two others to "call on him and his wife at his Anacostia Mansion." The next Sunday, Johnson and his group made the trek "across the long Anacostia Bridge and up the long hill" to meet the Douglasses. Recalling the visit years later, Johnson remembered Douglass as "every inch a chieftain." Helen was "very pleasant to talk

to and showing evidence of deep culture, and much interested in and attentive to her husband." The guests were entertained "graciously" and shown "many relics, spear heads, swords, muskets" and other mementos of the full life Douglass had lived. "After this, he took down his violin and gave us several renditions of 'Ye Olden Times'" and other popular folk songs.

Writing in his unpublished autobiography, Johnson, born into slavery in Wake County, North Carolina, would become the first black American elected to the New York state legislature in 1917. He remembered the pleasantness of his visit. "Mr. Douglass and his wife seemed to live happily alone at Anacostia, in surroundings that bore every evidence of culture and refinements. Newspapers, books, and magazines were plentiful, not as ornaments but showing signs of having been used."

Now back in the saddle, Douglass returned to business as usual, fully throwing himself into the 1888 presidential campaign. A leading voice of the Republican Party, Douglass was vocal that the party "can no longer repose on the history of its grand and magnificent achievements." Although Douglass initially supported Ohio senator John Sherman, he got behind the ticket of Benjamin Harrison. "I made speeches in five different states, indoors and out-of-doors, in skating rinks, and public halls, day and night, at points where it was thought by the National Republican Committee that my presence and speech would do most to promote success." Although on the surface there were few similarities between Anna Murray and Helen Pitts, both of Douglass's wives handled their husband's frequent absences with aplomb and dignity.

Throughout the eleven years of their marriage, Helen Pitts Douglass proved herself not only a loyal wife, as Anna Douglass had been, but also one who could handle nearly anything and everything thrown at her. In January 1889, while her husband was serving on the Inaugural Committee of President-elect Benjamin Harrison, Helen demonstrated she had street smarts, as well as book smarts. "At 9 o'clock yesterday morning John Anderson, a colored man living on the Flats in Hillsdale, and who has been acting in a peculiar manner for several days, became violently insane and rushing from his house ran down Nichols avenue, yelling, gesticulating and scattering pedestrians right and left," read the lead item in the *Post*'s Anacostia neighborhood notes. "Turning up Jefferson street, he ran to the house of Fred Douglas and rang the bell. Pushing his way past the frightened servant girl, he confronted Mrs. Douglass and at once proposed to offer prayer." Helen Pitts was reportedly unfazed and "took in the

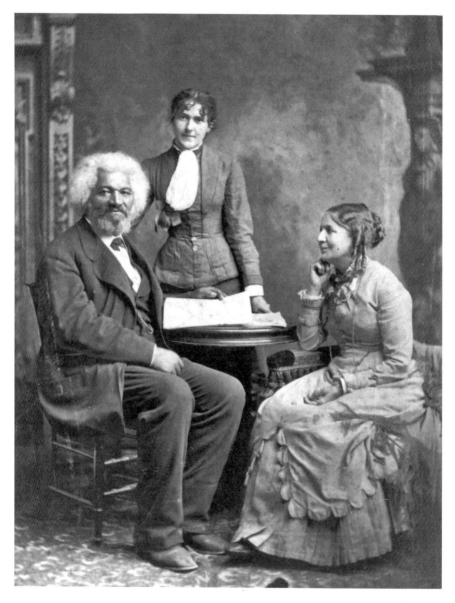

Frederick Douglass with Helen and Eva Pitts. *National Park Service, Frederick Douglass NHS.*

situation, and tried to quiet John, but suddenly he rushed into the dining-room and entered a closet." Not missing a beat, she "quickly shut the door and locked it keeping the lunatic a prisoner until Officer W.T. Anderson came and took him in custody." John "will probably be committed to the asylum," the story concluded.

8

Grand Pa Douglass

I am working hard Grand Pa and I will assure you that what has been spent on me in music has been of great advantage to me. [I]n that direction you have helped me very much and I feel thankful...
—*Joseph Douglass, October 10, 1888*

The lessons of his life that Frederick Douglass imparted to the world, he shared with his family in more intimate settings. Sitting on his lap one day, Fredericka Sprague, the fifth daughter of Rosetta and Nathan Sprague, was taught her "first lesson that I can recall in the power of politeness." She was sitting on her grandfather's knee playing with the chain to his gold watch. "Freddie, do you want to see the wheels of Grandpa's watch go around?" her grandfather asked, to which she replied in the affirmative. "Then tell the watch to open," said her grandfather. Fredericka promptly said, "Open, watch." The watch failed to open, and Fredericka looked to her grandfather's face for an explanation. "Oh, but you didn't say it nicely—my watch wants you to say, 'Please open.'" On cue, Fredericka responded, "Watch, please open!" The gold lid flew back, revealing all the "wonderful little busy wheels" turning at the same time in different directions. "Again and again did grandpa go thro' that performance—'Watch, open'—case remained closed. 'Watch, please open.'—Presto! the case flew back," Fredericka recalled years later, "and it was not until I was a very much older girl that I learned grandpa's thumb released the case and not just the word 'please.'" To at least one

of his grandchildren, Frederick Douglass taught a lifelong lesson in the power of the magic word.

Fredericka, born in 1872, remembered her "babyhood days" at 316–318 A Street Northeast, playing "with the best play-fellow in the wide world" with a fondness. She also credited her "remarkable grandparents" for the caring of "a group of five wide-awake youngsters—the oldest not more than eleven and a baby boy of six months." As did "all of Mr. Douglass's grand children," Fredericka "learned a very definite trait of his character, which made contact with him easy for his grand children." Douglass had two parts of his day: "his working time and his play time and he was visibly annoyed by any infringement upon either."

From infancy every grandchild was taught to respect the closed door. However, every grandchild also knew "that door would not always be closed, that at a certain time it would open and then the fun!" Douglass would stand "in the open doorway of his study—legs astride as tho' bracing himself for the onslaught he knew his shrill whistle was certain to bring." He would round up "the smallest one and perching her up on his shoulder, the rest swinging on arm and coat tail, singing and shouting, we would march down the hall, into the dining room and into the kitchen—most distracting to the grandmother, I am certain, busily engaged in supervising preparations for dinner."

Rumbling onto the carpeted parlor floor, "Grandpa would drop down on hands and knees," where he would play the role of the family horse. "Jump on," he would cry out to his gang of grandchildren, who would promptly "scramble atop of that broad back, the one nearest the head using the long hair for reins and away we would gallop." While at play, both child and adult knew the universal law of fairness still applied. For most invented childhood games, the rules are known only to the select group that creates the game. While at play, "children as well as adults are prone to reveal their true characteristics whether magnanimous, selfish, spiteful, rude, honest, cheats, etc. as they are possessed, the good sportsman, the bad sportsman as portrayed by his ability to play the game fairly."

Whenever in a "real mischievous mood," Douglass would exclaim, "Come, let's play 'Wheel Barrow.'" Douglass's grandchildren would drop to the floor, their feet in his hands, and "we would attempt to circle the room in our hands. Tumbling, screaming, sometimes crying from the falls, as our little arms would tire, we were not allowed to quit until we had reached the 'starting point,'" usually a table or chair. "Grandfather indulged in exercise daily," Fredericka recollected. "At Cedar Hill today will be found a

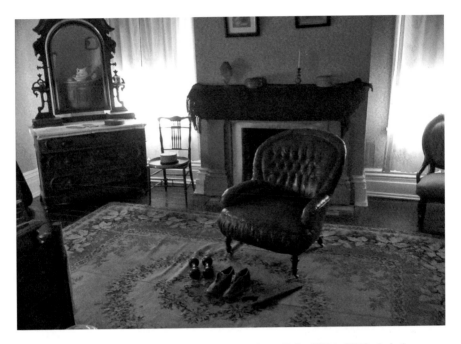

Frederick Douglass's room, complete with dumbbells, at Cedar Hill in 2012. *Author's collection.*

pair of dumb-bells, each weighing thirty-five or forty pounds." As Douglass always kept his flesh solid, the purpose of the games he played with his grandchildren, even the girls, "was to develop muscle."

In quieter times, Annie and Hattie Sprague, Fredericka's older sisters, would "dress grandpa's hair" with "braids tied in ribbon hanging over his shoulders." However, "that form of amusement to the grandchild proved distressing to the grandfather, as in the midst of the braiding, company would be announced!" Anna Douglass and Rosetta would come to the rescue and "follow him to his room to aid in restoring the locks to normal arrangement atop that massive head."

To his family, Fredrick Douglass was the king of his Victorian castle on Cedar Hill. To accommodate his growing bundle of grandchildren, the home was expanded. The third generation of Douglasses quickly learned the ins and outs of the city, going back and forth between their grandfather's home in Uniontown, Frederick Jr.'s home on Nichols Avenue in nearby Hillsdale, Charles's home (the first Douglass family home in Washington) at 316 A Street Northeast and Lewis's (who had no children) home in the

Strivers Section of Northwest Washington on Seventeenth Street. It was Cedar Hill where the generations of Douglasses in Washington gathered for family meals and games of croquet on the back lawn. Away from the prying public eye, Frederick and Anna raised their children, grandchildren and the many extended and long-lost family members and orphans they took in and helped support across their years from Massachusetts to Washington. The collective affection his family felt for "Douglass" and his home on the hill is apparent from an acrostic Rosetta Sprague Douglass and her sister-in-law, Rosabelle Sprague, presented to Frederick for his birthday:

> C—is for cedar that stood on the hill by the home of our Douglass, who to us is so dear.
>
> E—is for eloquence, which so magically held the audience of Douglass, with a boundless spell.
>
> D—is for Douglass who labored so bravely to abolish the terrible wrongs of slavery.
>
> A—is for argument good and strong which Douglass used against the nation's wrong.
>
> R—is for Rochester, from which many a slave was helped on to Canada, by Douglass, the brave.
>
> H—is for Hill, upon which stands the home of Frederick Douglass, our friend so well known.
>
> I—is for industry for without which our race cannot wish the world to keep pace.
>
> L—is for liberty for which we are still striving, the hope to realize we are even abiding.
>
> L—is for love, the greatest thing on earth we give to our Douglass, this day of his birth.

From Cedar Hill, the strings of a violin could often be heard drifting through the country air. Closely connected with Douglass's love of family was his love of music. "He is fond of music and often plays the violin accompanied on the piano by Mrs. Douglass," wrote James Monroe Gregory in his 1893 biography. "It is related that in earlier days while an exile in Scotland, passing along the street in a despondent mood he saw a violin hanging out at a store door, and going in bought it. He then went home, shut himself up, played for three days until he was in tune himself and again went out into the world—a cheerful man."

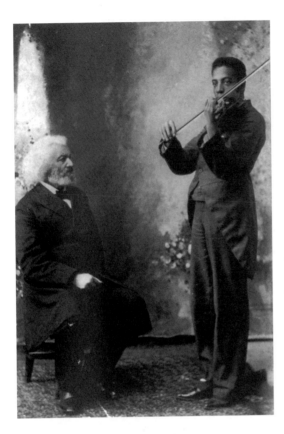

Frederick Douglass seated alongside his grandson, Joseph Douglass. Joseph would become a world-famous violinist, performing at the White House for multiple presidents. *Library of Congress.*

A November 1894 newspaper article confirms this account, although happening in a different country and with slightly different particulars. "I went into a music store in Dublin and asked to look at violins. The proprietor handed me one with seeming reluctance. He appeared to be afraid that I would break it," remembered an aging Douglass. "I took the instrument from his hand and played the 'Rocky Road to Dublin.' He was speechless for a moment or two." The man's wife joined him, giving Douglass an audience of two for whom he "played 'The Irish Washerwoman,' and they danced for me. Then I asked the price of the violin, for I liked it. But the dealer snatched it out of my hand." For some reason, the man wanted to keep it. "He sold me another violin, though, really a much better one, for half a crown." I.D. Marshall, writing as a special correspondent for the *Wichita Daily Eagle*, said, "Mr. Douglass may not play the violin now, but during those times which he always speaks of 'as trying men's souls' his violin was one of his chief solaces. He has a grandson now, of whom he is very fond, to whom he descended the

musical faculty, and who has shown so much talent as a violinist that he is to be sent abroad in order that his musical education may be finished."

According to letters and newspaper accounts, Douglass delighted in playing the violin for grandchildren and guests alike, when they visited Cedar Hill. After dinner, he would give improvised performances, taking requests as well as performing his personal favorites, such as "Suwannee River" (which has been criticized as a nineteenth-century minstrel) and "The Star-Spangled Banner." According to the National Park Service, Douglass taught his grandchildren "slave songs" that he had learned in his adolescence. "The grandchildren sang and clapped their hands while [Grand Pa] Douglass tapped his feet."

Joseph Douglass was born in the Anacostia area on July 3, 1869, to Charles and Mary Elizabeth Douglass, their second of six children and the only one who would live to adulthood. Following in music the path of his famous grandfather and father, Joseph took up the violin at a young age, receiving classical training at the New England Conservatory for five years and later at the Boston Conservatory. According to a history of black American music, Joseph would become the "first black violinist to make transcontinental tours and was the direct inspiration for several young violinists who later became professionals." In his role as director of the Department of Music at Howard University and headmaster at music schools in New York, Joseph helped cultivate the budding talent of those who came behind him. According to his obituary in the *Post* from December 8, 1935, "His appearances at the White House were regularly scheduled during administrations of Presidents McKinley, Roosevelt, and Taft, after which he undertook concert work." No doubt, Grand Pa Douglass would have enjoyed joining Joseph in a duet before such an auspicious audience.

9

Twilight

I enclose you one of my photographs. It will probably be the last occasion I may have to have my photograph taken, as I am fast approaching the sunset of life," Douglass wrote in a letter in early spring 1894. As old age set in, Douglass began grappling with his own mortality. Two years before, he had written to an old abolitionist, telling him, "I am now seventy-five years, and though my eyes are failing and my hand is not as nimble as it once was I hope to do some service."

Since becoming a septuagenarian, Douglass had been appointed, in 1889, by President Harrison, as minister resident and consul general to Haiti and chargé d'affaires for Santo Domingo, winning the admiration of the Haitian people for resisting encroachments of American imperialism. In 1893, the Haitian government asked Douglass to preside at its pavilion at the World's Columbian Exposition in Chicago after no exhibit space was made available to showcase the achievements of black Americans. From the Haitian pavilion, Douglass and Ida B. Wells distributed a pamphlet entitled *The Reason Why the Colored American Is Not in the World's Columbian Exposition.*

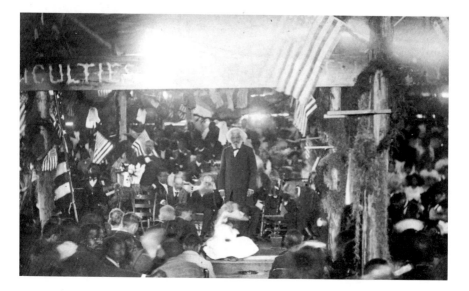

Frederick Douglass delivering a lecture, circa March 1892. *Library of Congress.*

On August 25, 1893, set aside as "Colored People's Day," Douglass began reading a prepared paper. Hecklers taunted Douglass, whose voice reportedly "faltered." Invoking the youthful spirit of the enslaved Fred Bailey running the streets of Baltimore, Maryland, decades earlier, Douglass threw his remarks aside and, with no mercy in his eyes, unleashed the wrath of a man who had had enough.

"There is no Negro problem. The problem is whether the American people have loyalty enough, honor enough, patriotism enough, to live up to their own Constitution," Douglass bellowed for all to hear. Speaking from the depths of his soul for more than an hour, Douglass said, "We Negroes love our country. We fought for it. We ask only that we be treated as well as those who fought against it." Wells later apologized to Douglass for doubting him, thinking he had become docile in his old age.

In the 1890s, Douglass spoke out against the convict-lease system and lynch law in the South on the page and stage. In January 1894, at the Metropolitan African Methodist Episcopal Church, Douglass delivered a lecture, "Lessons of the Hour," which was excerpted in newspapers throughout the country:

I have sometimes thought that the American people are too great to be small, too just and magnanimous to oppress the weak, too brave to yield up the

right to the strong, and too grateful for public services ever to forget them or fail to reward them. I have fondly hoped that this estimate of American character would soon cease to be contradicted or put in doubt. But the favor with which this cowardly proposition of disfranchisement has been received by public men, white and black, by Republicans as well as Democrats, has shaken my faith in the nobility of the nation. I hope and trust all will come out right in the end, but the immediate future looks dark and troubled. I cannot shut my eyes to the ugly facts before me.

It was fitting that it was the church where Douglass railed against America's unrepentant sins. The first words Frederick Douglass ever read were words written in the Bible. Never knowing his father, Douglass was "not more than thirteen years old, when in my loneliness and destitution, I longed for someone I could go, as to a father and protector." Fred Bailey found, through the "preaching of a white Methodist minister, named Hanson" that "in God I had such a friend." It was in the streets Douglass also found God. "My desire to learn increased, and especially did I want a thorough acquaintance with the contents of the Bible. I have gathered scattered pages of the Bible from the filthy street gutters, and washed and dried them, that in moments of leisure I might get a word or two of wisdom from them." Douglass found fellowship in "a good old colored man named Charles Lawson" known to pray three times a day, praying while he walked to work. "I went often with him to prayer meeting and spent much of my leisure time on Sunday with him," Douglass recalled. Lawson "could read a little," and "I could teach him '*the letter*,' but he could teach me '*the spirit*'; and high refreshing times we had together, in singing, praying and glorifying God." In Douglass's 1855 autobiography, *My Bondage and My Freedom*, he tells of being physically threatened if he continued his friendship with Lawson. Undaunted, Douglass continued to seek out Lawson's company. "He threw my thoughts into a channel from which they have never entirely diverged. He fanned my already intense love of knowledge into a flame, by assuring me that I was to be a useful man in the world."

In Baltimore, Douglass also sought and found solace in the Methodist church on Dallas Street. In New Bedford, Douglass "joined a little branch of Zion," according to his own reminiscences published in 1895 in James Walker Hood's *One Hundred Years of the African Methodist Episcopal Church*. "As early as 1839 I obtained a license from the Quarterly Conference as a local preacher, and often occupied the pulpit by request of the preacher in

charge." Before Douglass made his first public utterances in the company of abolitionists, he was a practiced preacher in the church. Douglass demurred when asked unexpectedly to speak at a Massachusetts Anti-Slavery Society retreat in Nantucket in the fall of 1841. Those who had recently heard him exhort in the New Bedford Methodist Church called his bluff when he pleaded an inability to speak.

This was the start of Douglass's long career advocating reform.

Many years later, Douglass heard that the church in which he had "first received his religious education" was in financial straits. It was the church community, the outreach ministry of Charles Lawson, who had first uplifted his spirit. In the early months of 1892, Douglass went to Baltimore "for the purpose of paying off the mortgage," according to the *New York Times*. Douglass held a lifetime loyalty to the church. Until his last breath and in death, Douglass was upheld by the church.

A review of the collected lectures Douglass gave in his years in Washington shows that he frequently spoke at city churches from Reverend Grimke's Fifteenth Street Presbyterian Church to the First Congregational Church at Tenth and G Streets Northwest to Asbury Methodist Episcopal Church at Eleventh and K Streets Northwest to the Metropolitan African Methodist Episcopal Church. According to Holland's biography, Douglass never forgot "the pregnant and striking fact that American slavery never was afraid of American religion." However, Douglass knew the importance of the black church in uplifting his race, especially in Washington, D.C.

When the city swelled with contrabands during the Civil War, it was the black churches that formed "Relief Associations," according to article after article in the *Christian Recorder*. A November 1862 announcement of the Union Bethel Church (later Metropolitan AME) opened, "BRETHREN AND SISTERS: We appeal to you for aid in behalf of our poor, destitute, and suffering people from the South, who have come amongst us destitute of all the comforts of life, and in the most abject poverty and want, from the hoary-headed old man and woman, to the infant at the breast." Washington's black church community, largely of free persons of color, did not sit idle; years before the creation of the Freedmen's Bureau the church was extending its hand. The cornerstone for a new Metropolitan AME Church was laid in September 1881 at 1518 M Street Northwest, blocks from the White House. In the late spring of 1886, the church's opening was consecrated by Bishop Daniel Alexander Payne. Luminaries in attendance at the 2,500-seat grand church included South Carolina congressman and hero of the war Robert Smalls and Frederick Douglass, both men donating ornamentations. It was

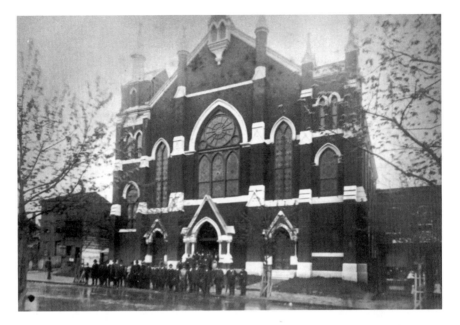

Exterior of Metropolitan African Methodist Episcopal Church, 1518 M Street Northwest, Washington, D.C. *National Park Service, Frederick Douglass NHS.*

at Metropolitan that the popular Bethel Literary and Historical Society presented discussions on far-ranging topics of the day, as well as talks on history, philosophy and science. When Douglass returned home from Europe in 1887, it was Metropolitan that threw him a welcome-home reception with more than two thousand people attending. Before departing for Haiti in 1889, Metropolitan held a large event to bless him in his travels. Douglass was presented with a King James Bible. It was to Metropolitan that Douglass would be called home.

The last public appearance Frederick Douglass never made was at church. "The members of friends of Campbell A.M.E. Church, Hillsdale, are celebrating the twenty-seventh anniversary of the organization of the church with appropriate services. The church is handsomely decorated," the February 20, 1895 edition of the *Evening Star* noted in its Suburban News section for the Anacostia neighborhood. "Tonight Rev. Dr. Collett, presiding elder of the Potomac district, will read a paper, and a short address will be made by Fred. Douglass." That evening, Helen and Frederick sat down for dinner. Douglass shared the goings-on of the National Council of Women meeting he had attended during the day. Known to use mimicry

A pew marker for Frederick Douglass within the sanctuary of Metropolitan African Methodist Episcopal Church. *Author's collection.*

as extra emphasis when sharing his opinion, when Frederick got up from the table, Helen thought that is just what he was doing as he moved into the center hall.

"He fell to the floor without uttering a sound. His wife rushed to his assistance and at a glance saw the serious nature of the attack," the *Star* reported. "She was alone at the house at the time, and she hurried at once to the porch and by her cries soon brought assistance." A messenger rushed to find the nearest doctor. Within twenty minutes, Frederick Douglass was pronounced dead, the cause heart failure. Word quickly spread, first throughout Washington and then the entire country. Tens of millions of Americans learned the news in the next day's paper from the country's largest cities to its emerging small towns. "Of remarkable men this country has produced at least its quota and among those whose title to eminence may not be disputed the figure of Frederick Douglass is properly conspicuous—a fact that will be accentuated by the sudden death of him who did so much for himself and for the enslaved millions of his race who by force were compelled to residence in this country," editorialized the *Star*:

Twilight

It is not enough to say that Frederick Douglass was a great man—the term has degenerated and is frequently misapplied, it is, but fair to show wherein his greatness was and what it consisted. Self-elevated from the degrading depths of slavery and ignorance to the highest plane upon which philanthropic man may here stand, he retained to the last simplicity such as is but rarely to be found in those who have come up through great tribulations and accorded place in the midst of the mighty.

On Monday, February 25, the city's colored schools closed. Out of respect for the dead, businesses run by black Washingtonians closed as well. At dawn, an assembly of men, women and children had already gathered outside the Metropolitan AME Church waiting to pay their respects and view the body of Frederick Douglass. "As the sunny morning hours passed the gathering swelled until, when the blue-coated policemen came to take charge, the crowd reached down M street to 15th and down that thoroughfare past L street." At eight thirty in the morning, after a private service was held at Cedar Hill for Douglass's immediate family, a "colored camp of the Sons of Veterans" took guard of the casket as it made its way downtown. Along the way, hundreds of people joined the procession. "A few minutes before 10 o'clock a plain hearse drove slowly through the waiting concourse to the church doors, where it was met by the trustees of the church," reported the *Star*.

After reciting Psalm 105, verses 17 through 19, Dr. Jeremiah E. Rankin, president of Howard University, said, "There is but one parallel to the life of Frederick Douglass and this is found in the Bible; the Bible, which surpasses all other literature." Back at Cedar Hill, on the incoming letter rack on Douglass's desk, was a letter from Lucius Harrod, a former messenger, of Hillsdale:

Kind sir, By reason [of] ill health since 1888 which rendered me unable to perform my duties my wife was accepted in my stead. From then to this month she has faithfully attended the same. At the same time I have been detained in and about my house. Now by reason unknown to me she is dismissed. And I have been detained in my room by sickness for the last 2 weeks. I have 5 children and the sum of seven dollars (7) to pay monthly in the Equitable Building Association by reasons which I have been unable to re-build since my house was burned down in '88.

Harrod then quoted scripture, Psalm 40, verse 17: "I am poor and needy yet the Lord thinketh upon me." Knowing Douglass to be charitable,

The desk of Frederick Douglass at Cedar Hill today. *Author's collection.*

Harrod ended his letter: "And if you can do me any good in whatever way you may it will be greatly accepted." According to the 1896 city directory, by that year Harrod had found work as a reverend. In the outward mail bin on the same desk was the last letter Douglass ever wrote and sealed. On Cedar Hill letterhead, Douglass tendered a brief introduction for his wife to Massachusetts senator George F. Hoar. The subject was the preparation of a paper on Egypt.

Epilogue

We didn't come here on the Niña, *the* Pinta, *or the Greyhound Bus. My family escaped from Robert E. Lee's plantation and we've been here ever since.*
—*Reverend Oliver "OJ" Johnson, native Washingtonian and fifty-eight-year resident of Anacostia*

*I got love for my brother, but we can never go nowhere
Unless we share with each other. We gotta start makin' changes
Learn to see me as a brother 'stead of two distant strangers
And that's how it's supposed to be.*
—*The late Tupac Shakur, as heard today on the streets of Historic Anacostia*

While employed as a poverty worker on the 1600 block of Good Hope Road Southeast, I would walk to the office from the Anacostia Metro station, every morning and most afternoons passing the home of Frederick Douglass perched atop the hill, fifty-one feet above W Street Southeast. On the morning of June 7, 2010, I went about my regular routine, which was to get off the train, walk down Martin Luther King Jr. Avenue Southeast, turn right at W Street Southeast and then turn left at Sixteenth Street Southeast. This morning was a little different.

With the Douglass house, a boarded-up brick apartment building partially covered in ivy and a handful of vacant homes mere steps behind me, I approached the corner of Sixteenth and W Streets Southeast. Usually quiet at eight thirty in the morning, the corner was flanked by police cruisers,

Way-finding sign for the Frederick Douglass National Historic Site at Sixteenth and W Streets Southeast in Historic Anacostia. The Metropolitan Police Department has installed a closed-circuit television camera to watch over the corner. *Author's collection.*

yellow crime tape and signs that the forensic crime lab had only recently left. Taking this in stride, I continued walking and, within five minutes, had a press release from the Metropolitan Police Department on my computer screen giving the cold facts:

> *On Saturday, June 5, 2010, at approximately 2:57 am, units from the Seventh District were dispatched to the 1600 block of W Street SE to investigate the report of a shooting. Upon arrival, officers located an unconscious subject who was suffering from apparent gunshot wounds. DC Fire and Emergency Medical Service personnel responded and determined the victim had no signs of life. The victim was then transported to the Office of the Chief Medical Examiner, where he was pronounced dead.*

The victim was seventeen years old. In a day or two, it was reported that the young man, of the 2300 block of Pitts Place Southeast, had been under the supervision of the city's beleaguered Department of Youth Rehabilitative

Services. More than two years later (at the time of this book's publication), his murder remains unsolved.

To get through each day (the good and the bad), I would often seek counsel in my co-worker Anthony Moore, a native Washingtonian, who had more experience than me working in the field of social services. Together we developed curriculum, organized trainings and workshops and shared our experiences working in the tempestuous neighborhoods of Washington that lie east of the Anacostia River (mine primarily as a teacher and reporter) to better serve our "clients'" needs, our focus delivering measurable outcomes—in this case job placements and retention.

Before the end of that week, which started by walking past the homicide scene, I said to Anthony, "A seventeen-year-old runaway from DYRS is shot and killed within sight of the home of the world's most famous runaway slave. What is really going on out here?" To which Anthony, always ready to share his fresh insights, said, "Freddy-Fred is not real, you can't see him, you can't touch him. He's not coming down to the corner to mentor these kids; even if he did, they wouldn't know who he is." Instead of crossing the Anacostia River for lunch simply to eat something other than hard-fried carryout, we decided to take the short walk from our office to the Douglass home, a National Park site. Anthony had never been to the house. Throughout our school days, we had never been taught about Frederick Douglass as part of the curriculum.

Standing at the summit of Cedar Hill, looking over the immediate neighborhood, we saw the roof of the long-abandoned St. Teresa's School the next block over on V Street Southeast, seemingly close enough to hit with a rock's throw, and the nationally known landmarks the Capitol Dome, Washington Monument, National Cathedral, National Basilica and RFK Stadium at various lengths in the distance. Anthony, his hand caressing his face, said, "You mean to tell me a black man owned this? This is what he saw? I don't believe it." Knowing the history of the country and his city, he knew it was true but was unable to wrap his mind around it.

No expert on Douglass, nor pretending to be one, I told Anthony the little I knew of the history of the home gleaned from a combination of a handful of tours I had taken and a cursory knowledge of Douglass's writings and life. It was in junior high school that I somehow picked up *Narrative of the Life of Frederick Douglass, an American Slave*, either at the school library or in the hallways, and quickly read through it. The next day I shared what I had learned with some of my black friends. To my surprise, or rather naiveté, I cannot remember a single friend knowing anything about Douglass other than that they had heard the name before, somewhere.

"If you saw Fred walking these streets and you ran up to him, what do you think he would say to you? Do you think he'd stop and talk with you? Could you ask him, 'How did you do it?' How did you earn this?'" Anthony asked. By this time, one of the site's rangers had appeared from the administrative office just out back of the home. "Hey, guys. Beautiful day. Thanks for coming. What brought you here today?" With no hesitation, Anthony questioned, "I want to know about Fred. Who was he? What did he mean to this neighborhood? What did he mean to this city?" Caught up in conversation, we learned that, other than Douglass's own autobiographies, nothing of consequence had been written that explored Douglass's years in Anacostia. We lingered at Cedar Hill nearly a half hour beyond our lunch break before eventually making it back to our respective desks. Usually a conversationalist like me, Anthony hadn't said very much since we got back. Knowing my background in journalism and interest in the city's history, Anthony broke the silence, "Hey, John, you think you could write something about what Freddy-Fred meant to this neighborhood? Somebody has to do it."

More than two years later, that day's memories still vivid, I can now appreciate how important Anthony's questions were and the seed of discovery he helped to germinate. Over the past eight months, starting from nothing, I feel I have taught myself enough about Frederick Douglass for a lifetime. Yet around every corner, I come across a new connection he had, or a helping hand he extended or an idiosyncrasy of "who he was." Great men like Frederick Douglass warrant lifelong study. With this in mind, I know this portraiture of Douglass's years in Washington, D.C., is rather incomplete, but it is a start.

There are many elements of Douglass I was unable to explore in this book yet helped me to "keep-a-plugging away," as Paul Laurence Dunbar, a young man Douglass took an interest in, famously wrote in his poetry. First, I had heard here and there that Charles Douglass played on an early black baseball team in Washington in the immediate years after the Civil War, his father supportive and known to attend a game or two. Anthony Gualtieri and Jennifer Morris of the Smithsonian's Anacostia Community Museum and Ryan Swanson, a history professor at George Mason University (whose book on early black baseball in Washington, D.C., will be published in 2013), helped to confirm these facts. Frederick Douglass was an early fan of America's pastime.

At Nationals Park, the home of the Washington Nationals, a September 1870 proclamation from the "Head Quarters of the Washington Mutual Baseball Club" making Frederick Douglass an honorary member can be seen

Proclamation, September 5, 1870, from the Mutual Base Ball Club making Frederick Douglass an honorary member, as seen inside Nationals Park today. *Author's collection.*

throughout various points of the stadium's concourse, where the history of Washington, D.C. baseball is documented. I also found an article indicating that in late summer 1891, after returning to the United States from Haiti, Frederick Douglass was one of nine hundred spectators to take in a game between the Cuban Giants and an all-Washington Club at, then, National Park. The Cuban Giants are recognized as one of the most formidable early black barnstorming baseball teams.

Secondly, during the research, I had to take a couple days' break as the son of an early supporter was killed in Afghanistan serving in the United States Marine Corps. With my younger brother an active-duty U.S. Marine with two combat tours, I felt the loss of the twenty-two-year-old native Washingtonian—nowhere as deeply as did his mother, my friend, but I felt it personally. I had interviewed and written about him for a story in the *Washington Times* nearly three years before, when he was fresh out of boot camp. On May 30, 1871, Douglass gave a short address, "The Unknown Loyal Dead," at Arlington National Cemetery. The following is an excerpt of his remarks:

> *Those unknown heroes whose whitened bones have been piously gathered here, and whose green graves we now strew with sweet and beautiful flowers, choice emblems alike of pure hearts and brave spirits, reached in their glorious career that last highest point of nobleness beyond which human power cannot go. They died for their country.*

Whenever I needed Douglass, he was there.

Furthermore, as new scholarship is expected to emerge on Douglass in the upcoming years, there are still large gaps in Douglass's historiography related to his years in Washington. Before setting foot in the District, Douglass supported Myrtilla Miner's opening of the Normal School for Colored Girls in 1851. While living in Washington, Douglass (and his children) spoke out and worked against inequity in the city's school system. Late in life, Douglass delivered "a course of short talks for the benefit of the public schools" at the "High School, M St., N.W.," one of the earliest public high schools for black Americans in the country. Douglass as a lifelong journalist will surely one day earn the volume it so rightfully deserves.

To close, this book was put together out of necessity rather than leisure. I have been reporting on the Greater Anacostia neighborhood for more than three years now. Although I remained objective as I gathered information, the "Southside" beat is not for the faint of heart. The Historic Anacostia

Through his activism, William Alston-El, a resident of Anacostia for more than forty years, keeps the spirit of Frederick Douglass alive. *Author's collection.*

neighborhood has been studied and restudied for the past forty-plus years by think tanks, academics, consultants, city and federal agencies and nonprofit advocacy groups in an effort to determine how to both jumpstart economic development and save and preserve the diverse housing stock. For decades, the neighborhood has been identified as "up and coming." But there is a feeling in the air now that, even as residents continue to organize and fight the "oversaturation" of social services agencies that fill previously vacant buildings on the commercial strip (government transfer payments taking the place of commerce), a renaissance might be for real. I do hope so.

Walking the residential streets of Anacostia with my friend William Alston-El, we pass too many vacant houses, or what remains of them, that were developed by the likes of Henry A. Griswold, a local business partner of Frederick Douglass, to not feel something is wrong here. William confides in me, "If Fred was alive you better believe he wouldn't sit by quietly and let this happen to his neighborhood."

Selected Bibliography

Books

Blassingame, John W. *The Frederick Douglass Papers.* Vol. 4, *1864–1880.* New Haven, CT: Yale University Press, 1991.

———. *The Frederick Douglass Papers.* Vol. 5, *1881–1895.* New Haven, CT: Yale University Press, 1992.

Breul, Nicholas. *Metropolitan Police Department, Washington, DC, 150th Anniversary, 1861–2011, Nation's Finest.* Morley, MO: Acclaim Press, 2010.

Brown, William Wells. *The Black Man, His Antecedents, His Genius and His Achievements.* N.p., 1863.

Clark-Lewis, Elizabeth. *First Freed: Washington, D.C. in the Emancipation Era.* Washington, D.C.: Howard University Press, 2002.

Crowder, Ralph L. *John Edward Bruce: Politician, Journalist, and Self-Trained Historian of the African Diaspora.* New York: New York University Press, 2004.

Douglass, Frederick. *Frederick Douglass Autobiographies, Narrative of the Life of Frederick Douglass, an American Slave, My Bondage and My Freedom, Life and Times.* New York: Library of America, 1994.

———. *A Lecture on Our National Capital.* Washington, D.C.: Smithsonian Institution Press, 1978.

Foner, Philip S. *Frederick Douglass.* New York: Citadel Press, 1964.

Gregory, James Monroe. *Frederick Douglass the Orator*. Springfield, MA: Willey & Company, 1893.

Holland, Frederic May. *Frederick Douglass: The Colored Orator*. New York: Funk & Wagnalls, 1891.

Howard, General Oliver Otis. *Autobiography of Oliver Otis Howard, Major General United States Army*. Vol. 2. New York: Baker & Taylor Company, 1907.

Hutchinson, Daniel Louise. *The Anacostia Story, 1608–1930*. Washington, D.C.: Smithsonian Press, 1977.

Kendrick, Paul, and Stephen Kendrick. *Douglass and Lincoln: How a Revolutionary Black Leader and a Reluctant Liberator Struggled to End Slavery and Save the Union*. New York: Walker & Company, 2007.

Leach, Margaret. *Reveille in Washington, 1860–1865*. New York: Harper Brothers, 1941.

Logan, Rayford W. *Howard University: The First Hundred Years, 1867–1967*. New York: New York University Press, 1968.

Masur, Kate. *An Example for All the Land: Emancipation and the Struggle over Equality in Washington, D.C.* Chapel Hill: University of North Carolina Press, 2010.

McFeely, William. *Frederick Douglass*. New York: W.W. Norton & Company, 1991.

———. *Yankee Stepfather: General O.O. Howard and the Freedmen*. New York: W.W. Norton & Company, 1984.

Payne, Daniel Alexander. *Recollections of Seventy Years*. Nashville, TN: A.M.E. Sunday School Union, 1888.

Peck, Taylor. *Round-Shot to Rockets; A History of the Washington Navy Yard and U.S. Naval Gun Factory*. Annapolis, MD: United States Naval Institute, 1949.

Penn, Irvine Garland Penn. *The Afro-American Press and Its Editors*. Springfield, MA: Clark W. Bryan & Co., Printers, 1891.

Preston, Dickson J. *Young Fredrick Douglass: The Maryland Years*. Baltimore, MD: Johns Hopkins University Press, 1980.

Quarles, Benjamin. *Frederick Douglass*. New York: Da Capo Press, 1997.

Rhodes, Jane. *Mary Ann Shadd Cary: The Black Press and Protest in the Nineteenth Century*. Bloomington: Indiana University Press, 1999.

Rice, Allen Thorndike. *Reminiscences of Abraham Lincoln by Distinguished Men of His Time*. New York: North American Publishing Company, 1886.

Ricks, Mary Kay. *Escape on the Pearl: The Heroic Bid for Freedom on the Underground Railroad*. New York: HarperCollins, 2007.

Townsend, George Alfred. *Washington, Outside and Inside: A Picture and a Narrative of the Origin, Growth, Excellencies, Abuses, Beauties, and Personages of Our Governing City*. Cincinnati, OH: J. Betts & Company, 1873.

Whyte, James Huntington. *The Uncivil War: Washington During the Reconstruction, 1865–1878.* New York: Twayne Publishers, 1958.

Williams, George Washington. *History of the Negro Race in America, 1619–1880.* Vol. 2. New York: G.P. Putnam's Sons, 1883.

Collections

Frederick Douglass National Historic Site, National Park Service
Photograph Collection & Archives

Library of Congress
Manuscript Division, Frederick Douglass Papers

Moorland-Spingarn Research Center
Howard University Archives, Record Group 55, Office of the Secretary
Minutes of the Howard University Board of Trustees, November 1866–February 1915

Moorland-Spingarn Research Center
Manuscript Collection, Frederick Douglass Papers

Series B > Writings about Frederick Douglass
Box 28–2, Writing 27
Johnson, Edward A. "My Visit to Frederick Douglass" Unpublished ms., n.d.
Box 28–2, Writing 31
Perry, Fredericka Douglass. Recollections of her grand-father (typescript), n.d.
Box 28–2, Writing 35
Sprague, Rosabelle, and Rosetta Douglass Sprague. An acrostic (holograph), n.d.

Series C > Correspondence
Box 28–5, Letter 124
Douglass, Frederick, to John Marshal Harlan, December 19, 1887.
Box 28–5, Letter 125
Harvey, Chas. A., to Frederick Douglass, October 14, 1879.

Box 28–5, Letter 127
Douglass, Frederick to George F. Hoar, February 19, 1895.
Box 28–5, Letter 133
Richards, A.C., to Frederick Douglass, March 19, 1877.

Series M> Photographs, Artifacts and Scrapbooks
Box 28–10, 2 scrapbooks
2nd book, article with headline "THE CAPITAL" in top left column, November
 28, 1875.

Mississippi State University
Papers of Ulysses S. Grant

University of North Carolina
Documenting the American South (online)

University of Rochester
Frederick Douglass Project
Letter 3, Frederick Douglass, note, September 1, 1874.
Letter 5, Frederick Douglass, note, February 4, 1877.
Letter 12, Frederick Douglass to [George] F. Edmunds, January 6, 1880.
Letter 30, Frederick Douglass to Mrs. Sara Jane (Clarke) Lippincott, October
 9, 1882.
Letter 33, Frederick Douglass to Mrs. Jenny Marsh Parker, January 8, 1885.
Letter 62, Frederick Douglass to Henry Augustus Ward, September 23, 1874.
Letter 78, Frederick Douglass to Amy Kirby Post, July 14, 1882.
Letter 81, Frederick Douglass to Amy Kirby Post, January 15, 1877.
Letter 107, Frederick Douglass Jr. to Amy Kirby Post, October 30, 1872.
Letter 113, Frederick Douglas to Amy Kirby Post, January 20, 1871.
Letter 114, Frederick Douglass Jr. to Amy Kirby Post, February 8, 1872.
Letter 115 Frederick Douglass Jr. to Amy Kirby Post, February 14, 1872.
Letter 134, Frederick Douglass Jr. to Amy Kirby Post, July 8, 1882.

Rutherford B. Hayes Presidential Center
Frederick Douglass Vertical Files
Rutherford B. Hayes Diary & Letters

Newspapers

Baltimore Sun
Brooklyn Daily Eagle
Christian Recorder
Cleveland Gazette
Evening Star
National Leader
National Republican
New Era/New National Era
New York Evangelist
New York Times
New York Tribune
People's Advocate
Prairie Farmer
Washington Bee
Washington Grit
Washington Post
Washington Sentinel

Magazines

Champion Magazine. "Douglass Centennial Number" (February 1917).
Poore, Ben Perley. "Washington News." *Harper's New Monthly Magazine* 48 (January 1874).
Townsend, George Alfred. "New Washington." *Harper's New Monthly Magazine* 50 (February 1875).

Records

Boyd's Directory District of Columbia, 1860–1920.
Congressional Globe, 1860–1905.
District of Columbia Building Permits, 1872–1895.

District of Columbia Land Records, 1873, 1877, 1878.

Howard University Catalogue, 1869–1912.

Records of the Legislative Council of the District of Columbia, 1871–1873.

Maps

Geography and Map Division, Library of Congress.

Washingtoniana Division, Map Collection, Martin Luther King Jr. Memorial Library.

Journals, Lectures and Papers

Journals

Journal of Negro History

Cromwell, John W. "The First Negro Churches in the District of Columbia." Vol. 7, No. 1 (January 1922).

Davis, Lenwood G. "Frederick Douglass as a Preacher, and One of His Last Most Significant Letters." Vol. 66, No. 2 (Summer 1981).

Douglass, Frederick, "Two Letters of Frederick Douglass." Vol. 36, No. 1 (January 1951).

Grimke, Francis J. "The Second Marriage of Frederick Douglass." Vol. 19, No. 3 (July 1934).

Holmes, Dwight O. "Fifty Years of Howard University: Part 1." Vol. 3, No. 2 (April 1918).

Sprague, Rosetta Douglass. "Anna Murray-Douglass—My Mother as I Recall Her." Vol. 8, No. 1 (January 1923).

Organization of American Historians Magazine of History

Horton, James O., "'What Business Has the World with the Color of My Wife?' A Letter from Frederick Douglass" Vol. 19, No. 1 (January 2005).

Records of the Columbia Historical Society

Burr, Charles R. "A Brief History of Anacostia, Its Name, Origin and Progress." Vol. 23 (1920).

Chase, Hal S. "Shelling the Citadel of Race Prejudice': William Calvin Chase and the Washington 'Bee'. 1882 – 1921" Vol. 49 (1973/1974).

Gordon, Martin K., "The Black Militia in the District of Columbia, 1867 – 1898" Vol. 48. (1971/1972).

Richardson, Steven J. "The Burial Grounds of Black Washington: 1880–1919" Vol. 52 (1989).

Washington History

Bowling, Kenneth, "From 'Federal Town' to 'National Capital': Ulysses S. Grant and the Reconstruction of Washington, D.C." Vol. 14 (2002).

Gilmore, Matthew B. and Harrison, Michael R., "A Catalog of Suburban Subdivisions of the District of Columbia, 1854 – 1902." Vol. 14, No. (2002 / 2003).

Lectures

Fought, Leigh. "Anna Murray Douglass." Frederick Douglass National Historic Site, Washington, D.C., July 21, 2012.

Schmidt, Sandra. "On Being Black in an Overwhelmingly White Police Department." 38th Annual Conference on D.C. Historical Studies, November 5, 2011.

Turk, David. "The Impact of U.S. Marshal Frederick Douglass Closing the Chasm." Frederick Douglass National Historic Site, Washington, D.C., February 14, 2005.

Master's Thesis

Nelson, Julie R. "Have We a Cause: The Life of Helen Pitts Douglass, 1837–1903." Shippensburg University, 1995.

Author's Note: Many sources and collections were accessed digitally, the Library of Congress's Frederick Douglass Papers being the most significant, followed by important material made available for the public good mainly by universities and public libraries.

Index

About the Author

John Muller is a Washington, D.C.–based journalist, historian, playwright and policy analyst. A former reporter for the *Washington Times*, he is a current contributor to Capital Community News, Greater Greater Washington and other Washington, D.C. area media. His writing and reporting have appeared in *Washington History*, the *Washington Post*, the *Georgetowner*, *East of the River*, the *Washington Informer*, *Suspense Magazine* and *Next American City* (online). He has written extensively about municipal and neighborhood politics, public policy and current affairs in the Washington, D.C. metropolitan area for the past three years. In 2004, Muller co-founded a theater company, DreamCity Theatre Group, which was a finalist for three 2007 Mayor's Arts Awards, including Outstanding Contribution to Arts Education. Muller is a 2007 graduate of George Washington University, with a BA in public policy, and a 1995 graduate of Greenwood Elementary School in Brookeville, Maryland.

About the Photographer

Matthew Parker is a native Washingtonian and graduate of the University of Tennessee School of Architecture. "The curriculum taught me ways to observe, understand spatial relationships and gather the experiences of a specific place," he said. In May 2011, Matthew launched the Art Trike, Washington, D.C.'s first mobile art bike business. Since 2005, his work has been featured at Art on the Avenue, Arts on Foot, Rockville VisArts, Downtown Holiday Market, National Building Museum and Artomatic. Matthew has worked with clients including the University of Maryland Alumni Center and the Washington Redskins. You can find more information on his work at www.reinventing-reality.com and on Twitter @dcphotocollage.

Visit us at
www.historypress.net